中国西南拼布
Quilts of Southwest China

主编 玛莎·麦克道尔 [美] 张丽君 Edited by Marsha MacDowell and Lijun Zhang

云南民族博物馆、贵州民族博物馆、广西民族博物馆、密歇根州立大学博物馆、印第安纳大学马瑟斯世界文化博物馆、国际民间艺术博物馆、纳布拉斯卡大学林肯分校国际拼布研究中心与博物馆合作项目出版物。

A collaborative publication project of the Yunnan Nationalities Museum, Guizhou Nationalities Museum, Guangxi Museum of Nationalities, Michigan State University Museum, Mathers Museum of World Cultures at Indiana University, Museum of International Folk Art, and International Quilt Study Center & Museum at University of Nebraska–Lincoln.

D1369281

广西人民出版社

版权归属

云南民族博物馆、贵州民族博物馆、广西民族博物馆

2016 中国南宁

Copyright Yunnan Nationalities Museum, Kunming; Guizhou Nationalities Museum, Guiyang; Guangxi Museum of Nationalities, Nanning, China 2016

2016 年出版　　Published　2016

版权所属，未经版权所有人书面同意不得将书中的任何内容用于翻版及其他侵权用途。

All rights reserved. No part of this book may be reproduced in any form without written permission of the copyright owners. All images in this book may not be used without the permission of the copyright owners. Every effort has been made to ensure that credits accurately comply with information supplied.

本书主要出版经费由云南民族博物馆、贵州民族博物馆和广西民族博物馆提供。亨利·鲁斯基金及纳布拉斯卡大学国际拼布研究中心和博物馆提供了辅助支持。

Major funding for this publication has been provided by the Yunnan Nationalities Museum, Guizhou Nationalities Museum, Guangxi Museum of Nationalities.

Additional support provided by the Henry Luce Foundation and the Friends of the International Quilt Study Center & Museum, University of Nebraska–Lincoln.

图书在版编目（CIP）数据

中国西南拼布：汉、英 /（美）麦克道尔，张丽君主编. —南宁：广西人民出版社，2016.3

ISBN 978-7-219-09830-1

Ⅰ.① 中… Ⅱ.①麦… ②张… Ⅲ.①布料—手工艺品—介绍—西南地区—汉、英 Ⅳ.① TS973.5

中国版本图书馆 CIP 数据核字（2016）第 048746 号

中国西南拼布　ZHONGGUO　XINAN　PINBU

责任编辑　董苏煌　吴语诗

责任校对　蓝雅琳

出版发行	广西人民出版社
社　　址	广西南宁市桂春路 6 号
邮　　编	530028
印　　刷	南宁市桂川印务有限责任公司
开　　本	889mm×1194mm　1/16
印　　张	9.75
字　　数	150 千字
版　　次	2016 年 3 月　第 1 版
印　　次	2016 年 3 月　第 1 次印刷
书　　号	ISBN 978-7-219-09830-1/T·59
定　　价	88.00 元

版权所有　翻印必究

目　录

Table of Contents

项目合作博物馆介绍

拼布作品

About the Participating Museums

Gallery of Quilts

序一

　　中美民俗学会在过去八年一直致力于创建一个连接专家、学者和机构的网络以共享两国的学术专业志趣。其中的活动以非物质文化遗产政策和博物馆实践为主题，包括在两国举办论坛以及进行两个学会中的研究生、年轻学者和资深会员间的交流和互访。通过这些活动我们建立了深厚的友谊和卓有成效的互动。中国西南拼布展便是我们这种合作精神的一种体现。由密歇根州立大学博物馆和云南民族博物馆牵头举办的展览向美国观众展示了中美拼布传统的异同。中美民俗学会期待今后与我们在学者交流、展览和田野作业等方面进一步交流与合作。

朝戈金 博士，中国民俗学会会长

迈克尔·安·威廉斯 博士，美国民俗学会会长

Preface（1）

　　For the past eight years, the China Folklore Society and the American Folklore Society have worked together to create a network of institutions, as well as professionals and scholars in both countries in order to share both scholarly and professional interests. Our activities have included forums, held in both countries, which have focused on topics such as intangible cultural heritage policy and museum practices, as well as exchanges and visits involving graduate students, young professionals, and senior members of our societies. From this work have come both good friendships and productive interactions. The exhibit Quilts of Southwest China embodies the spirit of our collaborations. Spearheaded by the Michigan State University Museum and the Yunnan Nationalities Museum, this exhibit will share with museum goers across the United States the commonalities and the differences between our two countries' quilting traditions. CFS and AFS look forward to continued communications and collaborations through further scholarly exchanges, exhibits, and field schools in the coming years.

Chao Gejin, Ph.D., President, China Folklore Society
Michael Ann Williams, Ph.D., President, American Folklore Society

序二

2010 年 9 月美国民俗学会罗仪德会长一行 5 人到访云南民族博物馆，我有幸认识了玛莎、胡世德夫妇。两年后，"化零为整：21 世纪美国的 25 位拼布制作者"展览由美国驻华大使馆介绍引进云南民族博物馆，第一次向云南观众展示了美国拼布艺术的魅力。当不同的元素被重新调动、组合、拼接在一幅拼布作品上，艺术家的才华、创意和想象力——甚至他们的故事、生活和情感都通过这些拼布传达给我们，感染着我们，吸引了我们。

这种艺术形式是如此的具有异域风情，但有时却又让人感到非常熟悉。作为中国唯一的民族类国家一级博物馆，长期致力于收藏、研究、展示少数民族传统文化，我们很快就注意到了美国的这项文化传统与我们中国民族民间生活中的审美和创造有异曲同工之妙。在我们博物馆的藏品中，也不乏美丽的被面、背被（拼布）等。精美的造物也凝聚着各少数民族人民的审美、才华、情感和故事。

美国人对于拼布传统的珍重和对于拼布艺术的热情，启发我们开始以一种新的角度重新审视我们的拼布收藏。玛莎博士是"化零为整"展览中的资深专家，通过"化零为整"在中国的巡展，我们和玛莎、胡世德夫妇有了更紧密的联系和交流。他们曾多次访问云南，我们成了好朋友，促成密歇根州立大学博物馆与云南民族博物馆建立了友好合作关系。两馆就拼布收藏、资源共享、数字化建设等有了实质性的合作与交流。玛莎、胡世德夫妇与我们共同策划中美民族博物馆之间的馆际交流，胡世德博士、谢沫华馆长分别担任中美合作项目总协调人，并吸收了广西民族博物馆、贵州省民族博物馆、马瑟斯世界文化博物馆、圣达菲国际民俗艺术博物馆作为合作成员，相继在中美双方召开多次协调会议，

Preface（2）

In September 2010, Dr. Timothy Lloyd, Executive Director of the American Folklore Society brought a group of five U.S. folklorists to visit Yunnan Nationalities Museum (YNM). It was then that I had the pleasure of meeting Dr. Marsha MacDowell and Dr. C. Kurt Dewhurst, two folklorists based at Michigan State University Museum, who were part of that group. Two years later, YNM hosted the exhibition The Sum of Many Parts: 25 Quiltmakers in 21st America, which was circulated to YNM by the United States Embassy in China. For the first time, Yunnan audiences were introduced to American quilts. Through their various arrangements of designs within their rectangular forms, the quilts provided evidence of the talent, creativity, and imagination by the artists who made them. Moreover, the stories the artists told about their lives and their quilts affected and fascinated all who saw the exhibition.

For YNM staff, this form of art seemed exotic, yet very familiar. As the only first-level ethnic museum in China, dedicated to collecting, researching and demonstrating ethnic minorities' traditional cultures, we immediately noticed this American textile art tradition had much in common with textile art traditions in China. The YNM collections contain beautiful quilts, bed covers, baby carriers, and other exquisite textiles that also embody the aesthetics, talents, emotions and stories of Chinese people.

After witnessing how Americans cherished their quilt traditions and were enthusiastic about quilt art, YNM staff members were prompted to review YNM's quilt collection from a new perspective. As it happened, Dr. MacDowell was the senior scholar for The Sum of Many Parts, and, as part of the programs surrounding the exhibition, she returned to China with Dr. Dewhurst to give talks and to see the exhibition in Kunming. We became friends and thus was started the formation of many more friendships between staff members of YNM and the Michigan State University Museum. These friendships have now led to

并得到了美国鲁斯基金会的资助和美国民俗学会的支持，2015 年 9 月"中国西南拼布展"如期在美国开展并在美国巡展至 2017 年。

感谢胡世德夫妇、杰森·拜尔德馆长、玛莎馆长、高聪馆长、王颀馆长，和你们相识、相交、相知是一件愉快的事，感谢中美六个合作博物馆的团队为此付出的辛劳。胡世德教授曾经提倡用"协作"代替"合作"，在中美博物馆之间创造一种紧密无间的战略合作伙伴关系，我赞同他的意见。我们中国人用"同舟共济扬帆起，乘风破浪万里航"来形容有共同理想的合作伙伴齐心协力所能展开的前景。两国的民族博物馆专家如今已经在同一条船上扬帆起航，让我们期待一次成功的远航！

a collaborative relationship for quilt collecting, resource sharing, digitization, staff exchanges, and other projects. MSUM and YNM together planned a US-China ethnic museums communication program, for which Kurt and I served as coordinators and, together, we brought in four other collaborating museums as partners: Guangxi Museum of Nationalities, Guizhou Nationalities Museum, Mathers Museum of World Cultures at Indiana University and Museum of International Folk Art. We had coordinating meetings in both China and America, and received funding from the Luce Foundation and support from the American Folklore Society. The product of our first project-based collaboration, the exhibition Quilts of Southwest China opened in September 2015 at the Michigan State University Museum as planned and will tour to at least three other locations in the U.S. through 2017.

On a personal note, I would like to thank Dr. Marsha MacDowell and Dr. Kurt Dewhurst, Director/Dr. Jason Baird Jackson, Director/Dr. Marsha Bol, Director Gao Cong and Director Wang Wei. It has been a great pleasure to know and work with you. And I also extend thanks to all the teams at six partner museums for their efforts. Kurt once suggested we should "collaborate" instead of "cooperate". I agree with him. We Chinese use "Sailing on the same boat, to the great voyage" to describe the promising prospects for vision-sharing partners. Now that ethnic museum experts from our two countries are working on the same boat, let's look forward to a successful voyage!

谢沫华 云南民族博物馆馆长，研究馆员

Xie Mohua, Director, Professor of Relics and Museology, Yunnan Nationalities Museum

导言

《中国西南拼布》的出版是我们多方位合作项目的成果之一。此项目包含多个目标。首先，中美两国的合作博物馆基于对物质和非物质文化遗产特别是民族地区的纺织传统的共同兴趣进行了共赢互利的合作项目，我们的合作内容包括田野作业、藏品研究、举办展览、出版展览图册以及人员交流。我们希望通过此项目合作各方能够对彼此的文化、机构和专业实践及政策有进一步的了解。如何进行最佳合作的知识经验有助于我们加强机构和个人之间的联系并且有助于我们今后谋求进一步的合作。所以《中国西南拼布》的一个重要方面是学习如何进行合作。

其次，合作团队致力于促进对具体的物质和非物质文化遗产的认识并向世界范围内的观众展示这些知识成果。我们的主要研究对象是传统拼布被面。中国传统拼布被面方面的研究还比较缺乏。中国的传统拼布被面与西方欧洲的拼布被子在制作技艺、形态和使用上都有很多相似之处。世界上其他国家有很多人在制作拼布被子，也有一批学者在研究拼布。我们希望《中国西南拼布》对这些人有裨益的同时，也能在中国范围内引起人们对拼布制作和使用的更为深广的探索。

Introduction

This publication, *Quilts of Southwest China*, is one result of a multifaceted project that has had several important goals. First, a binational collaboration of museums whose staff members shared similar interests in tangible and intangible cultural heritage, and in particular, the traditions of making and using textiles in ethnic communities, sought a project that would be of mutual interest to all parties and would have multiple dimensions—fieldwork and collections-based research, development of an exhibition and publication, and professional exchanges. The hope was that by engaging in such a project together, the parties would learn from each other about the cultural, institutional, and professional practices and policies of each institution and how those differed by institution or by country. The goal was that the resulting knowledge of how collaborative work could best be done would strengthen institutional and personal relationships and position the museums to pursue other future work with each other as well as with other museums in both China and the U.S. In other words, learning "the how" of working together was an important element of the Quilts of Southwest China project.

Secondly, the collaborators endeavored to advance new knowledge about a specific aspect of intangible and tangible cultural heritage and to make that knowledge accessible to worldwide audiences. The project team members focused on investigating traditional bedcovers—a form of textiles in China for which little research had previously been done but that had strong similarities in terms of construction techniques, styles, and uses to the quilts of Western European origination. Because there were already tens of thousands of individuals in other countries engaged in aspects of quilt production, and because a body of scholarship on quilt studies already existed, it was hoped that the results of the Quilts of Southwest China study would be of great interest to this pre-existing audience and that the exhibition and publication would foster interests in deeper and wider investigations of the production and use of bedcovers in China.

本书是建立在上述目标和中美工作人员辛勤的付出基础上的。在中国西南拼布这个大框架下，本书的内容以我们展览的拼布被面、文字解读和展板为雏形。就像用碎布片缝制而成的拼布，本书的文章以拼布研究为连接点形成一个整体。博物馆学者和独立学者的投稿文章内容包括中国纺织品传统、当代中国拼布艺术、中英文术语研究、中国美式拼布的兴起、拼布索引数据库中国拼布信息的录入、搜集记录中国拼布的挑战以及拼布被面艺术制作的保护和传承等。中美六家博物馆和美国的另外一家合作机构也撰文介绍了各馆概况及馆内的文化遗产活动特别是与纺织品相关的活动。

This publication is, then, a result of these aims and the good work of many individuals in China and in the U.S. The content of the publication builds upon the objects and interpretive and didactic texts that were presented in the exhibition and situates the exploration of the quilts of southern China in a broader framework. Like the pieces of fabric that are sewn together to create a patchwork textile, these articles attempt to show a whole cloth of relationships connected to this focused study. To achieve that, we have asked museum-based and independent scholars to contribute written pieces on general and particular traditional textiles in China, contemporary Chinese art quilts, nomenclature in bilingual and binational research, an emerging Chinese-American quilt tradition, the incorporation of Chinese quilts into the Quilt Index (an international digital repository of thematic material culture), challenges of documenting and collecting Chinese bedcovers, and efforts to preserve and perpetuate bedcover art making. Each of the core U.S.-China partner institutions and an additional US partner institution also share descriptions of their institutions and their activities related to traditional cultural heritage, especially those pertaining to textiles.

玛莎·麦克道尔 博士，密歇根州立大学博物馆馆长

张丽君 博士，广西民族博物馆研究二部馆员

Marsha MacDowell, Ph.D., Curator and Director, Michigan State University Museum

Lijun Zhang, Ph.D., Research Curator, Guangxi Museum of Nationalities

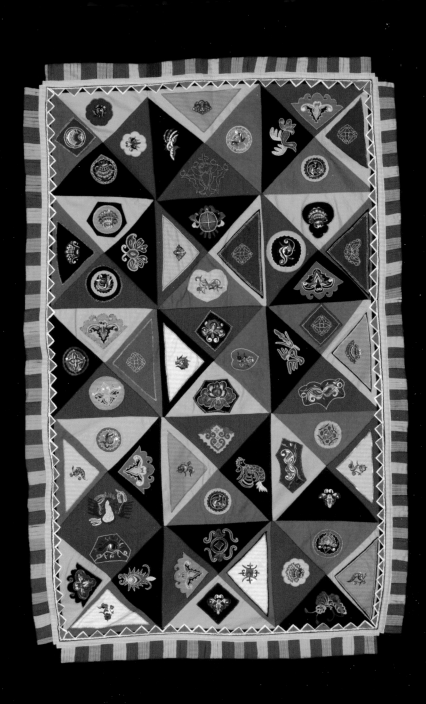

中国西南拼布：
研究的推进

Quilts of Southwest China: Research in Progress

纺织品是历史和文化的物质证据，可以记录很多与贸易、宗教、传统、迁徙、社区和个人相关的信息。纺织品的非物质特征——其用途、意义、故事、制作技艺与知识——通常会与个人和社区的身份认同和文化遗产相融合。学者、收藏家和博物馆很少关注中国制作和使用拼布被面的传统，拼布被面的公共和私人收藏不多，关于拼布被面的出版物也很少。《中国西南拼布》项目中所做的研究和征集工作是对这种使用小块布片缝纳成艺术纺织品和实用纺织品的物质和非物质文化遗产的先创性的记录之一。

非物质文化遗产与中国拼布研究

中国的每一个民族都有其日常生活和特殊时节的独特传统。这些在群体内部习得的传统是连接个人与群体以及个人与过去的纽带。传统是我们当前社会的核心，也是我们文化知识传承的途径。中国作为一个正在经历巨变的国家对非物质文化遗产保护做出了郑重的承诺。成千上万的工作人员在地方、区域和国家层面上致力于对非物质文化遗产的记录和推广工作。为确保这些非物质文化遗产能得到保护和推广，中国推出了很多保护和存续非物质文化遗产的举措，这些举措很多是针对中国 56 个民族当

Textiles are material evidence of history and culture and can tell us much about trade, religion, traditions, migration, communities, and individuals. The intangible characteristics–the uses, meanings, stories, skills and knowledge about production–associated with these textiles are often integral to the identity and cultural heritage of individuals and communities. The textile traditions in China of making and using quilts or bedcovers has received little attention by scholars, collectors, and museums; few examples are in public or private collections and little has been published on them. The research and collecting done for the Quilts of Southwest China project provides some of the first documentation of the intangible and tangible cultural heritage associated with the traditions of using small pieces of fabric pieced and appliquéd together to form artistic and functional textiles.

Intangible Cultural Heritage and the Study of Chinese Quilts

Every ethnic group in China has distinctive traditions practiced both every day and on special occasions. These traditions, often learned informally within a group, connect group members to each other and to their past. They are a central part of life in the present, and provide a means to carry cultural knowledge into the future.

中的非物质文化遗产的。[i] 我们正是在这一语境下开展的中国西南拼布被面研究。

中国拼布概况

拼接、缝补和贴布等用针线缝纳布片的拼布技艺在不同的地方和文化中由来已久。[ii] 中国发现和出土了公元前770年东周时期的装饰性丝绸被子。[iii] 在明朝时期（1368—1644），有些地区很流行用小块布片缝制衣服。因为缝纳的布片很像一块块的稻田，这种衣服又被称为"水田衣"。[iv] 亚洲一些国家的僧人穿百衲衣以示苦修，但这种衣服并不是教服。（图1）中国用"纳"字来指称拼布技艺，因此有些中国僧人也自称纳子。[v] 现在我们可以从网上买到僧人穿的百衲衣。[vi] 在陕西和山西，新生儿的父母会

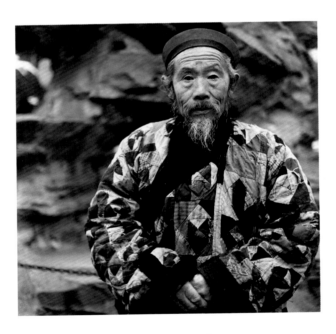

图1 刘铮（音），穿百衲衣的道士，北京，1994
（版权所属刘铮，由北京艺门提供照片）
Figure 1. Liu Zheng, A Taoist Monk Wearing Patchwork Clothes, Beijing, 1994
(Copyright Liu Zheng. Photograph courtesy of Pékin Fine Arts)

China, a country undergoing massive changes, has made a deep commitment to ICH. Thousands of workers are documenting and recommending ICH for safeguards on the local, provincial, and national level. To ensure that these recognized ICH elements would be protected and strengthened, many new strategies for protection and perpetuation are being established and many of these strategies target the ICH associated with the 56 ethnic groups within China officially recognized by the People's Republic of China. [i] It is within this context that the exploration of bedcovers or quilts in southwest China was launched.

Patchwork in China: A General Overview

The techniques of piecing, patching, and appliquéing fabrics together and then binding layers of fabric together with stitches—the fundamental elements associated with the textiles known as quilts—have been known to exist for centuries in different locales and cultures. [ii] In China, decorative quilts made of silk dating back as far as 770 B.C., during the Eastern Zhou Dynasty, have been discovered. [iii] During the Ming Dynasty (1368–1644), clothes made of many small pieces of cloth sewn together were especially popular in some regions. Because the patchwork shapes were visually similar to those of rice paddies, the clothes have been referred to as "Paddy Field" clothes. [iv] Buddhist monks in several Asian countries have worn garments of patchwork to evoke their humbleness or so that the clothes would not be perceived as religious garments. (Figure 1) The Chinese character Na also means patchwork and some Chinese monks are referred to as Na-Zi (纳子). [v] Even today, an individual can order a patchwork monk's robe online. [vi] In Shaanxi and Shanxi, bedcovers or items of clothing are made for a new child out of pieces of fabric contributed by friends and family—figuratively representing the notion that it takes a village to raise the child. These textiles are sometimes called baijiabei

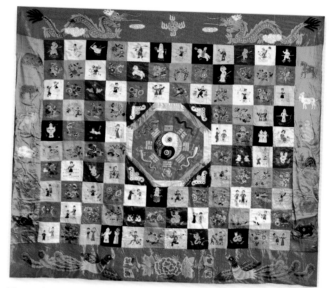

图2 百家被，中国西安，2015

Figure 2. 100 Good Wishes Quilt, Xi'an, China, 2015

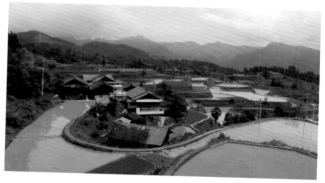

图3 群山中的村寨（马丽亚摄）

Figure3.Mountain landscape with village. (Photo by Ma Liya)

向亲戚朋友讨要布片做百家被或百家衣，代表着大家一起共同养育小孩。[vii]（图2）在这些地区，人们也会把用吉祥图案和传统剪纸图案装饰的拼布门帘挂在门上用于遮蔽私人空间，并且相信这种门帘具有辟邪的功能。[viii]

在中国西南地区的少数民族服饰和家庭用品中拼布技艺的使用尤为突出。虽然这些少数民族的语言、起源、历史和生活方式存在差异，但他们拥有相似的拼布艺术。（图3）对于很多少数民族来说，服饰是身份认同和一个民族区别于另一个民族的主要识别方式之一，甚至同一民族的不同支系也可以

（百家被），or "one hundred families" bedcovers and baijiayi（百家衣）or "one hundred families" clothes. [vii] (Figure 2)In these provinces pieced and appliquéd textiles, often decorated with auspicious symbols and constructed of cloth much like traditional papercutting, are hung in doorways for privacy and protection from natural and spiritual forces. [viii]

It is among the ethnic minority groups of Southwest China, however, that the traditional use of appliquéd, pieced, and patchwork textiles for clothing and household items has been the strongest. These ethnic groups have different languages, stories of origins, histories, and ways of living but many of them share the same patchwork art. (Figure 3)For many of the millions of ethnic minorities in this region, clothing and adornment is one of the primary ways in which identity has been traditionally expressed and distinguishes one ethnic group from another and, even among the same ethnic groups, members of one village from another. (Figure 4)Much has been written about these traditions of ethnic clothing and museums have formed large collections of historical costumes. But other textiles produced and used within these ethnic groups, such as cloth carriers (sometimes called slings) for babies, doorway coverings, and bedclothes, including ones made especially for weddings, have only just begun to be studied. Given the large population of minorities in southwest China, it is a given that hundreds of thousands of bedcovers have been made.

The Quilts of Southwest China research project has already revealed new insights about this element of China's intangible cultural heritage in the contexts of both the traditional and changing landscapes of the communities in which the bedcovers are created and within the broader Chinese nation. A few are shared here.

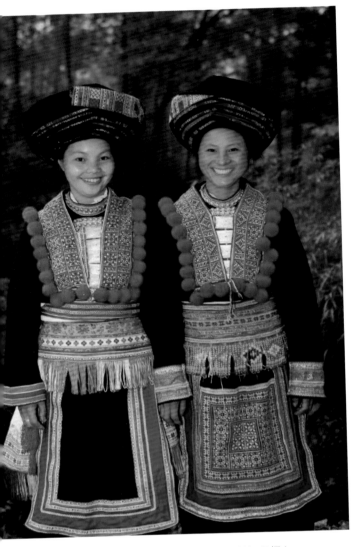

图4 村寨中身着传统服饰的盘瑶妇女（梁汉昌摄）
Figure 4. Pan Yao traditional clothing. (Photo by Liang Hanchang)

Traditional Quilts: An Ecosystem of Knowledge

In order to produce a quilt, skills and knowledge of many different textile techniques are needed including how to spin yarn and thread from home-grown cotton, weave the yarn and thread into cloth, and then to dye the cloth with natural pigments such as indigo. The weaving requires the craft of making looms and the dyeing requires the technique of producing pigments. Embellishment of cloth with appliqué and embroidery requires paper-cutting patterns that quilt artists either make themselves or buy from paper-cutting pattern specialists. Tracing and studying the process of the production of a quilt would help us understand the ecosystem of knowledge and skills in a society and to better understand the vulnerabilities and challenges for sustainability of one art or a cluster of arts.

Quilts and Traditional Belief Systems

Like many other forms of traditional arts in China, people make and use quilts that reflect their creative ideas and their beliefs. Like many other practitioners of traditional arts, many quilt artists incorporate auspicious designs in their work. Auspicious designs include patterns representing happiness, prosperity, grace, longevity, high social status, fruitfulness, positive attitudes, good wishes, and protection from evil. The images are usually symbolic. For instance, a dragon and phoenix represents high social status and grace; a lotus symbolizes purity and righteousness. Some auspicious designs are derived from consonant association of words. For example, in Chinese the word "fish" is pronounced the same as the word "prosperity", thus an image of a fish represents prosperity or the wish to be prosperous.

Quilt artists usually have designs in their mind already before they start making a quilt and will choose certain designs to best connect with the person for whom

通过服饰来识别。（图4）关于这些民族服饰传统的著作有很多，博物馆也有丰富的民族传统服饰馆藏。但是关于这些少数民族一些特定的纺织品，比如背带、门帘和床上用品包括婚床用品的研究才刚刚起步。中国西南少数民族人口众多，我们有理由推测这一地区手工被面的数量应该也不少。

在中国和西南少数民族面临的传统继承与变迁的背景下，《中国西南拼布》研究项目的拼布被面研究力图发掘这种中国非物质文化遗产形式的文化意义和内涵。

传统拼布被面：知识生态系统

在制作拼布被面的过程中，人们将会用到一系列的纺织技艺和知识，包括用自产的棉花纺线、织布，用蓝靛等天然染料染布等。织布需要织机和制作织机的技艺，染布需要制作染料的技艺。贴布绣和刺绣需要剪纸花样，拼布艺人的剪纸花样或是自己剪或是从剪纸艺人那里购买。记录和研究拼布被面的制作过程可以帮助我们了解社会知识和技艺的生态系统，并更好地理解某种艺术或一系列艺术可持续性发展的脆弱性和面临的挑战。

拼布被面和传统信仰体系

与中国的很多其他传统艺术一样，拼布被面的制作和使用反映了人们的创造力及信仰。与很多其他传统手工艺人一样，很多拼布被面制作艺人会在作品中使用吉祥纹样。这些吉祥纹样表达了人们对幸福、富裕、优雅、长寿、地位、成就、乐观、祝福和庇佑等的追求。这些纹样通常都是象征性的。比如，龙凤象征优雅和崇高的地位；莲花象征纯洁正直。有些吉祥图案来源于谐音字。比如，中文的"鱼"字和"余"谐音，因此人们用鱼纹来代表富足以及对富裕生活的向往。

拼布艺人通常在做拼布被面之前就已经有了纹样设计的构思并根据使用者来选取特定的纹样。比如，如果拼布被面是为新婚夫妇做的，艺人就会选择蝶恋花的纹样来代表爱情；如果是给老人做的，艺人可能就会用松鹤图来代表长寿。

有些拼布被面与民间文学形成互文关系。拼布艺人有时候会用与神话、传说和故事相关的纹样。比如，苗族拼布艺人使用的蝴蝶图案可能与苗族起源神话中的蝴蝶妈妈有关。

the quilt is made. For instance, if the artist made the quilt for a wedding bedcover, she would use designs such as butterflies and flowers since those symbols represent courtship and love. If a quilt is made for an older person, she might use images such as a crane or pine tree which represent longevity. Some quilts are intertextualized with folk literature; the quilt artist sometimes conveys myths, legends, and folk tales through her choice of symbols. For instance, when Miao quilt artists incorporate a butterfly design in their work, they perpetuate the Miao origin story of the butterfly as the ancestor of Miao people.

Challenges to Safeguarding and Protecting Quilt Traditions in Southwest China

While commercially manufactured, Western-style textiles are beginning to become more commonly used for everyday wear and domestic use, ethnic community members still consider their clothing a public marker of cultural identity and still make and use traditional clothing although, increasingly, for special and not everyday use. However, when ethnic groups live close to each other, encounter an increasing number of visitors through cultural tourism, and are connected via the Internet to other cultures worldwide, ethnic group members borrow and adapt styles from other cultures. For other textiles that are less publicly-visible—such as quilts—the making of these special bedcovers in many ethnic minority communities has diminished and may be altogether disappearing as commercially manufactured textiles become more available and as younger ethnic community members no longer have the time, interest, or skills to make handmade quilts. As fewer individuals make and use these handmade textiles, the knowledge and skills needed to make them is also being lost. International, national, and regional, agencies are beginning to promote intangible and tangible cultural heritage and scholars, cultural practitioners, and local artists are beginning to document the art of quiltmaking. It is hoped that strategies

保护中国西南拼布传统所面临的挑战

虽然商业生产的、西方式的纺织品在人们的日常着装和家庭用品中越来越常见，但少数民族地区的人仍然认为服饰是他们文化身份的公开标识，尽管渐渐地这些服饰只在特殊时节穿着，当地人仍然会制作和使用传统服饰。然而，由于少数民族毗邻而居而且当地人越来越多地接触外来文化旅游者，并且通过网络受到世界文化的影响等原因，少数民族开始借用其他文化的元素风格。由于工业生产的纺织品的普及以及年轻人不再有时间、兴趣和技艺来制作拼布被面，少数民族地区像拼布被面一类的比较少让外人看到的纺织品制作正在逐渐减少其至有可能会消失。制作和使用手工纺织品的人越来越少，相关的知识和技艺也在慢慢消失。但同时由于国际、国家和地方层面对非物质文化遗产和物质文化遗产的重视，学者、文化工作者和当地艺人开始记录拼布制作艺术，他们策略性地保护现存的传统纺织品以及纺织品艺人的知识和技艺以确保这些传统的传承。

中国当代拼布艺术：传统的新形式和受到的新影响

随着社会的发展和与外界更为频繁的接触，中国拼布制作艺术正在经历各种变化。目前这些变化主要发生在城市地区，很多传统艺人不可避免地最终也会感受到这些变化带来的影响。缝纫机的普及减少了人们制作纺织品所要投入的时间和精力。在像长城和秦始皇陵兵马俑这些著名的旅游区，商贩会出售色彩鲜艳的带有生肖图案和熊猫图案的拼布商品。"化零为整——21世纪美国拼布作品展"向中国观众展示了西方拼布的设计、图案和样式。在

will be developed to preserve the remaining historical textiles and the knowledge and skills of artists so that the tradition of making them can continue.

Contemporary Quilt Art in China: New Forms and New Impacts on Old Traditions

As society develops and as Chinese have more frequent contact with others outside their country, the art of making quilts in China is changing in many aspects. While most of these changes are currently happening in more urban contexts, inevitably many traditional artists across the country will feel the impacts. The increasing availability of sewing machines has reduced the labor and time of making textiles. At major tourist sites such as the Great Wall and the Pottery Warriors, vendors offer for sale brightly colored quilts with Zodiac signs and images of pandas. Exhibitions like The Sum of Many Parts showcase Western quilt designs, patterns, and forms to Chinese audiences. The techniques and patterns are being influenced by Western textile arts. At the same time that most younger ethnic community members have been losing interest in the traditional form of ethnic Chinese quilts, an emerging interest in DIY (do it yourself) crafts is occurring in China, particularly among the younger, mostly urban Han generation. For these young people, making quilts (or quilted purses, wearable art, toys, and wall hangings) for home decoration, personal adornment, and gift-giving represents having a new hobby and lifestyle. Already a new industry of equipment, conventions, publications, and fabric production is occurring in China to meet this fast-growing movement. Interestingly, as part of this trend, some young people are starting to collect Chinese traditional quilts.

In the fast-growing contemporary art world in China, quilts are finding a place. Already one contemporary artist, Yin Xiuzhen, has created a patchwork art installation when she covered an elongated Volkswagen

很多少数民族地区的年轻人对中国少数民族传统拼布样式已经失去兴趣的同时，在中国年轻人当中，特别是在城市中的汉族年轻人当中，却逐渐流行起了DIY。对这些年轻人来说，为家庭装饰、个人装饰或赠送礼物制作拼布被面（或者拼布钱包、服饰、玩具和壁挂）是一种新的爱好和生活方式。中国已经发展了相关的器材用具、规章约定、出版物和布料制造产业来迎合这一快速发展的领域。有意思的是，在这种趋势中一些年轻人开始收藏中国的传统拼布被面。

在中国快速发展的当代艺术界，拼布被面也找到了其立足之地。艺术家尹秀珍用拼接的布片覆盖了一辆大众公交车，由此创造了一件拼布艺术品。[ix] 在北京成立的中国流行色协会拼布色彩

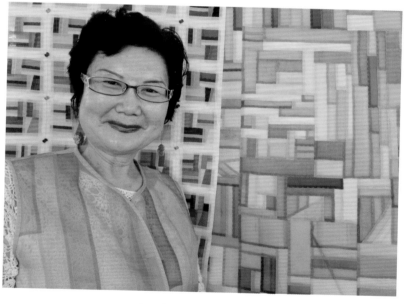

图5 金媛善及其拼布作品
Figure 5. Quilt made by Jin Yuanshan

与艺术专业委员会推动了中国拼布在纺织品当代艺术中的发展。委员会的成员之一金媛善是一位朝鲜族中国拼布艺术家，她同时也是国际工作室艺术拼布协会的中国代表，虽然她原来接受的是传统美术训练，但现成为了一位拼布艺术家。（图5）她的作品在华盛顿史密森民俗生活节和中国妇女与儿童博物馆都展出过。[x]

bus with pieced together clothes. [ix] There is now a China Quilts Color and Art Committee in Beijing that promotes quilts as textile contemporary art. One committee member who is also the Chinese representative to the international Studio Art Quilt Associates, is Jin Yuanshan, a Korean/Chinese artist trained in traditional techniques but who now specializes in art quilts. (Figure 5)Her work has been featured at the Smithsonian Folklife Festival in Washington, D.C., and in a special one-woman show in 2013 at the Museum of Chinese Women and Children in Beijing in conjunction with the aforementioned exhibition The Sum of Many Parts. [x]

The Research Continues

Our documentary field research with artists in villages, literature review, and museum object-based inquiry has certainly advanced knowledge about quilts in southwest China and has already identified questions for further inquiry. For instance: Do the techniques, colors, patterns, materials, and design motifs used in these quilts indicate a specific ethnic group or village aesthetic and textile tradition? Were all of the fabrics in a quilt made locally? Who made the fabrics? If the fabrics were from elsewhere, where were they from and how did they get to the villages? What makes a good or beautiful quilt and who determines that? Can the fabric or pattern help us determine the age of the quilt? Are certain bedcover artists regarded as better than others and, if yes, why? What are

研究的推进

我们在村寨中进行的记录、田野研究以及文献研究和博物馆馆藏研究促进了我们对中国西南地区拼布被面相关知识的了解，同时也提出了一些今后可以进一步探讨的问题。比如：这些拼布被面中使用的技术、色彩、纹样、材料和设计母题是否代表一个特定族群或村落的审美和服饰传统？制作拼布被面的布料都是当地自产的吗？谁织的布？如果这些布料是从别的地方来的，它们从哪里来？又通过什么途径来到当地村落？怎样才算是一床好的拼布被面或漂亮的拼布被面？由谁来做这些判断？我们可以通过布料或纹样来判断拼布被面的制作年代吗？人们会比较和评判拼布被面制作者的技术吗？为什么？拼布被面及其制作材料、纹样和制作技艺的当地术语是什么？婚床的被面有哪些特征？这些婚床被面是谁做的，未婚女性或新娘的女性亲戚？婚床被子是怎样融入到婚恋实践中的？这些拼布被面是由一个人单独完成还由一群人共同完成？为什么对拼布被面的研究如此之少？为什么博物馆的拼布被面馆藏如此之少？如果个人和社区不再制作和使用拼布被面，那他们用什么样的被面？

我们的项目团队成员希望通过《中国西南拼布》的研究为将来进一步的研究和调查打下基础，以期对拼布这一重要的中国文化遗产有更深入的了解。

玛莎·麦克道尔 博士，密西根州立大学博物馆馆长

张丽君 博士，广西民族博物馆研究二部馆员

local terms for the materials, patterns, techniques, and finished textile? What are the characteristics of bedcovers that are called wedding bedcovers? Who makes them—an unmarried woman, a female relative? And how do wedding covers figure into courtship and marriage practices? Is each textile made by one individual or are more involved? Why has so little research been done on these bedcovers and why are so few of them in museums? If individuals or communities are no longer making and using these textiles, what are they using for bedcovers?

Project team members hope the research in this Quilts of Southwest China project lays the groundwork for much more research by others and that further investigation will reveal more about this important aspect of Chinese cultural heritage.

Marsha MacDowell, Ph.D., Curator and Director, Michigan State University Museum

Lijun Zhang, Ph.D., Research Curator, Guangxi Museum of Nationalities

注释

ⅰ 根据2015年10月15日维基百科信息，"汉族是中国人口最多的民族，占中国13亿人口的90%以上。中国最大的少数民族是中国西南山区的壮族，约有1700万人口。这一地区的其他少数民族包括苗族（940万）、侗族（280万）、布依族（280万）、瑶族（270万）、白族（190万）和傣族（120万）。"

ⅱ 在中国，英语中被称为"quilt"的床上用品有不同的称呼。被子通常是由大片布料制成的由被面和被芯组成的盖在身上的床上用品的统称。拼布被面特指由布片拼接而成的被面。两到三层的比较厚的拼布形式常用于制作小孩的衣服、背带和被子等比较小的拼布产品。中国的被面也有单层的，由小块布片拼接缝制而成，类似于西方拼布被子的制作工艺。"quilt"这个词用于指称多种不同的拼布艺术，比如壁挂和其他只有一层或两层的拼布艺术品。

ⅲ 《化零为整》P.14。

ⅳ 徐雯、刘琦．《布纳巧工：拼布艺术展》．北京：中国纺织出版社．2010. 第13页和第17页。

ⅴ 《布纳巧工：拼布艺术展》第14页；Thomas Watters, The Influence of Buddhism on the Chinese Language. Shanghai: Presbyterian Mission Press, p. 487.

ⅵ 《手工艺术》

http://www.myadornart.com/products.asp?cid=145.Accessed October 15, 2015.

ⅶ 《布纳巧工：拼布艺术展》第12页。

ⅷ Feng Shanyun and Lan Peijin. 2002，《陕西拼布艺术》．北京：外文出版社；《中国西南拼布艺术》．文化中国．http://traditions.cultural-china.com/en/16Traditions992.html. Accessed October 15, 2015.

ⅸ "殷秀珍"，Wikipedia. https://en.wikipedia.org/wiki/Yin_Xiuzhen. Accessed July 25, 2015; 潘清，"殷秀珍"，《美国艺术》2010年9月1日 http://www.artinamericamagazine.com/news-features/magazine/yin-xiuzhen/. Accessed July 25, 2015; Carol Yinghua Lu, "Yin Xiuzhen". Frieze. Issue 115, May 2008. http://www.frieze.com/issue/review/yin_xiuzhen/. Accessed July 25, 2015; and Hou

Notes

ⅰ According to Wikipedia,(https://en.wikipedia.org/wiki/Ethnic_minorities_in_China), accessed October 15, 2015. The Han ethnic group is the largest, numbering over 90% of the c. 1.3 billion Chinese citizens. The largest minority ethnic group, as of 2015, is the Zhuang (nearly 17 million), who live mostly in the mountainous regions of southwestern China. Other large ethnic groups in this same region include the Miao, often referred to in the West as Hmong (9.4 million), Dong (2.8 million), Buyi (2.8 million), Yao (2.7 million), Bai (1.9 million), and Dai (1.2 million).

ⅱ In China, textiles used on beds are known by a number of different names, including terms that translate as "quilt" in English. Beizi(被子) are comforters with covers often made of large pieces of cloth. Pinbubeimian(拼布被面) are textiles that incorporate layers of cloth quilted together. Two- or three-layer quilts in China are usually smaller pieces of textiles made as bedcovers, clothes, and to hold and carry a baby or small child on a person's back. Chinese bedcovers also sometimes are made with single layers of blocks of pieced patchwork and appliqué, textile construction techniques commonly associated with Western quilts. The word "quilt" describes many different textiles including those made as art for walls and those that have only one or two layers.

ⅲ The Sum of Many Parts, p. 14

ⅳ Xu Wen and Liu Qi, 2010.The Art of Patchwork, Beijing: China Textile & Apparel Press,p.13 and 17

ⅴ The Art of Patchwork, p. 14; see also Thomas Watters, The Influence of Buddhism on the Chinese Language. Shanghai: Presbyterian Mission Press, p. 487.

ⅵ Handcraft Arts Gallery

http://www.myadornart.com/products.asp?cid=145.Accessed October 15, 2015.

ⅶ The Art of Patchwork, p. 12

ⅷ Feng Shanyun and Lan Peijin. 2002.The Patchwork Art of Shaanxi Province. Beijing: Foreign Language Press and "The

Hanru, Stephanie Rosenthal, Wu Hung and Yin Xiuzhen. 2015. Yin Xiuzhen. London: Phaidon Press.

http://www.phaidon.com/store/art/yin-xiuzhen-9780714867489/

X 2014 年史密森民间生活节中国传统与生活艺术项目"黑龙江拼布" http://www.festival.si.edu/past-festivals/2014/china/from_the_land/patchwork.aspx ；中国中央电视台 2010 年 10 月 21 日影视：http://english.cntv.cn/program/cultureexpress/20101021/101660.shtml. Accessed October 15, 2015.

Patchwork Art of West China." Cultural China. http://traditions.cultural-china.com/en/16Traditions992.html. Accessed October 15, 2015.

IX "Yin Xiuzhen", Wikipedia. https://en.wikipedia.org/wiki/Yin_Xiuzhen. Accessed July 25, 2015; Pan Qing, "Yin Xiuzhen", Art in America, September 1, 2010.

http://www.artinamericamagazine.com/news-features/magazine/yin-xiuzhen/. Accessed July 25, 2015;Carol Yinghua Lu, "Yin Xiuzhen". Frieze. Issue 115, May 2008. http://www.frieze.com/issue/review/yin_xiuzhen/. Accessed July 25, 2015; and Hou Hanru, Stephanie Rosenthal, Wu Hung and Yin Xiuzhen. 2015. Yin Xiuzhen. London: Phaidon Press.

http://www.phaidon.com/store/art/yin-xiuzhen-9780714867489/

X See "Patchwork Heilongjian Province," 2014 China Tradition and the Art of Living program at the Smithsonian Folklife Festival http://www.festival.si.edu/past-festivals/2014/china/from_the_land/patchwork.aspx and also "Video: Patch up fabric leftovers into fine arts" CCTV, October 21, 2010.

http://english.cntv.cn/program/cultureexpress/20101021/101660.shtml. Accessed October 15, 2015.

中国民族服饰与拼布艺术

Chinese Traditional Costume and the Art of Patchwork

"拼布"是当代国际通用的一个词汇，近年来引入中国，成为中国当代纺织艺术种类的一个专用名词。在中国传统服饰艺术中，"拼布"也称作贴绢、百衲、堆绫、补花等，并有着各自不同的工艺技法。就工艺特色而言，拼布是把剪为几何形状的各色碎布块拼接起来，连成大块的装饰布，用于缝制衣物，百衲衣是其中最为典型的。贴布（贴绢）是在底布上贴缝长条形的布或绢，构成几何图案，色彩斑斓，贵州毕节苗族和云南麻栗坡彝族服饰中最常见。贴花亦称为补花，是将布料剪出花纹，然后缝缀在底布上形成装饰效果，是中国各民族最常见的装饰艺术。（图1）堆绣是把小片绸绢叠成许多三角形，通过重叠的方法堆出图案花纹，现今黔东南苗族服饰的堆绣技艺依然精湛。

中国拼布艺术已有3000年历史，西周时期就有关于"贴绢"制作的记载，汉唐以来"堆绫补花"多有实物流传于世，明清时期的"绢绫贴花"是中

图 1 云南丘北苗族贴花女装
Figure 1. Tiehua dress from Miao ethnic group of Qiubei in Yunnan Province

Patchwork, which is a commonly used word in modern society, has become a special technical term in Chinese textile art since its recent introduction into China. When patchwork is used in making Chinese traditional costumes, it is called terms such as Tiejuan, Baina, Duiling or Buhua, each of which means a different craft and technique. According to its technical features, patchwork means matching different pieces of cloth together to form a larger piece of decoration. It can also be made into dresses with Baina dresses as the most typical example. Tiebu (or Tiejuan) means quilting pieces of rectangular cloth or silk on large piece of cloth to form colorful patterns. It is most popular among Miao ethnic groups in Bijie County of Guizhou Province and Yi ethnic groups in Malipo of Yunnan Province. Tiehua is also called appliqué, meaning sewing cut fabric shapes onto larger pieces of cloth for decoration; it is a common decoration method used by artists of many ethnic groups in China. (Figure 1) Duixiu means duplicating pieces of silk triangles to form specific patterns. Miao artists in southeast Guizhou are skilled in this technique.

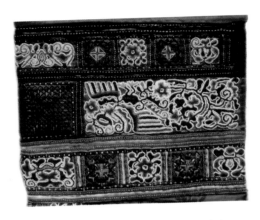

图2 贵州台江凯棠苗堆绫绣女装袖
Figure 2. Duiling dress from Miao ethnic group of Kaitang,
Taijiang in Guizhou Province

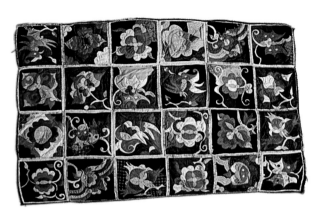

图3 贵州荔波布依族补花被面
Figure 3. Buhua quilt from Buyi ethnic group of Libo in
Guizhou Province

国拼布艺术的高峰，至今中国还有 30 个民族拥有拼布技艺，其中汉族、苗族、瑶族、彝族、壮族、布依族、羌族、侗族、拉祜族、傣族等民族的拼布最为精彩。（图 2，图 3）中国当代拼布艺术仍然在民族地区流行，用以装饰服装和美化生活用品。

历史悠久、技艺精湛的各类拼布艺术，作为中国重要的传统手工技艺，已列入国家级或省市级非物质文化遗产名录，越来越受到国家的重视和保护。

In China, the history of patchwork can be traced back over 3000 years. There were records of Tiejuan in the Xi Zhou Period. Extant examples of costumes with Duiling from Han Dynasty and Tang Dynasty could be found even today. (Figure 2 and Figure 3)Appliqué sewn with thin silk in the Ming and Qing dynasties might be considered the peak of Chinese patchwork art. Presently, over 30 ethnic groups in China have their typical patchwork art. Among them, the work of Han, Miao, Yao, Yi, Zhuang, Buyi, Qiang, Dong, Lagu and Dai nationalities are regarded as most splendid. In modern China, patchwork is still a popular way to decorate clothing in ethnic communities.

Patchwork art with its delicate techniques is an important traditional handicraft in Chinese history. It is appreciated and protected by the people and is included in national and local intangible cultural heritage lists.

Yang Yuan, Deputy Curator and Researcher, Chinese Museum of Women and Children

杨源 中国妇女儿童博物馆副馆长，研究员

名称的内涵：
文化差异、语言差异和命名法的差异

What is in a Name? Different Cultures, Different Languages, Different Nomenclature

2012 年到 2013 年间，中国引进了一场美国的拼布被巡展，主题为"化零为整"，在中国的六家博物馆展出。此次巡展很成功，不仅为中国百姓开启了认识拼布被的新窗口，还同时引发了一些反思。

"Quilt"这个英文单词在我国英语学习者常用的英语辞典《朗文当代英语大辞典》中解释为一个名词，中译为"被子"，举例用的词组是"百纳被"。在他它辞书，如《韦氏辞典》中，它可以作名词也可以是动词。作名词时，它的意思是一种有衬垫的床罩；作动词时，表示填充、垫填或内衬出类似被子的物品，或者表示将中间垫有东西的几层布料缝合起来，或者表示制作各种绗缝物。不尽如人意的是，解释相对详细的《韦氏辞典》并非我们的常用辞典，并且即使是这里的解释，对我们来说似乎仍然不太清晰。不同年龄，不同家庭和文化背景的人对此可能有不同的认识。

这大概就是密歇根州立大学博物馆最初与云南民族博物馆沟通拼布被子展时，后者有些困惑的部分原因。事实上，由于国人对它的这种认识以及它在博物馆的不重要地位，中方识别的"拼布被"还不多。在那时，我作为中美博物馆项目交流的翻译和协调人，有点像局内人兼局外人，可以了解到中方博物馆人的一些想法以及美方人员对这个词的理解。在当时，中方博物馆人员在他们的馆藏中找到的拼布被子很少，他们也很好奇为什么美方博物馆人员对拼布被子这么感兴趣。

In 2012 and 2013, The Sum of Many Parts in China: 25 Quiltmakers in 21st-Century America, an exhibition of contemporary American quilts, was shown at six museum venues in China. The exhibition and accompanying publication drew new audiences to the museums and opened a window for Chinese people to see quilts or bedcovers in a different way and simultaneously aroused scholarly interest in this material culture tradition.

The word quilt, in Langman Dictionary of English Language and Culture, a popular reference book used by English language learners in China, is explained as a noun meaning "a cloth cover for a bed filled with soft warm material such as feathers" with an example of "patchwork quilt." [i] In Merriam-Webster: Dictionary and Thesaurus, a reference commonly used by English language speakers, quilt as a noun means "a padded bed coverlet"; as a verb means "to fill, pad, or line like a quilt; or to stitch or sew in layers with padding in between; or to make quilts." [ii] Unfortunately, this dictionary is not one commonly used by Chinese and its explanations still seem vague to many Chinese. Therefore, individuals from different families and cultural backgrounds at different ages may have different opinions of what the word quilt means.

The dissimilar understandings of the word quilt became evident to a number of individuals affiliated with the creation of The Sum of Many Parts early in the development of that exhibition. At the time, I was working as an interpreter and coordinator for the emerging partnership activities between the Chinese Folklore Society and the American Folklore Society. Since the museum component of the partnership included the Yunnan Nationalities Museum and the Michigan State

正如马美莎（Marsha MacDowell）在她与玛丽合作的文章《化零为整：21 世纪美国的 25 位拼布被制作者》中所言："拼布被在美国有着独一无二的地位"。根据这篇文章，数十年以来，美国关于拼布被的研究和实践一直在增长，而且相关教育推广与建立社群关系的建设也在增加。我有幸见证了美国拼布制作、拼布研究和拼布展览的流行。2012 年，我分别在北卡罗纳州罗利市的郊区和密歇根州参加过几次"拼布被"集会和展览，尤其是密歇根州立大学博物馆收藏的令人感叹的各种"拼布被"，并且还在华盛顿首府举办的史密森尼民间生活节期间参观了"拼布被"主题展。在这些展示中，有古老的和现代的绗缝被等床上用品，也有其他形式的绗缝品，例如绗缝的围裙、杯垫和包包。由此看来，美国人民似乎非常清楚什么是"拼布被"，而且也知道拼布这个词可以被用于很多被子和日用品之外的东西。美国的"拼布被"制作者还会通过制作被子及其成品来表达一些主题和意愿，例如用来纪念因艾滋病而去世的人们以此引起公众对健康问题的关注。

University Museum, both of which were connected to The Sum of Many Parts, and since I worked with individuals at both of these institutions, I was in a unique position to encounter and understand how the word quilt was used by Chinese cultural workers and how it was used by American cultural workers. Indeed, at the time, Chinese museum professionals recognized very few textiles as "quilts" in their collections and were intrigued with why quilts interested American museum professionals and scholars.

In the essay in the catalogue accompanying The Sum of Many Parts, co-authors Marsha MacDowell and Mary Worrall stated: "Quilts have a unique place in American culture."[ii] They also noted that scholarship and research on American quilts has been on the rise for decades and that there were communities of quilt historians and quilt artists in the United States. I also had the opportunity to witness the popularity of quiltmaking, quilt study, and quilt exhibitions in the United States. For instance, in 2012, I visited a quilting bee near Raleigh, North Carolina, attended a major quilt festival in Grand Rapids, Michigan, saw quilt exhibitions and collections at the Michigan State University Museum in East Lansing, Michigan, and witnessed displays of the AIDS Memorial Quilt at the Smithsonian Folklife Festival, held on the National Mall in Washington, D.C. At these American events I saw historical and modern quilted bedcovers, as well as many other forms of quilted and patchwork items such as aprons, tablemats, and tote bags. Americans seemed to me to be clearly aware of what the word quilt encompassed and that quilts could be used in many ways beyond just as covers for beds or as household items. For instance with the AIDS Memorial Quilt, textiles were made to memorialize those who died of AIDS and to raise public awareness about the ongoing health problem.

The obvious difference between the Chinese and American quilt phenomena cannot be ignored. In China, a person can easily purchase mechanically quilted bedcovers, clothes, and bags and it is hard to imagine seeing many diverse handmade quilts in a museum, let alone a special museum for quilts. Many researchers

中美之间有关"拼布被"的差异不可忽视。在中国城市，我们可以轻易买到机械制作的拼布绗缝品，如拼布绗缝的被子、衣物和包包。美国有很多研究人员在研究历史和当代拼布活动。然而，我们很难想象在任何博物馆中看到多样化的拼布被馆藏，更不要说这样的主题馆。为何美国人民意识到了他们的拼布绗缝的传统，而我们中国百姓却似乎还缺乏此方面的意识或尚未意识到它的价值呢？毫无疑问，这不仅是在不同国家历史政治框架下的一个语言阐释的问题，还是一个文化解释的问题，正如格尔兹所道的"比较不可比较之物"。此次中美《中国西南拼布》研究也许会是探索中国拼布被以及相关文化现象的一次开创性转折点。我们期待看到这项研究是否会带来对中美拼布制作及使用的异同的新认识和中美语境中对这个词的用法的新认识。

have been investigating historical and contemporary quilt activities in America but there is little or no research concerning the history and current practice of Chinese quilts. [iv] Why do Americans have awareness of their quilt traditions and Chinese people seemingly haven't been conscious of theirs? Undoubtedly, this is not merely a question of linguistic interpretation, but also a question of intercultural translation, as Geertz noted "comparing incomparables", in different national frameworks of history and politics. The collaborative research by Americans and Chinese for the Quilts of Southwest China might be a pioneering turning point for exploring the traditions of quilts in China. It will be interesting to see if this research leads to new understandings of the similarities and differences in quiltmaking and use in China and the United States as well as new understandings of how the word quilt is used in Chinese and American contexts.

陈熙 中山大学中国非物质文化遗产中心博士、研究助理；美国民俗学会中美民俗学和非物质文化遗产论坛项目协调人

Xi Chen, Doctoral Candidate and Research Assistant, The Institute of Chinese Intangible Cultural Heritage, Sun Yat-sen University; China Coordinator, China-US Forum on Folklore and Intangible Cultural Heritage Project, American Folklore Society

Notes

i Chen, Limin, Lingcha Wei, Yanli Lu, and Xiankui Zhang. 2004. Langman Dictionary of English Language and Culture. Beijing: The Commercial Press, p.1428.

ii Copeland, Robert D. (general editor). 2012. Merriam-Webster: Dictionary and Thesaurus. Merriam-Webster, Inc., p. 852.

iii MacDowell, Marsha, and Mary Worrall. 2012. "The Sum of Many Parts: 25 Quiltmakers from 21st-Century America," in Teresa Hollingsworth and Katy Malone, eds. The Sum of Many Parts: 25 Quiltmakers from 21st-Century America. Minnesota, Minneapolis, Minnesota: Arts Midwest, p. 13.

iv Based on a preliminary search of the China Integrated Knowledge Resources Database, http://oversea.cnki.net/kns55/default.aspx. Core users range from top universities, research institutes, government think tanks, enterprises, and hospitals to public libraries.

中国少数民族拼布被面中的世俗与宗教意象

Secular and Religious Imagery in Chinese Ethnic Minority Quilt Covers

中国西南地区的少数民族经常在其艺术创作中借用汉族的象征图案。这种汉族图案与当地民族信仰的融合常常是由中国历史上少数民族自愿或非自愿的迁徙造成的。比如少数民族会借用汉族民间信仰的道教形象。因此，我们下文中讨论的这幅少数民族的拼布被面中的倒数第二排右侧出现麒麟吐玉书中的玉书也就不足为怪了。

这幅由国际拼布研究中心和博物馆馆藏的拼布被面为我们提供了此类跨文化意象的精彩图例。这幅被面应该是几十年前由广西环江的毛南族人制作的。拼布布料以红色、蓝色、黑色为主。图案内容主要有花叶纹、宗教图案、动物纹和几何纹。拼布正面有少量褪色，一些布料也比较易损，但这是一幅非常值得关注的拼布作品，特别是被面上展示的丰富且具有代表性的图案意象。

此拼布被面上有 35 个方块，展现了 18 种图案纹样。其中有 17 种图案是成对出现的，只有一种图案是单个的。被面上的图案以花叶纹为主。鉴于这类图案在汉族和少数民族文化中丰富的寓意，出现大量的花叶纹并不奇怪。例如，被面左上方的石榴因为籽多被认为是多产的象征。在汉族家庭，人们期待家里多添丁进口，特别是添加男孩，所以石榴代表着多子多孙。石榴和桃子、佛手瓜一起构成好运有福气的意象。拼布被面中间第二排的桃子图案

Ethnic minority groups in Southwest China frequently have adopted Han symbols for use in their own art work. The appearance of Han visual imagery coupled with native ethnic beliefs is often the result of cultural exchange through both the voluntary and involuntary migration of minority groups throughout China's history. One example can be seen through the ethnic minorities' adoption of Daoist pictorial elements, appropriated from Han indigenous belief. It is then not surprising when the jade books—discussed below and seen in the quilt's second row from the bottom, far right—appear in the textile art of minority groups.

This quilt cover from the International Quilt Study Center & Museum's collection provides an excellent catalog of cross-cultural imagery. Made several decades ago likely by a member of the Maonan ethnicity in Huanjiang Maonan Autonomous County, Guangxi Zhuang Autonomous Region, it displays assorted floral, religious, animal-related and geometric motifs appliqued with predominantly red, blue and black fabrics in both commercial prints and solids. Despite some fading at its top and the fragile nature of a few of its fabrics, it is a dynamic piece that draws attention, especially once one notices the diverse representational imagery.

In the quilt's 35 blocks, there are 18 individual motifs: 17 of them are represented twice and one appears only once. The majority of images are botanical, which is unsurprising, as flowers and fruit carry a range of meanings in both Han and ethnic minority cultures. The pomegranate, for instance, which appears in the

有两个方块中的图案是蝴蝶。蝴蝶在汉族文化和少数民族文化中都很重要。它代表着欢乐、爱情和喜结良缘。还有两个方块中的图案是龙与鱼在嬉戏。中文里的鱼与余谐音，所以鱼纹代表肥沃或丰产。龙与男性生殖力相关，道教中的阳被认为是活跃的力量或自然的二元性。这种联系引申出对水龙的崇拜，汉族和少数民族的农村农业地区通过水龙来求雨。

最后，右边第二竖排的钱币纹和如意纹代表着富裕和财产。除了几何纹方块和钱币纹方块之外的其他方块四角相交的地方都绣上了如意纹。

以上所列的意象并不是对象征符号的全面展示，而是对未经记录的拼布被面进行阐述的一次尝试。我们希望以此激发专业人士和非专业人士的兴趣，并且为研究广袤丰富的中国少数民族文化景观打开一扇窗户。

Butterflies, which have significance in both Han and various minority cultures, flutter across two blocks. Their presence is suggestive of joy, love, and good fortune in courtship or marriage. A dragon romps with a fish in two other blocks. Fish, or yu 鱼 in Chinese, is a homophone with another character, yu 余 meaning "abundance." The presence of fish represents fertility or prosperity. The dragon is associated with virility, thus yang essence in Daoist belief is thought to be the "active" force in yin-yang or the duality of nature. This association is extended to the worship of the "water dragon," summoned for rainfall by both Han Chinese and minority groups living in rural areas with agriculture economies.

Finally, a coin surrounded by four "wishes granted" ruyi (如意) figures (top row) and the overlapping coin pattern (both in the second column from the right) indicate wealth, prosperity, and auspiciousness. Additionally, the ruyi also appears in the four corners of all but the geometrically patterned and overlapping coins blocks.

Although the imagery above is not an all-encompassing index of symbols, it is an attempt at understanding previously undocumented quilt covers. It is our hope it will generate more interest from both specialists and non-specialists alike and serve as an entry point for study within the vast cultural landscape of ethnic minority groups living in China.

玛琳·F.汉森 纳布拉斯卡大学林肯分校国际拼布研究中心和博物馆国际馆藏部研究策展人

克里斯订·S.麦库尔 密歇根州立大学博物馆中国西南拼布展藏品助理

翻译 张丽君

Marin F. Hanson, Curator of International Collections, International Quilt Study Center & Museum, University of Nebraska-Lincoln

Kristin S. McCool, Collections Assistant, Quilts of Southwest China Exhibition, Michigan State University Museum

Translation: Lijun Zhang

中国贵州和广西拼布传统研究

Researching Traditional Quilts of Guizhou Province and Guangxi Province in China

由纳布拉斯卡大学林肯分校国际拼布研究中心提供资助，我们在中国西南的贵州和广西两地进行了拼布传统研究。2013年，我们在贵州中南部和与之毗邻的广西北部进行了为期十天的田野研究。我们在这一地区发现了各种各样的包含被套和被芯的被子制作和使用传统，这种被子与其他文化的拼布被子存在异同之处。

这一地区少数民族众多，包括壮、布依、苗和瑶，少数民族之间常常毗邻而居。我们发现这些民族的艺人制作拼布被面的模式大致相同。被面中间部分用8—11平方英尺（约合0.74—1.02平方米）大小的锁边方形布片拼接缝制而成。拼布艺人通常会在方块中拼贴相同的纹样，但也有人在上面拼贴鸟、蝴蝶、鱼等各式各样生动活泼的纹样。周围的底布是蓝靛染的手工织布。被套内厚厚的填充棉花用针线固定。我们给很多人看了一些历史上保存下来的拼布纹样，希望他们能认出可能与他们自身文化有较强联系的纹样，可惜我们的愿望落空了。我们发现这些被面在传统上是由新娘的家人给她做的嫁妆，他们结婚的时候会做两三套，而其他时间则不会去做这种被面。

虽然我们先前掌握的资料预示我们可能会在毛南族地区找到拼布被面，但我们并没有在这些地区找到这样的被面。但在拉洞壮族村我们找到了熟知拼布被面制作技艺的妇女。村里的两位年纪比较大的妇女还完整地保存着她们作为嫁妆带到夫家的拼

With support from the International Quilt Study Center at the University of Nebraska–Lincoln, we have conducted research on quiltmaking traditions in Guizhou Province and Guangxi Province in southwest China. In 2013, we spent ten days of field research in the contiguous regions of south central Guizhou and northern Guangxi. There we found many variations on the tradition of making and using bedding consisting of a cover and a filling that share some similarities and differences with quilts of other cultures.

The large number of ethnic communities in the area includes those of Zhuang, Bouyei, Miao, and Yao nationalities and often different nationalities live in close proximity to each other. We found that textile artists of all these groups used the basic format when constructing their bedcovers. They made a center panel by sewing together individually constructed 8– to11–inch squares with bound edges. The artists typically used a repeated appliquéd pattern on the squares but some appliquéd unique images of stylized birds, butterflies, fish and other lively creatures. To this center panel, artists added a border or edge of hand woven fabric, often dyed in indigo. A plain back cover of a similar hand woven fabric is added. Holding stitches are used to tack the filling of thick, raw cotton into place within the cover. We showed pictures of historic quilts to many individuals in the hopes that they would be able to identify patterns with which they might have strong cultural ties but unfortunately, no such strong ties were confirmed. We found that these textiles were traditionally made by a bride or members of her family for her dowry, two more are made at the time of marriage, and that the quilts were not made at other times or for other occasions.

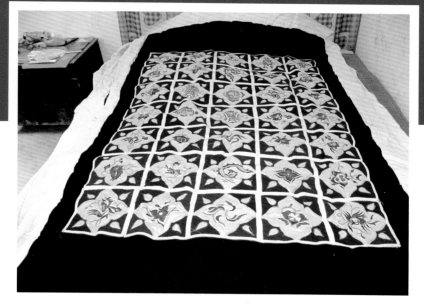

图1 拼布被面
Figure 1. Quilted bed cover

布被子。她们日常生活中不用这些被子，只有客人来的时候才会拿出来用。这些填充了棉花的被子以白色手工织布为底布，非常厚实。其中一床是刺绣纹样，另一床是贴布绣纹样。（图1）这些被子都是两位妇女在1994年到1996年之间她们大概20岁的时候做的。我们问她们现在是否还有人做这样的被子，其中一位说她最近还帮她侄女做了一床这样的结婚被子。但是当她侄女过来的时候，她说她搬家的时候把这床被子扔了。

进行传统拼布被面田野研究的挑战之一是老的被面很少被保存下来。而且这些被面是日用品，容易损耗。几位长期做纺织品采购生意的人说他们在21世纪初期去村寨里买了很多拼布被面等着它们升值。当我们给村里的一位妇女看我们带来的一床老的拼布被面来说明我们想要找的东西时，她说她想买下我们的被面，也许她想通过拼布被面买卖挣钱。

有几个人告诉我们在1940年至1960年之间拼布被面的制作传统快速没落。人们现在大多使用从集市上买来的现代被子。这种被子被套上通常有色彩艳丽的机打图案，里面是棉花或化纤填充物，用带把手的透明塑料袋装着，价格大约在200块钱左

Although our early sources had indicated that we might find pieced quilts among the Maonan ethnic artists, we did not find any. However, in Ladong, a traditional village of Zhuang people, we found women who still knew the techniques for making quilts. Two older women we met in the village still had their dowry quilts in good condition which they used for visitors, not for daily use. These quilts were bulky with the cotton filling and hand woven white cotton backing. One featured embroidered designs in the center of the squares, the other featured appliquéd designs. (Figure 1) Both women made their quilts when they were about 20 years old or c. 1994—1996. When asked if any were still being made, one said she had recently helped her niece make a wedding quilt. However, when the niece came she said that she threw the quilt away when she moved to a new home.

A challenge in doing field research on the traditional quilts is that so few of the older pieces still exist. In addition to the fact that they were made to be used and have therefore been used up, several longtime textile dealers reported visiting villages in the early to mid 2000s and purchasing as many of these quilts as they could find in anticipation of a future rise in value. When we showed one village woman an older piece we had brought with us as an example of what we were looking for, she offered to buy it, probably in hopes of making a profit.

右。现在结婚也是送这种商业生产的被子。所以我们的问题是为什么拼布被面的制作传统被摒弃，而许多年轻人要么不知道这种传统要么选择商业生产的被子。一部分的原因可能是现代化、优先性、时间限制或文化考量。但是，虽然作为嫁妆的拼布被子在家庭中很少使用，却可以从包括贵州凯里的一些村寨里从售卖旧纺织品的商人那里买到。（图2）在贵州黄平县和广西南丹县，一些艺人用古老的纹样来制作拼布被面。这些艺人可能可以为保存中国婚礼拼布被子文化传统贡献力量。

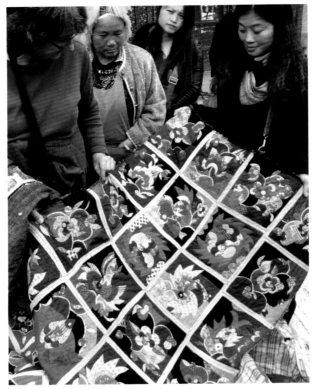

图2 纺织品商人展示被面
Figure 2.A quilt from a dealer

Several individuals told us that the tradition of quilting took a steep decline between 1940—1960. People now appeared to be sleeping with a modern version of the traditional quilt that seemed to be available at every village market. The cotton or synthetic filling was covered with an often brightly printed fabric and sold in a tailored clear plastic case with handles for about 33 U.S. dollars. These commercial quilts are now popular wedding gifts. The question arises as to why the tradition of quilting was dropped by so many and that many younger people are either unaware of the tradition or prefer manufactured bedcovers. Perhaps it was a part of modernization, priorities, time constraints, or cultural thinking. Still, wedding quilts, now rarely used at home, can be bought from dealers who sell older textiles in different villages, including several in Kaili, Guizhou. (Figure 2) In HuangPing County in Guizhou Province and in Nandan County in Guangxi Province some artists are making quilts tops using older patterns. Hopefully these artists will be part of the process of preserving the cultural tradition of Chinese wedding quilts.

帕梅拉·纳道斯基 亚洲拼布传统独立研究者

帕特里夏·斯托达德 中国少数民族纺织品商人和独立研究者

翻译 张丽君

Pamela Najdowski Independent researcher of Asian quilting traditions

Patricia Stoddard Dealer and independent researcher of Chinese minority textiles

Translation: Lijun Zhang

中国西南少数民族传统缝衲拼布被面艺术：珍藏历史馈赠，维护民族文化传承

Traditional Quilt Covers of Chinese Ethnic Minorities in Southwest China: A Collection of Memories, An Effort to Sustain the Tradition

　　早先在中国生活期间，我们就接触过多种工艺美术。我们对中国传统手工艺术的兴趣启蒙于20世纪60年代末期。我（王煜博士）在"文化大革命"期间曾随从父母下放到广西偏远村落，那段时期我和当地少数民族及其民间艺术有了最初的接触。我随后逐渐成为一名专业美术工作者并在1978年被广西艺术学院油画系录取。我们对中华民族的传统艺术，尤其是少数民族的民间工艺的研究在20世纪80年代末移居美国后得到进一步发展。

　　为发掘和进一步研究中国少数民族传统工艺，我们曾穿行在中国西南各省的偏远村落调查民间工艺，走访当地手工艺人，并且开始了对中国少数民族传统手工艺术品的收藏。在村寨走访中，除了增进与当地手工艺人的友情外，面对日渐消失的传统工艺，我们意识到对民族传统手工艺的保护与传承迫在眉睫。自此之后，我们便致力于为民间手工艺品寻求开拓国际市场的机遇，并策略性地将现代手工艺品推向更广泛的国际消费人群，为此我们建立了国际手工艺术设计联盟。该联盟的核心目标是协助国际手工艺者连接消费人群并确保这种联系在日后能不断地发展扩大。

Our involvement with Chinese arts and crafts began in the 1960s. Both of us had exposure to various disciplines of arts and crafts while growing up in China. I, Andrew Wang, lived in a remote village in Guangxi Province, southwest China, with my parents during the Cultural Revolution in the late 1960s and it is there where I had my initial experience with local minorities and their arts. I started to work as a professional artist in fine arts while I was living in Guangxi and was admitted to the Department of Oil Painting at the Guangxi Art College in 1978. We moved to the U.S. in the late 1980s and continued our interests in the art of our homeland, and especially in Chinese ethnic minority art.

To explore and study traditional minority arts, we frequently travelled to villages across southwest China to search for artwork and to meet with local artisans. Through these activities, we developed a personal collection of traditional Chinese minority arts, met and developed friendships with minority artisans, and began to see the need to preserve and sustain the arts. We focused our efforts on creating international marketplace opportunities for artisans and developing strategies to introduce these historical and contemporary handcrafted arts to broader audiences, including those in the United States. These efforts gradually led us to develop a sustainable global

我们其中一项主要工作是与民间手工艺者直接合作。这包括来自中国海南与西南三省的黎、苗、壮、布依、瑶、侗、彝等多个民族的传统纺织民间手工艺重要代表性传承人。她们的主要作品有传统刺绣、蜡染及其他手工植物防染、拼布，扎染、织锦等。我们认为成功的关键是创作出具有市场潜能的手工艺品和具有环保效益的工艺流程，并且能够使新创作的手工艺品在目前快速变迁的环境中得以维持发展。我们努力的另一个重要的方向是发掘注重人文、历史和艺术个性的消费人群组成的市场平台。分别从 2006 年和 2013 年起，我们先后连年推选中国少数民族艺术家参加美国新墨西哥州圣塔菲世界民间艺术展销大会和纽约国际礼品及家居纺织品工艺展。通过本联盟的努力，使传统艺人有机会向国际消费者展示自己的作品，从而进一步推动当地手工艺的发展。

我们也发现与其他能够承担同一种使命的个人及团体建立联系十分重要。这种使命感驱使我们去寻求具有创新性和可持续性的模式，从而使能够体现当地物质及非物质文化遗产的手工艺技术和知识不至于流失。因此我们加入了附属于联合国教科文组织的世界手工艺理事会。该机构的宗旨是积极支持国际原住民手工艺的保护和发展。

在工作中我们也观察到有些个人和团体也在不断地努力与世界各地的纺织手工艺人共同去发现、评估、解决，或至少是缓解在保护传统手工纺织工艺过程中所遇到的各种困难。这些工作包括解决妨碍传统手工艺发展的各种问题，比如资金和原材料的缺乏、知识和技能培训的需求、资源供给不协调、货运物流困难和创造出可持续的国内及国际市场的营销渠道等。我们意识到只有通过提高传统艺人对其手工艺品价值的意识，才能使手工艺创作实践持续发展。

handmade design alliance dedicated to both artisans and consumers. The primary object of this network is to connect artisans to new markets and ensure the network can continue growing into the future.

One key component of this effort is that we work directly with artisans, including those associated with six groups of textile artists of various ethnicities—including Li, Miao, and Yi—from three different provinces in south and southwest China. Their work includes traditional techniques of embroidery, beeswax-drawn designs with resist dye, patchwork, and ikat weaving. We believe it is critical to create new products with market appeal and to ensure that production methods are eco-effective and can sustain these newly created products in a rapidly changing environment. Another key component of our effort is to seek out marketplaces where buyers especially value the history, culture, and individual stories of the artists. Two market venues we have found especially welcoming have been the International Folk Art Marketplace, Santa Fe, New Mexico, which we have participated in since 2006, and the New York International Gift Fair and Home Textiles Market Show, New York City, New York, which we have participated in since 2013. Through the network, the artisans have an opportunity to continuously develop their artistic creativity and skills and to present the works to consumers in China as well as abroad.

We have also found that it was important for us to connect with other individuals and organizations that share a commitment to finding innovative and sustainable models to perpetuate the skills and knowledge of individuals whose work represents their community's tangible and intangible cultural heritage. Therefore, we have joined the World Craft Council (WCC), an international organization affiliated with the United Nations Educational, Scientific and Cultural Organization (UNESCO), which actively supports international indigenous artisans and craft-related activities over the world.

我们国际手工艺设计联盟帮助手工艺人建立与消费者之间的联系渠道，为当地手工艺人维持及振兴自己的传统文化提供策略性的指导。在我们不断努力发展这支国际合作团队，并培养纺织手工艺人的同时，我们也期待与西南少数民族拼布被面手工艺个人或团体进行合作，进一步提高人们对于这种传统手工艺的认识和欣赏，并且在帮助复兴这门手工艺的过程中发挥积极的作用。

Through our work, we have observed that individuals and organizations are increasing their efforts to work with textile artisans all over the world to identify, evaluate, and remove, or at least mitigate, barriers to sustaining unique artistic textile heritages. These efforts include addressing such factors impacting artists as lack of access to minimal financial resources and raw materials, need for knowledge and skills training, addressing sourcing bottlenecks and difficult shipping logistics, and creating sustained connections to local and global markets. We realize that we must work with artisans to increase the awareness of the value of their artwork so that they will continue their creative practices. The global handmade design network helps to connect artist and consumer, thus providing a strategy for indigenous artisans to sustain and revitalize their traditions in the modern world. As we continue our efforts to develop the network while at the same time cultivating work with specific textile artists, we look forward to collaborating with bedcover artists in southwest China to further increase the awareness and the appreciation of this traditional culture heritage and to play a role in helping to perpetuate the skills and knowledge of the artists.

王煜 博士，远音艺联创办人，艺术总监
王赵庆荣 远音艺联业务合作人，主任

Andrew Wang, Ph.D., Co-Owner, Distant Echo
Lily Wang, Co-Owner, Distant Echo

中国的"女红"与拼布

Chinese "NÜ GONG"(女红) and Quilts

20世纪20年代是中国文化、观念和社会大变革的时代。1925年3月21日，女作家凌叔华在《现代评论》上发表了短篇小说《绣枕》描述了父权社会中一位富家大小姐连夜赶工一件极尽精美的绣品，以期向那潜在的姻缘进行自荐，却在两年后才偶然得知，她的作品刚登场就被粗鲁的男人们践踏了。

批评家往往将这篇作品解读为女权主义的觉醒，但我认为在女作家含蓄有节的记叙中，真正动人心魄之处是其深沉的悲剧性。绣品就是艺术品，人类历史上最美的创作。在那针线之间凝聚着一个沉默的女人最高超的技艺、最无可排遣的欲望、最无处倾诉的激情和野心。这艺术品的美丽恰恰衬出了命运悲剧的微光。

汉语词汇"女红"指的是纺织、缝纫、编织、刺绣等工作和这些工作的成品，这些手艺在古代中国被看做是女性的天职。"女织"与"男耕"是小农经济的基础，也是封建意识形态的根基。汉代（公元前202—公元220年）开始，意识形态塑造者们用儒家理论规范礼俗秩序和家庭伦常，女学者班昭在她后来成为"女教"经典的著作《女诫》中，把女红的技艺提升到体现女性教育和修养的高度。在"女范"中，"妇功"与"妇德、妇言、妇容"并列，是淑女的守则。即使在衣食无忧的上流社会，女孩子也必须修习针线技艺，因为在这里强调的不仅是技艺，更是做女红过程中的精神状态："专心纺绩，不好戏笑"的低调、专注与谦卑。

自此以后，女红的技艺成为女性声誉的标准。史册中关于女性道德典范和传奇人物的描写总是离不开关于女红的描述。针线，成为女性诉说的媒

The 1920s was a revolutionary time in China, when society, culture and ideas were being shaken up dramatically. On March 21st, 1925, writer LING Shuhua published her short story "The Embroidered Pillow" in XIANDAI PINGLUN magazine [i] . The story first centers on a young woman from a wealthy family who is hard at work in the summer heat to exquisitely embroidered pillowcases in order to impress the family of her potential suitor. Then, two years later, the woman is still working on needlework alone, since she still has yet to marry. By chance she learns that her original piece, which she had intended for the husband she never got, was ruined by a thoughtless guest soon after the family had received it. Caring little for her, and less for her ruined work, the suitor's family gave the embroidery, the expression of her love, to the servants.

Literary critics have often lauded this story as the beginnings of an awakening of feminist consciousness in Chinese society, but its most fascinating feature is the deeper tragic spirit behind the calm narrative. The embroidered pillowcases are works of art, among the most beautiful creations of humankind. The stitches reveal the superb skills, hidden desires, secret passions, and unspoken ambitions of a quiet woman. The beauty of the object only highlights its tragic fate.

The Mandarin phrase "NÜ GONG" (女红) indicates the process and production of weaving, sewing, knitting, embroidery and other textile and needlework. These forms of craft labor were categorized as women's vocations in ancient China. In the terms of feudal ideology, "women weaving" and "men farming" were seen as the economic core of a self-sufficient society. By the time of the Han dynasty (202 B.C.–220 A.D.), these Confucian ideals were increasingly recognized by government institutions for their role in shaping the etiquette, customs,

介。在文字和语言响亮地争抢历史和意识形态话语权的男权社会，沉默的女人们以密码的形式表达和沟通——她们的智慧、趣味、情感和故事都缝在针脚之中。（张道一，2006；胡平，2006；潘建华，2009）然而，到了20世纪初意识形态转变的时代，这一整套的价值观被作为封建意识形态的垃圾和余毒，受到猛烈的冲击。《绣枕》中的大小姐们往往被"新女性"看做是甘受命运摆布的失败者和牺牲者，她们所抱有的价值观被看做不能适应时代变化的陈词滥调。

20世纪中叶之后的社会主义革命中，妇女们积极地从事与男人一样的工作。她们向往着成为工人，操作机器，而不是从事落后的"手工艺"。纺织和缝纫在教育体系中也被淡化了。

然而，针线技艺本身却静静地被流传下来。在家庭和社区中，制作和穿着传统服饰仍然紧密地联系着人们的文化身份、信仰和实践。到了今天，新的拼布制作的潮流兴起了：从大约2008年（在港台地区还要更早些）开始，众多新兴的拼布教室、工作坊和公司涌现出来。（许晓月，2009；秋水，2011）在城市中，女红开始帮助人们调整生活节奏，改变生活方式，珍惜家庭生活，或通过专注的实践来追求精神上的平静。

and family relationships in Chinese society. BAN Zhao (45 A.D.–117 A.D.) in her work on NÜ JIE(《女诫》Female Precepts)（BAN,108）promoted NÜ GONG as a way to cultivate virtue and accomplishments. [ii] Even in upper-class families, girls were expected to practice needlework, since it was seen as not only an essential skill, but also as a way to cultivate modesty, concentration, and humility. As BAN Zhao put it, "those focused on weaving won't play and laugh"（BAN,108）. [iii]

NÜ GONG became the measure of a woman's reputation. In historical records, stories, and legends, extraordinary women are always shown as possessing a high, sometimes fantastical degree of skill in NÜ GONG. Needle and thread also became a medium of female expression. In a patriarchal society, where male words and voices dominated the discourse, women expressed themselves most freely in this silent code—their intelligence, interests, emotions and stories were sewed in the stitches(ZHANG2006; HU 2006; PAN 2009) [iv] . However, with a shift of ideology in the early 20th Century, the values of NÜ GONG came to be seen as pernicious vestiges of feudalism. Women who behaved like the heroine from the "Embroidered Pillow" were increasingly viewed by the 'new women' of this period as pitiful figures who obediently sacrificed themselves for what now seemed an anachronistic cliché.

Following the Communist Revolution in 1949, women zealously took on the jobs of men. They yearned to become workers, operating machines instead of practicing outdated handcraft. Textile making and needlework faded from the educational curriculum.

Nevertheless, today needlework techniques continued to be passed down within families and communities, especially those in which the making and wearing of traditional clothing is so closely tied to cultural

从上述简短的历史回顾中，我们看到中国女红尽管少见于正史，但的确是"这个文化之所以达到相当高度的不可缺少的构型元素"。（胡平，2006，P11）这门沉默的艺术并没有发出太多的声响，但毫无疑问切实而清晰地表达着。这些静静的表达一度被压抑、忽略和遗忘，而今却渐渐引起了更多的注意，吸引了更多的倾听者和诉说者——作为一种富有生命力的表达，女红蕴含着美和智慧，也联系着私人和公共、感性和理性、过去和未来。

罗文宏 云南民族博物馆学术交流部馆员

identity, beliefs, and practices. New contexts for learning quiltmaking have developed: since 2008 (and in Taiwan even earlier), hundreds of quilting classes, workshops, and companies have started up. In more urban contexts, NÜGONG has turned out to be an effective way to help people adjust their pace, implement an alternative lifestyle, appreciate family life, or pursue spirituality through concentrated effort.

From this brief journey through the history of NÜGONG, we find that while it may not have been well recorded in the written history, without a doubt it has been an "essential element of this civilization" (HU,2006,p.11). It may not make much noise, but its expressivity and cultural importance has been loud and clear.

Luo Wenhong, Curator, Museologist, Yunnan Museum of Nationalities

注 释

ⅰ 陈西滢主编，《现代评论》1卷15期，北京：创造社和太平洋社

ⅱ 王相编，《女四书女孝经》，北京：中国华侨出版社，2011

ⅲ 王相编，《女四书女孝经》，北京：中国华侨出版社，2011

ⅳ 张道一，《中国的女红文化——母亲的艺术》，北京：北京大学出版社，2006

胡平，《遮蔽的魅力——中国女红文化》，南京：南京大学出版社，2006

潘建华，《女红——中国女性闺房艺术》，北京：人民美术出版社，2009

百家衣：中国拼布带来的美国新习俗

One Hundred Good Wishes Quilts: A New American Folkway Inspired by Chinese Patchwork

世界上纺织品的制作和用途各不相同，有些是用于对抗可见和不可见的某种力量，在精神和肉体层面上提供保护。中国56个民族中有很多辟邪的纺织品传统。在汉族当中，拼布被认为是能有效提供保护的纺织品。[i]

百家衣便是这种具有保护功能的纺织品。（图1）百家衣由各种形状的布条缝制而成。这些布条有正方形的、长方形的、三角形的、菱形的和六边形的。衣服上通常绣有吉祥图案。百家衣通常

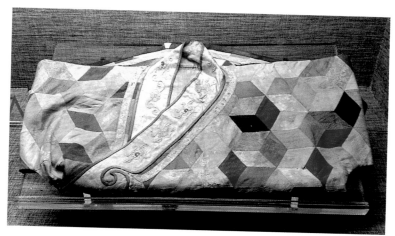

图1 百家被，19世纪晚期，中国绍兴鲁迅故居。图片由作者于2014年拍摄。
Figure 1. BaiJia Yi（"One Hundred Families Robe"），late 19th Century, Lu Xun's Former Residence, Shaoxing, China. Photo by the author, 2014.

是给家里的男孩做的辟邪物，因为男孩被认为是家族血脉的延续并承担照顾年迈父母的重任。它是具有社区基础的一种传统。据说"大家给孩子的母亲送去小块的丝绸和绣片用于给孩子做衣服，表达大家对孩子的祝福，希望百家衣能驱邪纳福"。

百家被是百家衣的近亲，关于百家被的记录同样缺乏。在中国北方的一些地区，人们用从亲戚朋

Around the world textiles have been made and used for many reasons, including for spiritual and physical protection against both known and unseen forces. In China there are many talismanic textile traditions in all of the 56 nationality groups. Among the Han Chinese, patchwork in particular is regarded as bearing potent protective power. [i]

One historical Han garment, the baijiayi (百家衣), or "one hundred families robe" (Figure 1), holds such power. Composed of hundreds of sewn patches in a variety of tessellating shapes (squares, rectangles, triangles, diamonds, and hexagons), the baijiayi is often embroidered with motifs considered auspicious. It makes sense, therefore, that patchwork robes were made as spiritually protective garments, particularly for male children, who were generally more valued for the fact that they would carry on the family name and would provide care for their aging parents. The baijiayi tradition reportedly had a community-based aspect to it as well. It is said that the custom was to "present the mother of a young boy with small pieces of silk and embroidery for her to sew together to make the child a jacket, all those contributing thus

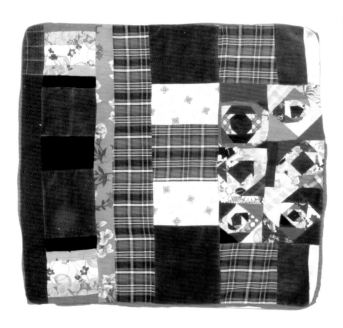

图2 百家被，由中国甘肃省的马夫人制作，1980年，纳布拉斯卡大学林肯分校国际拼布研究中心和博物馆，2013.021.0001.
Figure 2. BaiJiaBei, made by Mrs. Ma of Gansu Province, People's Republic of China, c. 1980, International Quilt Study Center & Museum, UNL, 2013.021.0001.

友那里收集来的布条给新生儿做小被子。百家被（图2）也被认为可以为新生儿提供保护。[ii]百家衣和百家被都是汉族民间信仰和物质文化的一种典型表现。

到了21世纪，百家被传统通过网络形式在收养了中国小孩的美国人当中激发了新的实践。20世纪90年代末期和21世纪初期，美国收养中国小孩的人数迅速增长，百家被也开始在他们当中流行起来，[iii]他们通过收养家庭建立的博客、论坛和其他网络空间迅速地吸纳、改造和传播这种实践。美国兴起了收养家庭的亲友给新收养中国小孩的家庭送布条做百家被的实践。亲友们在捐布条时还会写一张祝福小孩的卡片。[iv]

在与20位百家被制作者的访谈中，[v]我注意到这种受中国影响的纺织品在功能和意义上的一些主题。对很多人来说，制作百家被是一种适应机制，

joining in to wish the child good fortune and protection from evil."

Another, rarely documented relative of the baijiayi took the form of a bedcover. Thought to be limited to a few regions in northern China, this practice similarly involved gathering fabrics from family and friends to make patchwork for a new baby. The resulting baijiabei (百家被), or "one hundred families quilt" (Figure 2) was believed to grant the same spiritually protective power as the better-known baijiayi. [ii] Both textiles represent quintessential aspects of Han folk belief and material culture.

In a 21st-Century twist, however, the baijiabei tradition has inspired a new, Internet-driven practice in the United States among Americans who adopt Chinese children. Adoptive parents discovered the baijiabei tradition just as adoption from China was rapidly rising [iii] in the late 1990s and early 2000s and they quickly embraced, transformed, and distributed the practice, largely through adoption-focused weblogs (blogs), online discussion boards, and other websites. The making of patchwork quilts of fabrics donated by friends and families of adoptive parents to welcome Chinese children to their new family has become a widespread practice in America. Called One Hundred Good Wishes Quilts(OHGWQ) (Figure 3), the "good wishes" refers to the added element of donors submitting a written wish for the child along with their fabric. [iv]

In my interviews with 20 makers of OHGWQ, I've noted several themes regarding the function and meaning, particularly for the parents, of these Chinese-inspired textiles. [v] For many, the OHGWQ project provided a coping mechanism, a way for parents to both manage the stress of the adoption process and pass the time

图3 Jason，Jen 和Addison Kainz 与她们制作的百家被。图片由作者于2012年拍摄。
Figure 3. Jason, Jen, and Addison Kainz with their One Hundred Good Wishes Quilt. Photo by the author, 2012.

用于缓解等待收养手续通过时的压力以及消磨时间（有时是几年的时间）。它也反映了美国文化中已有的拼布被子实践的重要性：收养家庭的父母对拼布被子的触感、舒适性和纪念性已有的认知是他们接受百家被的原因之一。尤为重要的是，对于这些父母来说，百家被还代表着社区的概念。一位访谈对象说："我非常喜欢孩子和百家被一起来到家里，这代表着孩子被送布条的人的爱包裹着。"

最后，百家被也提供了一个中国文化和风俗的连接点。很多父母先前对中国文化所知甚少。他们人为百家被是一种中国的根；某种程度上，百家被代表着这些父母为孩子们在日常生活中保留他们出生地文化的决心。一位访谈对象说："说实话，要是没有中国的这层关系我不认为我可以完成它 ... 这是推动我的力量。"的确，作为中国避邪纳福之物的拼布与美国拼布传统的结合，百家被代表着连接文化的桥梁，就像"中国西南拼布"项目的文化桥梁作用一样。

while waiting (sometimes many years) for the adoption paperwork to move through the system. It also revealed the importance of quiltmaking practices already embedded in American culture: parents embraced the idea of a quilt partially due to preconceived notions they had about quilts' tactile, comforting, and commemorative qualities. Critically, the OHGWQ also represented the idea of community for these adoptive parents. One informant said, "I really liked the idea of a child coming home to have this blanket that, literally, she could be surrounded with, then also [she could be] metaphorically surrounded by all those people who love her and contributed to the quilt."

Finally, and most relevant to this volume, the OHGWQ project provided a point of contact with Chinese culture and folkways. Parents, many of whom had little prior knowledge of Chinese culture, identified the OHGWQ's Chinese roots as being critically compelling; in some ways, the quilt represents parents' commitment to retaining elements of their child's birth culture in his or her daily life. One informant said, "I honestly don't think I would've done it if it didn't have the Chinese [connection]. . .that's what really pulled at me." Indeed, as a marriage of Chinese spiritually protective patchwork and American quilt making traditions, the OHGWQ represents a bridge between cultures, much in the same way the Quilts of Southwest China project does.

玛琳·F.汉森 纳布拉斯卡大学林肯分校国际拼布研究中心和博物馆国际馆藏研究策展人

翻译 张丽君

Marin F. Hanson, Curator of International Collections, International Quilt Study Center & Museum, University of Nebraska–Lincoln, Lincoln, Nebraska

Translation: Lijun Zhang

注 释

i 这种力量可能跟佛教有关。中国和尚通常穿袈裟。袈裟来源于印度佛教的 kasaya 长袍——kasaya 指的是多种颜色（指代其拼布性质）——袈裟便是受历史上的佛穿缝补丁的衣服以示摒弃对物质财富的启发而来的。

ii 由于在中文中百家被一词可以指用零碎布片做成的纺织品，而不仅仅是社区中大家捐布片做成的被子，所以研究百家被的传播和流行变得更为困难。

iii 自 1994 年以来，美国跨国收养的最大来源地是中华人民共和国。从中国正式允许国际收养的 1992 年到 2005 年，美国家庭每年的收养小孩从 201 人增长到大约 8000 人，达到了高峰。虽然在此之后收养人数迅速减少，中国小孩在美国美国国际收养人数中占了很大的比重；比如 2012 年有 2696 个收养小孩来自中国，占了美国国际收养总人数的 31%。从 1999 年到 2013 年，超过 70000 名中国出生的小孩加入了成千上万的美国家庭。

iv 写贺卡是美国实践中独特的部分，特别是这种实践又与美国日趋流行的剪贴簿同时发生。

v 访谈是为我的博士研究而做的，将以博士论文的形式发表（论文目前尚未发表）。

Notes

i Much of this power likely has Buddhist sources. Patchwork robes, known as jiasha（袈裟）were commonly worn by Buddhist priests in China. Derived from the Indian Buddhist kasaya robe—kasaya being the Hindi word for "dirty color" or multicolored (referring to their patchwork nature)—jiasha were inspired by the historical Buddha's wearing of patched garments as a rejection of material wealth.

ii Assessing the spread and popularity of the baijiabei is made more difficult by the fact that in Mandarin the term can be used to simply describe the scrappy or patchwork nature of a textile, not necessarily its origin as a community-based project with many, or even hundreds of donors.

iii Since 1994, the single largest source for intercountry adoptions in the United States has been the People's Republic of China. Between 1992, when China first officially allowed international adoptions, and 2005, when these adoptions peaked, the number grew from 210 to nearly 8,000. Although the number has declined drastically since then, it still represents a large percentage of overall American intercountry adoptions; in 2012, for instance, 2,696 children were adopted from China, equaling 31% of all U.S. intercountry adoptions. Between 1999 and 2013, over 70,000 children of ethnic Chinese descent joined thousands of American families.

iv The addition of a written wish instills a distinctly American aspect to the practice, particularly as it has coincided with the rising popularity of scrapbooking in the U.S.

v Interviews were performed in the development of doctoral research, to be published as a dissertation (forthcoming).

贵州丹寨雅灰苗族百鸟衣上的拼布艺术

Patchwork Art On Bird Clothes in Yahui, Danzhai County, Guizhou Province

拼布作为一种用图案传递信息的文化，一门视觉的艺术，一种情感的表达，一直被贵州的苗族巧妙地运用在他们的服饰之上。贵州的许多地区，至今还能见到这种古老而独特的拼布艺术。

贵州丹寨雅灰苗族百鸟衣的制作，就体现了这种拼布的艺术。百鸟衣是一种上衣下裳连为一体、具有春秋"深衣"特征、通鬼神之用的礼服。在当地传说中，百鸟衣是由鸟的羽毛制成的。因苗族信仰万物有灵，崇拜自然，祀奉祖先，因此，在贵州丹寨雅灰一带，百鸟衣就成为了在"牯藏节"等重大节日期间所必须穿着的专用服装。缝制百鸟衣的绸布、丝线一般都是苗族妇女自己植桑养蚕，土法染织而成，百鸟衣上绮丽的蝴蝶、花卉、回纹以及几何图形均反映了苗族独特的审美。（图1）

图1 贵州丹寨雅灰苗族女式百鸟衣之胸围兜
Figure1. Belly apron as a component of bird clothes in Yahui, Danzhai County of Guizhou Province

Patchwork is an art that can transmit messages through images and patchwork artists use the technique express feelings. Miao people in Guizhou Province have traditionally applied patchwork art on their clothing. Even today, this ancient and unique art is seen on clothing in many places in Guizhou.

One example is the bird clothes made and used by Miao in Yahui, Danzhai County, Guizhou Province. With the upper body piece and the skirt connected, bird clothes look like spring or fall dresses in appearance. In local legend, bird clothes used to be made of bird feathers. In Miao folk beliefs, people believe everything has spirit and they worship the nature and their ancestors. Miao regard bird clothes as ceremonial costumes that communicate with the supernatural world and bird clothes on significant occasions such as ancestor worshiping ceremonies. The silk cloth and threads for making bird clothes are produced at home by Miao women and dyed with traditional methods. The design motifs on the clothes,

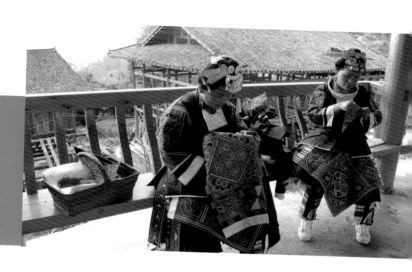

图2 贵州丹寨雅灰苗族妇女正在制作百鸟衣
Figure2.Miao women in Yahui, Danzhai County of Guizhou Province making bird clothes

百鸟衣的制作工艺主要为拼布，具体有两种方式：一为传统的布贴，一为茧片绣工艺。布贴，也称"贴花"，是将各色布块剪成所需图案贴缀镶订而成的一种刺绣手法，绣法简单，图案以块面为主，风格别致大方。茧片绣又称"板丝绣"，因刺绣时所用的材料"板丝"而得名，"板丝"是指将蚕放在木板上均匀地来回吐丝，木板被覆盖后揭下蚕丝，压平后即为"板丝"，再将染色后的板丝作为底衬在其上进行刺绣或将"板丝片"覆在绣布表面镶拼组合成图案。（图2）

无论是传统的布贴，还是濒危的茧片绣工艺，都是将碎布或丝片拼缝而成主图案的过程，其精工细作出来的百鸟衣不但工艺精湛，图案精美，而且还具有深厚的历史文化内涵。

such as butterflies, flowers, and geometric ornamentation, reflect the aesthetic preferences of the Miao. (Figure 1)

The main textile techniques used in making bird clothes are appliqué and silk cloth embroidery. Appliqué is used to combine small pieces of cloth of different colors and shapes to make a pattern. Silk cloth embroidery is also called board silk embroidery as the silk cloth used for the embroidery is board silk, a form of silk produced by silkworms spinning silk threads on a flat board. After the board is fully covered by silk, the whole piece of silk is peeled off and pressed as board silk. The dyed board silk becomes foundation cloth for embroidery or is appliquéd with other embroidered cloth to make a pattern. The particular form of textile production with board silk is rarely practiced in contemporary times and is considered an endangered aspect of intangible cultural heritage. (Figure 2)

Both the traditional appliqué technique and silk cloth embroidery are used in the patchwork process of putting small pieces of cloth together to form patterns. Bird clothes made with these techniques are delicate and beautiful in appearance and embody profound historical and cultural meanings.

马丽亚 贵州省民族博物馆文物中心馆员

Ma Liya, Curator, Cultural and Relic Center, Guizhou Nationalities Museum

广西少数民族背带

Ethnic Minorities Baby Carrier in Guangxi

背带，是背负婴儿所用的布兜，早在《史记·卫青传》中已有记载，背带被喻为背上的摇篮，是世代相传的育婴工具和民间工艺品，具有丰富的民俗文化和艺术价值，至今在广西少数民族地区还广泛流传。背带是当地妇女一针一线精心绣制而成的刺绣精品，其艺术风格、花纹图案、工艺手段等，皆同当地妇女盛装高度一致。（图1）

Baby carriers(also called baby slings)are used by many ethnic peoples in China to carry a baby on their back. The earliest published record in China of a baby carrier is in Shih Chi Biography of Wei Qing.In this book, a baby carrier is described as a cradle on a back. It is a nursery tool passed down from generation to generation and a folk craft with cultural and aesthetic values. Traditional baby carriers are still used in many ethnic communities in Guangxi Province. They are handmade by local women and are adorned with beautiful embroidered designs. The artistic styles, decorative pattern designs, and techniques used in baby carriers are highly consistent with those used in the production of local women's festival costume. (Figure 1)

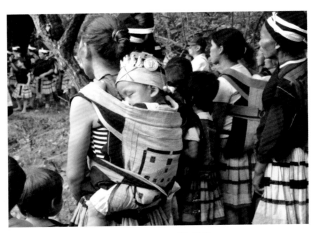

图1 广西南丹瑶族背带
Figure 1. Yao baby carrier, Nandan

以下从形制、纹样、色彩工艺三方面简单介绍广西少数民族背带。

广西少数民族背带基本都是典型的轴对称图形。背带在完全展开的时候，主体成倒梯形、T字形、长方形或正方形。大多数背带由背带盖、背带心、背带柱、背带尾、绑带等几部分构成。（图2，图3）

广西少数民族背带的纹样丰富多彩，图案内容以花叶、动物、几何纹饰为主。花的种类甚为丰富，牡丹、石榴、菊花、梅花、莲花、桂花、茶花等图案在背带刺绣中比比皆是。游鱼、飞鸟、彩蝶、蜜蜂、龙虾、狮虎、麒麟等动物纹样藏匿于花中与花浑然

Baby carriers are typically symmetric. When they are expanded, they look like an inverted trapezoid, T type, rectangular, or square. Most baby carriers consist of a cover, a center section, a pillar, a tail and a belt. (Figure 2, Figure3)

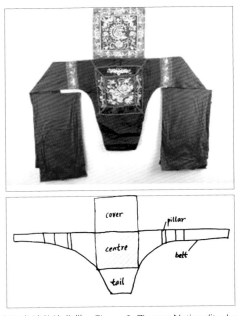

图2. 广西龙胜壮族背带　Figure 2. Zhuang Nationality, Longsheng
图3. 背带结构图　　　　Figure3. Structure of Baby Carrie

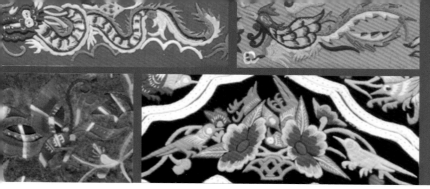

图4 龙　　　Figure 4. Dragon
图5 凤　　　Figure 5. Phoenix

图6 蝴蝶　　Figure 6. Butterfly
图7 花鸟　　Figure 7. Flower and Bird

一体，构筑成背带上的万物生灵。其中花叶纹、鸟纹、龙凤纹是壮族背带常用的纹样，侗族则喜欢用太阳纹和榕树纹，花草纹、蝴蝶纹、鱼纹是苗族背带常用的纹样，瑶族则喜欢用几何纹和八角太阳纹。（图4，图5，图6，图7）

　　广西少数民族背带的底布颜色基本上为黑色、蓝色、红色三种。其背带的色彩特征突出反映在丰富的刺绣色彩上，每个民族每个支系都有不同的配色习惯，大多数颜色非常丰富和鲜艳。在刺绣手法上，也是多种多样，广西的少数民族背带刺绣手法一般有平绣、挑绣、破线绣、打籽绣、锁绣、贴布绣、马尾绣等，通常一幅背带上同时采用几种绣法，使图案看起来具有立体感。其中贴布绣就是用不同颜色的布块拼接成各种不同的图案，并在布块上刺绣精美的图案，组合成一幅完整的画面，极具均衡感和对称美。在广西少数民族被面上最常使用贴布绣这种绣法。

Artists use many colorful patterns on the baby carriers they make. Most of the embroidered designs are flowers, animals, or geometric ornamentation. Flower designs include peony, pomegranate, chrysanthemum, plum blossom, lotus, osmanthus, and camellia. Animal designs include fish, bird, butterfly, bee, shrimp, lion, tiger, and kylin. Zhuang artists commonly use flower, bird, dragon and phoenix designs on their baby carriers. Dong artists commonly use sun and banyan tree designs. Miao use flower, leaf, butterfly and fish designs, and Yao artists typically use geometric ornamentation. (Figure 4, Figure 5, Figure 6, Figure7)

The fabric used for the backing of baby carriers is in three basic colors, namely, black, blue and red. Richer colors are shown by embroidered patterns. Although most of the ethnic groups like to use rich bright colors, each group has their own way of matching their favorite colors. The embroidery techniques used by artists also vary according to the ethnic groups with which the artists belong. The embroidery techniques include plain embroidery, cross-stitch embroidery, broken-thread embroidery, knot embroidery, lockstitch embroidery, appliqué embroidery, and horsetail embroidery. Sometimes several kinds of embroidery techniques are combined to make a more three-dimensional pattern. Appliqué is also often used by ethnic minority artists in Guangxi in making quilts. Appliqué is the technique of putting small pieces of cloth of different colors together to make a complete pattern. Most of the appliqué patterns used by southwest Chinese ethnic artists are symmetric.

艾兰　广西民族博物馆研究一部主任

Ai Lan, Director, The First Research Branch Department, Guangxi Museum of Nationalities

哈尼族贴花背被　　Hani Baby Carrier

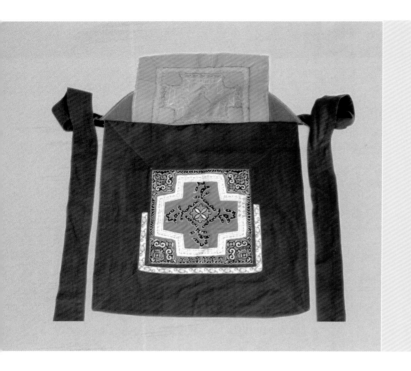

哈尼族贴花背被
（云南民族博物馆藏品）
Hani appliquéd baby carrier
（Collection of Yunnan Nationalities Museum）

　　拼布作为一种古典唯美的手工艺，在世界的文化历史长河中源远流长，中国作为世界文明最早的发源地之一，在拼布艺术的发展中占据了重要地位。从最初的功用性到现代的艺术性，拼布作为艺术逐渐彰显出其自身独特的魅力。

　　云南作为多民族的地区，各民族在自身的发展过程中都将拼布艺术融进了生产生活中，最具代表性的当属各民族的背被。背被盛行于中国山区，以云、贵、川三省最具代表性，用于将孩童背在身后，方便在山地行走及劳作。背被样式简单，大多为长方形配以背带，通过背带的缠绕将孩童稳妥地固定在背后。因背被的特殊用途，其被寄予了亲人深深的祝福，不仅由特定亲人亲手缝制，在花纹图案方面也有诸多讲究。比如用蝴蝶、鱼、鸟等动物吉祥图案和山茶花、石榴、四瓣花等花草纹样作装饰，不仅表达了少数民族对美的追求，同时把象征多子

Patchwork has a long history within cultures around the world and artists in China, one of the cradles of world cultures, have played important roles in the development of this art. From the original functional art to modern aesthetic art, patchwork is firmly a part of the history of Chinese material and expressive arts.

Throughout the history of all ethnic groups in the multiethnic region of Yunnan, artists have incorporated patchwork into the material culture traditions associated with daily life and ritual and ceremonial practices. Baby carriers might be considered the textiles in which patchwork is most consistently used; it is simultaneously perhaps the most public place that patchwork is found. In the mountainous southwest China, especially in Yunnan, Guizhou, and Sichuan, it is very common for people to use baby carriers to carry babies on their backs while walking and working. The style of a baby carrier is simple; it consists of a piece of rectangular shaped cloth with attached cloth braces (or ties) that are used to secure the baby on a person's back. Baby carriers also

多福、祖先崇拜等寓意的花草、动物图案造型巧妙的组合于背被上，背被造型与本民族的文化内涵相得益彰，在挖掘背被文化内涵的同时享受视觉的美感，体现了少数民族拼布艺术实用性与艺术性兼具的特征。背被的花纹图案大多以刺绣、镶补、挑花、补花为主，其中拼布由之前的节约材料逐渐转为艺术创造，利用不同色彩的布料拼出各种绚丽的图案，充分展示本民族独有的特色。

embody blessings from the babies' families; they are hand-sewn for the baby by relatives, who incorporate into the carriers designs of special meanings. For example, artists use auspicious designs such as butterflies, fish, birds, camellia, and pomegranates to express the pursuit of beauty and to represent fertility and ancestral worship. The combination of artistic designs with cultural meanings shows the characteristics and artistic features of ethnic minorities' patchwork. Most patterns on baby carriers are made with the techniques of embroidery, lace, appliqué, and inlay. Originally artists used patchwork techniques to make full use of available cloth materials. Gradually, patchwork has become a form of art creation and artists use fabrics of different colors to create a variety of beautiful designs and to demonstrate unique ethnic characteristics.

The baby carrier shown here is a fine composition, with ingenious layout, bright colors, and a well-proportioned lively style, bringing a strong artistic and visual affect. It is not only a necessary element of Hani daily life but also a Hani fine art.

程晓丹 云南民族博物馆学术交流部馆员

Cheng Xiaodan, Curator, Museologist, Yunnan Nationalities Museum

彝族绣花背被

Yi Embroidered Swaddling Blankets

背被是云南民间广为流传的孕婴用品，同时它也是漂亮的工艺品。早在三千多年前，人们使用的襁褓就是现今背被的雏形，其造型和功能沿用至今。

彝族背被色彩绚烂，以黑色和红色为主基调，红色象征勇敢、吉祥；黑色代表高贵与庄重。其构图精美，由五彩丝线刺绣马缨花、山茶花等纹样，并融合石榴、蝴蝶、鱼等吉祥图案，卷画出自然万物和谐共生美景。图纹与彝族生活、文化息息相关，文化内涵丰富。鸟、鱼、花往往同时出现于彝族的拼绣中，表达繁衍生息、丰衣足食的美好愿景。体现彝族火崇拜、生殖崇拜的马缨花象征吉祥、希望和平安，背被上的马缨花取其驱病除魔的寓意，并与美丽的蝴蝶相呼应，形成云南少数民族喜爱的"蝶恋花"搭配，传递母爱与祝福。

Swaddling blankets are commonly used in Yunnan Province to cover babies when people carry the infants on their backs. The type of cloth and its shape and function have precedents that date back to as early as 3,000 years ago.

The Yi swaddling blanket is colorful with black and red as its basic colors. Red symbolizes bravery and auspiciousness, and black symbolizes nobility and solemnity. Yi swaddling blankets have exquisite compositions which include decorative patterns such as lantana and camellia flowers embroidered with multicolored silk, and auspicious patterns such as pomegranate, butterfly, and fish. These designs present beautiful scenery and the harmonious coexistence of things in the natural world. These patterns are also closely related to the life and culture of the Yi since the designs all have cultural connotations. Yi often use embroidered designs of birds, fish, and flowers to express fertility and abundance. Representations of the lantana flower represent the fire worship and reproductive worship of the Yi and symbolize auspiciousness, hope, and peace. When a lantana flower is embroidered on a swaddling blanket it presents a symbol that wards off disease and evil. Minorities in Yunnan also favor a design that contains a combination of a butterfly and the lantana flower called "Butterfly Lingers Over Flower;" they consider that the design expresses maternal love and blessings.

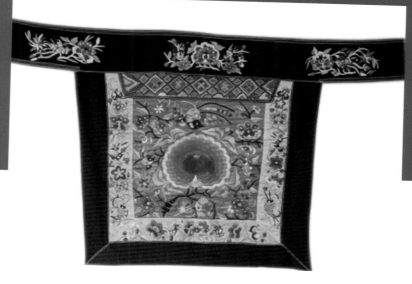

云南丘北县彝族刺绣背被 Yunnan Qiubei, Yi Embroidered Swaddling Blanket
（云南民族博物馆馆藏 Collection of Yunnan Nationalities Museum）

自然界中的水、火、日、月、星辰以及自然想象的光波、水纹及云彩，是古老彝族崇敬的对象，彝族先民使用抽象的手法将他们归结为简洁的图案，表现在背面上，表现出彝族对自然的热爱与向往。伴随着复纹、组合纹、套合纹交叉使用的视觉冲击力而来的是无穷的想象力和创造力。图案中心的马缨花成放射状排列，外面数朵马缨花构成环状结构，层次清晰；结合叶子、花苞、小鸟等图案，复合相融、平添生机、点面呼应，增强图案的整体性与立体感。

挑花、刺绣、镶补等工艺手法淋漓尽致地运用于背被，栩栩如生的图纹在巧夺天工的手艺中得以呈现。其中的镶补是彝族刺绣工艺中一种特殊的工艺手法，一般是先用带颜色的布剪好需要的图案，贴于绣面上，作为垫底面料，然后用针钉出纹样的轮廓。例如"对鱼石榴"图案采用这种工艺，图案层次分明、对比强烈、风格古朴、造型夸张生动。对鱼象征繁衍生殖，石榴寓意多子，是汉族用于求子求吉的图案，彝族对其钟爱是彝汉文化交融的见证。

Yi worship water, fire, sun, moon, and stars in nature as well as light wave, water wave, and clouds in the natural phenomena. Yi ancestors put the abstractions of these on their swaddling blankets, thereby expressing Yi love of nature. The complex pattern, combination pattern, and nested pattern on swaddling blankets shows the imagination and creativity of Yi artists. The center image of the piece shown here is a lantana with several smaller lantana surrounding it; the pattern is combined with patterns of leaves, buds and birds to form a integrated and three-dimensional picture.

Textile production techniques such as cross-stitch, embroidery, and inlay are applied to make swaddling blankets. Yi textile artists are known to often use inlay in their work; artists cut colored fabric into the shapes they want and sew them on a foundation fabric. This technique can be seen in the "Double Fish with Pomegranate" motif which presents a sharply contrasted, exaggerated, and vivid image in a simple style. The double fish motif symbolizes reproductivity and the pomegranate symbolizes fertility. The "Double Fish with Pomegranate" motif is also used by the Han nationality to pray for pregnancy and auspiciousness. It is likely that the favored use of this motif by Yi artists shows the cultural influence of the Han.

彝族丰富独特的文化蕴藏于巧妙构图与精湛工艺完美结合的背被中。这个小小的背被，代代相传，一针一线倾注着母亲对子女的疼爱，表达着家族对下一代的期望，寓意着人类种族延续的命脉。

The rich and unique culture of the Yi nationality is revealed in the tradition of making and using swaddling blankets. The textiles embody traditional and culturally meaningful designs, ingenious compositions, and exquisite craftsmanship. Family connections and a mother's love for her children are communicated as these small swaddling blankets are made and handed down from generation to generation. Therefore, the blanket expresses the expectations of the family for the next generation and symbolizes the development of the human race.

周浩玲 云南民族博物馆学术交流部馆员

Zhou Haoling, Curator, Museologist, Yunnan Nationalities Museum

多彩而独特的中国瑶族服饰

The Colorful and Unique Chinese Yao Costume

瑶族是中国典型的南方山地民族，全国瑶族人口 246 万（2007 年），分布在长江以南的广西、湖南、云南、广东、贵州和江西六省的 140 多个县。瑶族曾历经频繁的迁徙、游耕。按照语言、族源和文化变迁，瑶族大致可划分为盘瑶、布努瑶、茶山瑶、平地瑶四大支系。

盘瑶支系占瑶族人口的 60% 以上，广泛分布于湖南、广东、广西、江西、贵州、云南等省区，东南亚及欧美的瑶族也多属盘瑶。盘瑶支系包含他称为过山瑶、盘古瑶、顶板瑶等各种分支。广泛使用挑花是盘瑶服饰的最大特色。

布努瑶多数分布在桂西、桂西北及贵州、云南局部地区。布努瑶支系包含他称为红瑶、白裤瑶、青瑶等各种分支。布努瑶女性多穿裙装，女裙的形制和工艺多种多样，喜爱佩戴簪钗、耳环、项圈、串牌、链带、镯钏、戒指、银铃等银饰。（图1）

Yao is one of the ethnic groups in southern China. According to population statistics of 2007, the total Yao population in China is 2.46 million and lives mainly in the provinces of Guangxi, Hunan, Yunnan, Guangdong, Guizhou, and Jiangxi. Throughout history, Yao have been constantly migrating from one location to another as they have sought land for cultivation. Yao are divided into four groups: Pan Yao, Bunu Yao, Chashan Yao, and Pingdi Yao, each of which has a distinct language, origin stories, and cultural traditions.

The Pan Yao group accounts for more than 60 percent of the total Yao people and are distributed widely in Hunan, Guangdong, Guangxi, Jiangxi, Guizhou, and Yunnan. Most Yao people in southeast Asia, Europe and America are of the Pan Yao branch. Pan Yao includes subgroups such as Guoshan Yao, Pangu Yao, and Dingban Yao. One of the most distinctive features of Pan Yao textiles is the cross-stitch embroidery they use on their clothing.

Most Bunu Yao reside in the west and northwest of Guangxi with a small number in Guizhou and Yunnan provinces. Bunu Yao includes subgroups of Red Yao, White Trousers Yao, and Green Yao. Bunu Yao women favor wearing skirts with various styles and techniques, and body adornments such as silver ornaments, including hairpins, earrings, necklaces, chains, bracelets, rings, and silver bells. (Figure 1)

Chashan Yao are mainly distributed in the middle of the Dayao Mountains in Jinxiu Yao Autonomous County of Guangxi. Their costumes are simpler in terms of craftsmanship and ornaments. Some Chashan Yao women wear three big silver hairpins; this is regarded as a symbol of their group. (Figure 2)

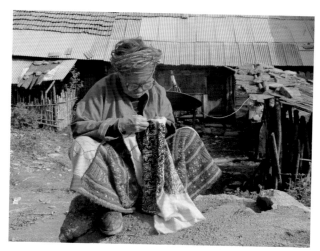

图1 布努瑶服饰（刘治福摄）

Figure 1. Bunu Yao clothing. Photo by Liu Zhifu.

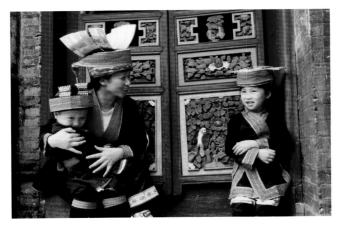

图2 广西金秀瑶族自治县茶山瑶服饰（李桐摄）
Figure 2. Guangxi Jinxiu Yao Autonomous County Chashan Yao clothing. Photo by Li Tong

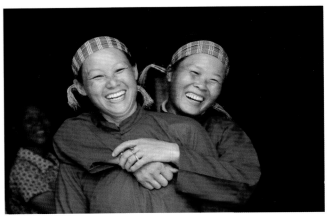

图3 广西富川瑶族自治县平地瑶女服（梁汉昌摄）
Figure 3. Guangxi Fuchuan Yao Autonomous County Pingdi Yao clothing. Photo by Liang Hanchang.

茶山瑶主要集中在广西金秀大瑶山腹地，其服饰在工艺和搭配上相对简朴。部分茶山瑶女子头戴三支翘翅大银板，为该支系的标志性装束。（图2）

平地瑶主要从盘瑶中演变而来，主要分布在湖南、广西、广东省交界的平原地带。与盘瑶相比，平地瑶的服饰已经大大简化和汉化。（图3）

中国早在汉代就有瑶族先民"好五色衣裳"和"衣裳斑斓"的记载。瑶族服饰具有款式繁多、色彩斑斓、图案古朴、工艺精美的特点。瑶族不同支系，其服饰各异，同一支系不同地区也不尽相同。瑶族服饰与自然环境、历史经济、宗教信仰、生产生活习俗等关系密切。

Pingdi Yao, mainly affiliated with the Pan Yao, are distributed on the plains along the border of Hunan, Guangxi, and Guangdong provinces. The costumes of the Pingdi Yao are simpler than those of other Yao groups and more similar to the traditional clothing of the Han. (Figure 3)

As early as the Han Dynasty, there are records of Yao people "loving the colorful clothes." Chinese Yao costumes are gorgeous and magnificent with ancient patterns and delicate handcraft. Different Yao branches have different costume styles. Even within the same branch, costumes are diverse according to different areas affected by environment, history, economy, religious belief, and local custom.

刘治福　广西民族博物馆藏品部主任

Liu Zhifu, Director of Collection Department, Guangxi Museum of Nationalities

拼布索引：
国际资源建设

The Quilt Index:
Building an International Resource

我们如何才能有效存取世界上成千上万的拼布信息呢？密歇根州立大学博物馆和密歇根州立大学人文与社科数字中心与拼布联盟合作建设了拼布索引（quiltindex.org）。拼布索引采集不同地方和时期的拼布及拼布艺人故事、图片和信息等资源。此索引是存储这些信息的工具，同时也为创造性实践、创新性研究和教育提供资源。

拼布索引最初的数据记录起源于20世纪晚期美国境内民间艺人和学者对拼布制作和拼布研究重新燃起的热情。当时越来越多人对作为艺术、历史记录和学术研究资源的拼布感兴趣。各州和地方级别的拼布记录项目鼓励人们把自己的拼布带到社区记录点登记拼布的文字描述、照片、历史以及制作者的个人信息。参与这些项目的大多是志愿者。成百上千的拼布信息被记录下来。我们发展了拼布索引存储这些信息以供公众使用，同时也为世界各地的公共和私人拼布信息互通搭建一个平台。拼布索引于2003年正式推出，至2010年，拼布索引完成了大量的数据录入项目并保存了250多家博物馆和一些私人收藏家的拼布信息。到2015年，拼布索引共记录了75000多幅拼布的信息。除了拼布和拼布艺人的信息之外，此索引还记录存储包括期刊、暂时性网络信息、论文、虚拟展厅和相关课程等内容，也具有通过关键词、产地、布料、颜色、纹样和制作技艺等进行搜索和比对的功能，用户可以借此比较拼布的异同之处。

How can one readily access tens of thousands of quilts from around the world? The Quilt Index (quiltindex.org), a digital humanities project developed by Michigan State University Museum and MSU's Matrix: Center for Digital Humanities and Social Sciences in partnership with the Quilt Alliance, is a robust, online resource that brings together stories, images, and information on quilts and quilt makers across time and place [i]. The Index is a tool for preserving this data and a resource for creative practice, innovative research, and education.

The first body of documentation housed in the Quilt Index stemmed from a revival of interest in quiltmaking and quilt study by artists and scholars in the late 20th Century particularly in the United States. During this time, an increasing number of individuals became interested in quilts as works of art, historical documents, and sources for academic research. Through state and regional quilt documentation projects, largely run by dedicated volunteers, individuals were encouraged to bring quilts they made or owned to community sites where physical descriptions, photographs and histories of quilts, and biographical details about their makers were recorded. Tens of thousands of quilts were documented. The Quilt Index was developed as a means not only to preserve and make these records accessible but also to accommodate data about quilts held in private and public collections around the world. The Quilt Index was officially launched in 2003 and by the end of the decade the Index included the records of many documentation projects as well as those of the quilt collections in over 250 museums and a few private collections. As of 2015,

为了实现打造真正国际化的拼布索引这一目标，索引工作组开始录入美国博物馆和其他国家的国际拼布信息。目前我们已经收录了南方和加拿大的一些拼布馆藏信息，其他国家的信息也在录入过程中。中国和美国博物馆基于对传统物质文化遗产的研究、教育、馆藏和展览的共同兴趣展开合作，其成果之一便是索引数据库中国拼布信息的增加。截至2015年年底，我们已经录入了云南民族博物馆、密歇根州立大学博物馆以及纳布拉斯卡大学林肯分校国际拼布研究中心和博物馆的中国拼布馆藏信息。我们预计在接下来的几年内将有成千上万的中国拼布信息被录入到索引系统中。

随着国际馆藏信息的增进，我们面临着诸如跨时区工作、电脑技术和网络连接差异、选择和建立恰当的合作伙伴关系、语言和术语等可预见的和不可预见的挑战。新的问题不断涌现，比如：拼布在不同文化中是如何定义的？纳入非传统形式的拼布意义何在？如果一件纺织品用了拼布制作技艺，我们是否应该将其纳入索引？

records of over 75,000quilts are in the Index. This object and artist-focused data in the Index is also enhanced with the inclusion of journals, digitized quilt ephemera, essays, online galleries, and lesson plans. Quilt Index tools include those to search and compare by key words, location of origin, fabric, color, pattern, and technique, and to be able to look for similarities and differences.

To meet the goal of making the Quilt Index a truly international resource, the Index team has already begun to add the collections of international quilts held by U.S. museums as well as collections housed in other countries. Already, selected collections from South Africa and Canada are in the Index and more are in the process of being added. Collections of Chinese quilts are being added as a result of the new collaborations among U.S. and Chinese museums that have common research, education, collections, and exhibition interests in traditional material cultural heritage. As of late 2015, collections of Chinese quilts from the Yunnan Nationalities Museum, Michigan State University Museum, and the International Quilt Study Center and Museum at the University of Nebraska-Lincoln have been added. The Index team anticipates thousands of Chinese quilts will be added in the coming years.

As international collections are added to the initial body of predominately American quilts in the Index there have been both expected and unexpected challenges of working across time zones and with different computer technologies and Internet access, soliciting and establishing appropriate partnerships, understanding and negotiating governmental, cultural and institutional practices, and working through issues of language and nomenclatures. New questions arise constantly. How is the term "quilt" defined in different cultures, if at all? What might be the value of including pieces that might not follow a traditional definition? If a textile includes techniques found in quilts, should it be included?

索引工作组选择使用广义的、包容性的拼布定义，以便开发跨文化学习和研究的潜力。正因为世界各地都有拼布和与拼布相关的纺织品技艺，在不同时期和地方的拼布间建立联系有利于我们构建一个对这种物质文化的历史更为综合全面的认识并为世界各地的人打开一扇在新的领域进行调查研究的窗户。

The Index team has chosen to use a broad, inclusive definition of the term quilt and thus the Index offers more potential for cross-cultural learning and research. Precisely because quilts and quilt-related techniques can be found throughout the world, the connections that can be made by viewing quilts made from different times and places are invaluable in stitching together a more comprehensive view of this material culture history and in opening doors of new arenas of inquiry for individuals around the world.

玛丽·沃勒尔 密歇根州立大学文化遗产研究策展人

翻译 张丽君

Mary Worrall, Curator of Cultural Heritage, Michigan State University Museum

Translation: Lijun Zhang

Notes

For more information about the development and scope of the Quilt Index, go to www.quiltindex.org. Major grants from the National Endowment for the Humanities and the Institute for Museum and Library Services with major in-kind support from Michigan State University, funded the initial developmental phases of the Quilt Index. More information can be found at http://www.quiltindex.org/about.php#grants.

"多彩de贵州"
——贵州少数民族艺术摄影精品展

Colorful Guizhou
—Photography Exhibit of Guizhou Minority Ethnic Arts

"多彩 de 贵州"——贵州少数民族艺术摄影精品展是贵州摄影界的一大品牌主题系列摄影展，始创于 2009 年，由贵州民族文化宫（贵州省民族博物馆）、中国民族画报社和贵州省摄影家协会联合主办，每两年一届，面向全国征稿。旨在借助摄影这种艺术形式，以摄影作品为载体，记录、展现贵州绚丽多姿的少数民族风情，力图打造成保护、弘扬古老优秀少数民族历史、文化的品牌展览。（图1）

Started in 2009, Colorful Guizhou—Photography Exhibit of Guizhou Minority Ethnic Arts is a biennial themed photography exhibit co-organized by the Guizhou Palace of Ethnic Culture/Guizhou Museum of Nationalities, China Pictorial Publishing House, and Guizhou Photographers Association. The main purpose of the exhibit is to present the beautiful and diverse minority ethnic landscape and culture through photography. A committee selects photos taken by photographers throughout China. They aim to make a brand exhibit that plays a role in the protection and promotion of

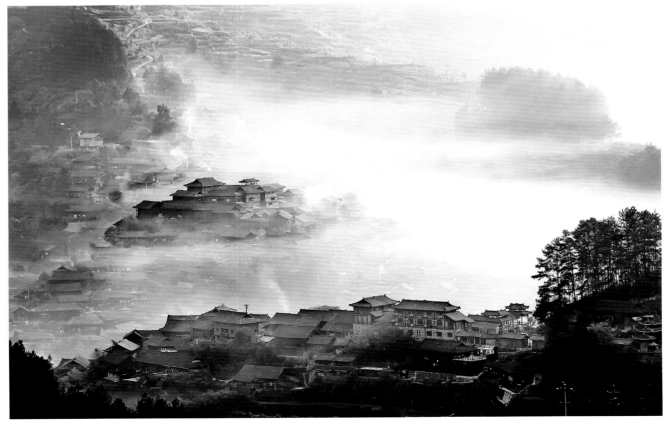

图1 云上苗寨　　Figure 1. Miao Village in the Mist

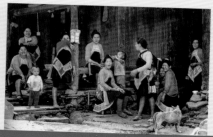

图2 贵州苗族（吴东俊摄）
Figure 2. Miao Girls in Guizhou, photo by Wu Dongjun

图3 贵州苗族
Figure 3. Miao women in Guizhou

图4 岜沙女人（邹伟摄）
Figure 4. Women in Biasha, photo by Zou Wei

民族艺术摄影作品题材包括民族村寨风光、节庆活动、日常生活等。其中的很多作品记录了多姿多彩的民族服饰。比如一些图片展现了节日人群中花枝招展的少女、用自制的背扇背上孩子的妇女以及茶余饭后在家门口闲聊的妇女们。（图2、图3、图4）他们的服饰衣裙或隆重，或日常，都有着五彩的图案、精致的花纹，点缀在盛装的肩背、环绕在常服的袖口、填充在背扇的一角，在裙摆上飞舞，在围腰上夺人视线。即便是简单色块的拼凑，红绿的鲜明撞色、蓝白的相互衬托，也跳脱了日常生活的重复，点缀了柴米油盐的滋味。五颜六色的服装便是人们穿在身上表达传统和信仰的视觉性语言。这些照片记录了少数民族生活中的重要艺术表达形式。

our excellent minority ethnic history and culture. The selection of photos is then exhibited at the Guizhou Museum of Nationalities. (Figure 1)

The contents of the photography include scenery of ethnic villages, festivals, and daily life. Many of the photos document colorful ethnic costumes. For instance, images show the girls wearing special clothing in festival, women carrying babies with homemade baby carriers, and a group of people in traditional clothes resting in front of a house. (Figures 2, 3, and 4).Both the festival costumes and the daily clothes are decorated with appliquéd patterns and delicate embroideries, either on the shoulder, around the cuffs, at the bottom of the skirt, at the waist line, or on the edges of the baby carriers. Even the simplest appliqué pattern of color blocks with red and green or blue and white cloth bring people beauty and joy in their repetition of daily life. The colorful clothes serve as a visual language that expresses cultural traditions and beliefs. The photographs record how these clothes function as an important art in ethnic minority life.

杜皓 贵州省民族博物馆文物中心助理馆员

Du Hao, Assistant Curator, Guizhou Museum of Nationalities

拼布艺人资料：
莫爱群（壮族）

ARTIST PROFILE:
MO AIQUN (Zhuang)

莫爱群，今年 57 岁，壮族，出生在中国西南部广西壮族自治区天峨县三堡乡的壮族村寨。13 岁开始跟母亲及村里的长辈学习纺织刺绣工艺，壮族的传统服饰、鞋帽、背带、被面等都会制作。30 岁时搬到天峨县城居住，有两个女儿一个儿子。现年 88 岁的母亲还在自己种棉、纺线、织布、染布和刺绣，家乡村里还有部分老人平时纺织刺绣，而年轻人大部分不做了，只有小部分年轻人还在坚守。莫爱群介绍："以前村里很多人做被面，通常是女孩结婚前开始制作，用来当嫁妆，老人们做的被面送给外孙作为满月的贺礼。现在已经很少有人还制作和使用这种传统的被面了。因为做一床被面需要一年左右的时间，太耗费时间和精力。我现在做的被面主要是留给儿女做纪念，希望能把自己的手艺留下来，以后的人还能看到我们壮族的传统工艺。"

Mo Aiqun was born in 1958 in a Zhuang village in Sanbao, Tianer County, Guangxi Province, in southwest China. At the age of 13, she started to learn textile making skills from her mother and other female elders in her village. Today she makes traditional quilts, baby carriers, and clothing, including hats and shoes. She has two daughters and a son.

Her mother, born in 1927, still grows cotton and practices weaving, dyeing, and embroidery. Some of the other elders in village also make textiles and do embroidery but most of the young women do not practice the traditional textile making skills. Mo says: "In the past, it was quite common to make bedcovers. Young girls made bedcovers for their marriage and the elders made bedcovers as gifts for the one-month ceremony of their grandchildren. Now few people make and use traditional bedcovers as it takes about a year to make one. It is very time and energy consuming. I make bedcovers for my children so that they can keep them as mementos in the future. I wish people can still see our Zhuang traditional arts in the future through my work."

——广西民族博物馆研究团队根据 2015 年对拼布艺人所做的田野访谈提供的资料

— From field interview conducted with artist in 2015 by Guangxi Museum of Nationalities research team

莫爱群访谈

莫： 我叫莫爱群，家乡在（广西天峨县）三堡乡。

访谈人： 您有几个小孩？

莫： 三个，两个女儿，一个儿子。

访谈人： 两个女儿有没有跟您学这个？

莫： 没有学，她们都不学。

访谈人： 她们不愿意学？

莫： 不愿意。读书去了。她们去外面工作了，都不愿意做了。

访谈人： 你想让她们学吗？

莫： 想啊，但她们都没有耐心跟我学啊。

这个被面是以前没有机械化时用织机手工做出来的。

我们结婚的时候就要用这个被面做嫁妆。

访谈人： 你是跟妈妈学的吗？

莫： 是啊，跟妈妈学，还有看别人做，自己就学回来。

这个拐弯的地方就要用线绕一圈。

访谈人： 您做这个是自己用吗？

莫： 我是做给我儿子的。三个小孩一个一床，留念妈妈的手艺，把手艺留下来。

其实这种被子才好睡，热天时盖起来是凉的，不出汗的。

Interview with Mo Aiqun

Mo: I am Mo Aiqun from Sanbao Town (Tian'e County, Guangxi).

Interviewer: How many children do you have?

Mo: Three, two daughters and a son.

Interviewer: Do your daughters learn how to make quilts?

Mo: No, they don't.

Interviewer: They don't want to learn?

Mo: No. They went to school and then work in the city. They don't make quilts.

Interviewer: Do you want them to learn?

Mo: Yes, but they don't have the patience. There was no machine in the past so the quilt was handmade. We brought quilts to our husbands' house as dowry when we got married.

Interviewer: Did you learn from your mother?

Mo: Yes, I watched my mother and other people making quilts and learned how to make them. You need to sew around the corner.

Interviewer: Do you make the quilt for yourself?

Mo: It's for my son. Each of my three children gets a quilt to keep them as memento of their mother's handcraft. The fabric is good for our sleep. It keeps you feel cool in summer.

拼布艺人资料：
黄碧瑜（壮族）

ARTIST PROFILE:
HUANG BIYU (Zhuang)

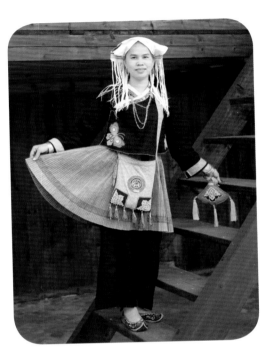

黄碧瑜，今年32岁，壮族，出生在中国西南部广西壮族自治区隆林各族自治县沙梨乡的壮族村寨。母亲和外婆都是当地的普通劳动妇女，家里的女性长辈都会纺织刺绣等手工技艺。19岁离开家乡到广西桂林市读书，22岁在南宁的一家旅行社工作，24岁结婚，25岁辞职，并正式开始自学家乡的纺织、染布、刺绣、拼布等手工技艺，遇到不懂的地方就回家乡向长辈们请教，如今她已经熟练掌握了这些技艺，制作出来的壮族传统服饰、背带、帽子、绣花鞋、被面等十分精美。关于传承她表示了自己的担忧："我很热爱自己民族和家乡的传统文化，如今家乡的妇女都不愿意做这些手工活儿了，年轻人只有我还在坚守，如果连我也不坚持，这门手艺早晚要失传。"关于为什么制作拼布被面，她解释："制作拼布被面工艺非常复杂，一床需要一年多的时间来制作，我现在制作的被面是想留给我的儿子以后结婚时用的，它承载了一个母亲对孩子的爱。"

——广西民族博物馆研究团队根据2015年对拼布艺人所做的田野访谈提供的资料

Huang Biyu was born in 1983 in a Zhuang village in Shali, Longlin County, Guangxi Province, China. The female elders in her family, including her mother and grandmother, all are masters of weaving and embroidery. At age 19, she left home to attend college in Guilin and, at the age of 22 became an employee of a tour company in Nanning. She got married at age 24 and at 25 she quit her tour company job and began to learn weaving, dying, embroidery, and quilting at home. Her female elders mentored her and helped when she had questions. Now Huang Biyu has mastered all the skills necessary to make beautiful traditional textiles, including bedcovers, baby carriers, and clothing. She expresses her concern for the future of textile making skills: "I love the traditional culture of my ethnic group and my hometown. Many people here are no longer making handmade textiles. I am the only one [in my hometown] who is still practicing the skills. The skills may disappear if I stop doing it." She also explains the reasons for making quilts: "It takes more than a year to make a bedcover and the process is complicated. I made this bedcover for my son's wedding to express a mother's love for her child."

—From field interview conducted with artist in 2015 by Guangxi Museum of Nationalities research team

黄碧瑜访谈

访谈人： 你叫什么名字？

黄： 我叫黄碧瑜。来自（广西）隆林县沙梨乡。

访谈人： 今年多少岁？

黄： 今年 31 岁，壮族。

访谈人： 这种胶水是市场上买的那种胶水吗？

黄： 对，如果在老家的话就会用米糊。

访谈人： 你这个图案是怎么来的？

黄： 是老人们传下来的。

访谈人： 这剪刀是手工做的还是买的？

黄： 手工做的，现在没有这种剪刀了。

访谈人： 是在隆林买的吗？

黄： 是老人留下来的。

访谈人： 是谁留下来的？

黄： 我外婆。我们壮族（配色）以五种颜色为主。

访谈人： 哪五种颜色？

黄： 红的、黄的、绿的、黑的，还有白的。以前自己种棉花自己织布要十几道工序。（绣花时）没有顶针的话手会受伤。蝴蝶代表"福"的意思。以前是用羊皮条来制作的。还没怀孕的时候就已经在设计怎么制作了。

访谈人： 你这个是做给自己的宝宝用吗？

黄： 是的，我原来就是这样想的。有时候一天不绣花手都痒。然后把这四块布缝合在一起。

访谈人： 这个是你自己创作的吗？

黄： 对。做这些布条差不多要 2 个月的时间。把它们一个个放上去后再一个个地缝连起来。

Interview with Huang Biyu

Interviewer： What's your name?

Huang： Huang Biyu.I am from Shali Town, Longlin County (Guangxi).

Interviewer： How old are you?

Huang： Thirty-one. I am a Zhuang.

Interviewer： Do you buy the glue from the market?

Huang： Yes. I would use rice paste in my hometown.

Interviewer： How do you learn to make the images?

Huang： I learn it from the elders.

Interviewer： Are the scissors handmade or machine made?

Huang： They are handmade. Now you can't find them in other places.

Interviewer： Are they from Longlin?

Huang： They are passed down from the elders.

Interviewer： From whom?

Huang： My grandmother on my mother side. For Zhuang people, we usually use five colors on textile.

Interviewer： Five colors?

Huang： Red, yellow, green, black, and white. The procedure for making cloth from cotton at home was complicated. Your hands may hurt if you don't use thimble when doing embroidery. A butterfly represents good fortune. It used to be made of lamb skin. I began to design it before I was pregnant.

Interviewer： Did you make it for your baby?

Huang： That was the original plan. Sometimes I enjoy doing embroidery everyday. I appliqué the four pieces of cloth.

Interviewer： Did you design it yourself?

Huang： Yes. It took about two months to prepare the small pieces of cloth. I put them on the foundation fabric before sewing them on it.

拼布艺人资料：
沙莎（回族）

ARTIST PROFILE:
SHASHA (Hui)

沙莎是云南当代艺术家，生于1968年。她大学时期的专业是大学艺术设计专业。除了拼布之外，沙莎还进行陶瓷、油画、木刻、民族家具设计等艺术创造。作为少数民族传统工艺专家，沙莎致力于保护云南少数民族传统文化和手工技艺，并且参与国际公益及艺术交流项目。

ShaSha, born in 1968, is a contemporary artist in Yunnan. She was majored in art design in college. In addition to quilts, her artistic work and creation includes poetry, oil painting, woodcarving, and design of ethnic furniture. As an expert of ethnic minority traditional arts, ShaSha woks on protecting traditional ethnic culture and handcrafts in Yunnan. She is also active in international non-profit and arts programs.

沙莎访谈

我出生在一个回族家庭。我的奶奶随时都在为我十多个兄弟姐妹做服装、做鞋子。

从小跟奶奶一起学缝衣服做手工。而且奶奶说一个女孩子会手工才能成为一个真正的女孩子。

我的家乡是一个生产红糖的地方。每年七八月份空气中都弥漫着一种甜蜜的芬芳。

所以我觉得这也注定了我一生都喜欢做一些美好甜蜜的事情。

每一个少数民族的服装，都有拼布的设计在里面。因为他们手工织出来的布，宽幅都在40公分左右。如果不够的地方，他们就会用其他的布来补充。

Interview with Sha Sha

I was born in a Hui family. My grandma was always making clothes and shoes for more than ten children in my family. Since then I was learning from grandma to do needlework. And grandma said a girl could only be like a girl after she learned how to make handcrafts.

My hometown is a place where brown sugar is produced. In July and August you can smell the sweetness in the air. So I think I am destined to be engaged in something beautiful and sweet.

In every group of ethnic minorities, you would find patchwork designs. Because the fabrics are hand woven and they can only be as wide as 40 centimeters. If it's not wide enough, people sew a separate fabric to it to make it

我在这次的被子上面使用了少数民族各种颜色的布拼在一起，把刺绣也拼在里面。因为少数民族的图案和色彩跟他们的信仰有非常大的关系，也跟他们居住的地理环境有很大的关系。比如说比较强大的少数民族比较喜欢用鲜艳的颜色和很夸张的刺绣图案。弱小一点的民族居住在半山、山顶或者在树林里面。为了保护他们族群的发展，他们的服装色系比较暗，暗色调，而且绣的花也很低调很少，就是便于隐藏。

民族的就是时尚的。其实你看整个流行的趋势，都在不同程度上使用和模仿少数民族的图案色彩和搭配。我觉得这个传承还是要跟现实生活连接起来。

wider. When I was making this quilt, I patched colorful fabrics and embroideries from different ethnic groups.

The colors and patterns of ethnic textiles are related to their beliefs as well as their living environment. For instance, stronger groups prefer brighter colors and exaggerate patterns. Smaller groups live in hillside, mountaintop or forest. To protect themselves, they tend to use darker fabric and fewer embroideries to make clothes to keep away from attention.

Being ethnic is fashionable. As we see the trends, ethnic patterns colors, and ways of matching are applied and imitated in the fashion industry. It seems to me that the continuity (of ethnic cultures) should be related to daily life.

——云南民族博物馆团队根据 2015 年对拼布艺人所做的田野访谈提供的资料

—From field interview conducted with artist in 2015 by Yunnan Nationalities Museum research team

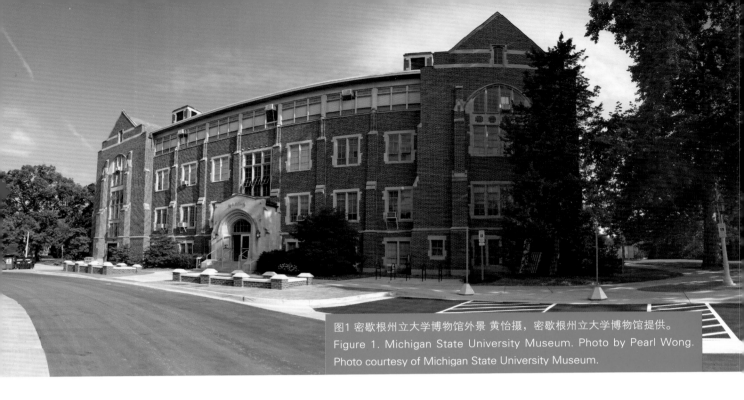

图1 密歇根州立大学博物馆外景 黄怡摄，密歇根州立大学博物馆提供。
Figure 1. Michigan State University Museum. Photo by Pearl Wong.
Photo courtesy of Michigan State University Museum.

密歇根州立大学博物馆
Michigan State University Museum

位于密歇根州东兰辛市的密歇根州立大学校园内的密歇根州立大学博物馆（密州大博物馆）成立于1857年，是美国中西部最古老的博物馆之一。（图1）该博物馆的宗旨是"经由教育、展览、及研究来致力于理解、诠释，并尊重自然和文化的多样性，建立和管理专注于密歇根州及大湖区和其他地区的馆藏"。密歇根州立大学博物馆（www.museum.msu.edu）由美国博物馆联盟认可，并且在2001年成为了密州第一个获得了由华盛顿特区史密森学会授权的拥有史密森伙伴地位的博物馆，从而拥有了更广泛的史密森文化和科学资源的使用权。

本博物馆公开管理大约一百万个来自世界各地文化和自然历史的藏品和标本，包括中国装饰和艺

Located on the campus of Michigan State University in East Lansing, Michigan, the Michigan State University Museum (MSU Museum) was established in 1857 and is one of the oldest museums in the American Midwest. (Figure 1) According to its mission, the museum "is committed to understanding, interpreting, and respecting natural and cultural diversity through education, exhibitions, research, and the building and stewardship of collections that focus on Michigan and its relationship to the Great Lakes, and the world beyond." The MSU Museum is accredited by the American Alliance of Museums, and, in 2001, became the first in the state to receive Smithsonian affiliate status from the Smithsonian Institution in Washington, D.C., thereby giving the MSU Museum broader access to Smithsonian's cultural and scientific resources.

术、纺织品和服装的馆藏。著名的中国藏品包括近50件19至20世纪初汉族的刺绣丝绸服装和家用纺织品以及228件17到19世纪间的茶壶。最近的中国收藏包括来自云南、贵州、广西的苗族、彝族、白族、侗族、壮族和布依族制造及使用的传统物件和纺织品。（图2）这些材料都伴随有静态和视频影像的记录。

借由强有力、多样化的和易接触的馆藏，田野和收藏品的研究，公共服务和教育课程，在校园内场地的展览，巡回展览以及逐渐增多的数字化启始项目，博物馆得以服

图2 馆员玛丽·沃勒尔正在编目纺织品（黄怡摄，密歇根州立大学博物馆提供）
Figure 2. Museum Staff Marry Worrall is cataloging the textiles.
(Photo by Pearl Wong. Photo courtesy of Michigan State University Museum)

务更广泛而多样的观众。博物馆与其他组织建立了持久的联系，包括密歇根州立大学的 MATRIX：数字人文社会科学中心、曼德拉博物馆（乌姆塔塔，南非）和云南民族博物馆（昆明，中国）。

密州大博物馆也是密歇根州传统艺术计划（MTAP）的基地，与密歇根州艺术和文化事务委员会合作共同维持。目的在于发展并制订计划——"借由密歇根州传统艺术和文化遗产的确认、建档、保存和展示，来增进多样化社会中的跨文化理解"。

The museum is a public steward for approximately one million objects and specimens of cultural and natural history from around the world and includes collections of Chinese decorative and fine arts, textiles and clothing. Notable Chinese collections include nearly 50 embroidered silk 19th- and early 20th-century garments and household textiles from the Han tradition, dating back to 1831 and a tea pot collection, composed of 228 examples made from ceramic, porcelain, metal and stone, dating from the 17th to 19th centuries. More recent Chinese acquisitions include examples of traditional objects and textiles made and used by Miao, Yi, Bai, Dong, Zhuang, and Bouyei peoples from Yunnan, Guizhou and Guangxi. (Figure 2) These materials are accompanied by still and video photographic documentation.

The museum reaches broad and diverse audiences through development of strong, varied, and accessible collections, field- and collections-based research, public service, and education programs, exhibitions at its campus-based facilities, traveling exhibits, and an increasing array of digital initiatives. The museum has enduring relationships with other organizations, including **MSU's MATRIX**: Center for Digital Humanities and Social Sciences, the Nelson Mandela Museum (Mthatha, South

MTAP 工作人员还经常与博物馆界以及美国和世界各地的其他专业同僚见面。他们在本州、美国和国际艺术和非物质文化遗产的政策发展、新博物馆和文化中心的设立，以及学生、传统艺术家、文化专家和管理人员的专业发展和培训机会中扮演了重要的角色。

密州大博物馆采用各种策略来维护、建档、展示、保护和维持传统知识和技艺留给子孙后代。这些措施包括民族志和社区参与的研究、展览、公共课程、扩展馆藏、出版、教育课程、数字资料库和工具、媒体材料、课程开发和公共服务。

经由数百位密歇根州公民的努力，在三个数字文资的记录、保护和教育计划下，密州大博物馆得到了成千上万个关于拼布被子、彩色玻璃窗以及密歇根州谷仓的文档 (http://museum.msu.edu/glqc/mqp.html, www.michiganstainedglass.org, www.michiganbarns.org)。其他正在进行的或将长期进行的计划主要包括密歇根文化传承奖和密歇根州的传统艺术学徒计划 (http://museum.msu.edu/s-program/mh_awards/awardees.htmlandhttp://museum.msu.edu/s-program/mtap/mtaap/awardees.html)。密州大博物馆在 1985 年推出的民俗生活节，演化成一年一度在东兰辛市区举行的大湖民俗艺术节（www.greatlakesfolkfest.net），有来自密歇根州、美国和世界各地极具特色的传统文化活动。

由于一些工作人员在纺织品上的特殊兴趣，有很多研究和展览项目都集中在纺织历史和传统上。其中包括在密歇根州定居的苗族难民的传统纺织物、芬兰裔美国人的拼布地毯制作、密歇根州非裔美国人的拼布制作、南非的拼布历史、拼布和健康、夏威夷原住民、美洲印第安人和阿拉斯加原生社区的拼布制作，目前最新的研究、展览项目是中国的拼布

Africa), and the Yunnan Nationalities Museum (Kunming, China).

The MSU Museum is also the home of the Michigan Traditional Arts Program (MTAP), in partnership with the Michigan Council for Arts and Cultural Affairs, which aims to develop and implement programs "to advance cross-cultural understanding in a diverse society through the identification, documentation, preservation, and presentation of the traditional arts and cultural heritage of the state of Michigan." MTAP staff members have also met regularly with museum and other professional colleagues around the U.S. and the world. They have played key roles in development of state, national, and international arts and intangible cultural heritage policy, new museums and cultural centers, and professional development and training opportunities for students, traditional artists, cultural specialists, and administrators.

The MSU Museum uses a variety of strategies to safeguard, document, collect, present, preserve, and sustain traditional knowledge and artistic skills for future generations. These include ethnographic and community-engaged research, exhibitions, public programming, collection development, publication, educational programs, digital repositories and tools, media materials, curriculum development, and public service. Three digital cultural resources documentation, preservation, and education projects involving hundreds of Michigan citizens have resulted in the documentation thousands of quilts, stained glass windows, and barns in Michigan. [i] Other major ongoing or long-term programs include the Michigan Heritage Awards and the Michigan Traditional Arts Apprenticeship Program. [ii] In 1985, the MSU Museum launched a folklife festival that evolved into the annual Great Lakes Folk Festival (www.greatlakesfolkfest.net), now held in downtown East Lansing, and featuring traditional culture from across Michigan, the United States, and the world.

Because several staff members have had special

布制作。密歇根州立大学博物馆是现在世界上最重要的拼布收藏基地之一。拼布索引（www.quiltindex.org）总部设在密歇根州立大学博物馆，是一个包含超过 75,000 件拼布的图像、数据以及世界各地的公共和私人收藏中关于拼布和其制作者故事的数字储存库。

interests in textiles, a number of research and exhibition projects have focused on textile history and traditions. These have included studies of the traditional textiles of Hmong (Miao) refugees who settled in Michigan, rag rug making of Finnish Americans, African American quiltmaking in Michigan, quilt history of South Africa, quilts and health, the making of quilts in Native Hawaiian, American Indian, and Alaskan Native communities, and now with this project, quiltmaking in China. The MSU Museum is now home to one of the most important collections of quilts in the world. The Quilt Index (www.quiltindex.org)is headquartered at the MSU Museum. The Index is a digital repository of over 75,000 images, data, and stories about quilts and their makers drawn from public and private collections around the world.

胡世德 博士，密歇根州立大学博物馆名誉主任及馆员，密歇根州立大学推广和参与事宜办公室艺术和文化倡议部主任

琳恩·斯旺森 密歇根州立大学博物馆文化收藏品经理

翻译 李凤荣

C. Kurt Dewhurst, Ph.D., Director Emeritus and Curator, MSU Museum and Director of Arts and Cultural Initiatives, University Outreach & Engagement, Michigan State University

Lynne Swanson, Cultural Collections Manager, Michigan State University Museum

Translation: Fengjong Lee

Notes

i For more information, see The Michigan Quilt Project (http://museum.msu.edu/glqc/mqp.html); the Michigan Stained Glass Census (www.michiganstainedglass.org); and Michigan Barn and Farmstead Survey (www.michiganbarns.org), conducted in partnership with the Michigan Barn Preservation Network.

ii For more information on the Michigan Heritage Awards and the Michigan Traditional Arts Apprenticeship program see: http://museum.msu.edu/s-program/mh_awards/awardees.html andhttp://museum.msu.edu/s-program/mtap/mtaap/awardees.html

云南民族博物馆 Yunnan Nationalities Museum

图1 云南民族博物馆外景　　Figure 1. Yunnan Nationalities Museum

云南民族博物馆矗立于风光秀美的昆明滇池国家旅游度假区内，占地面积13.33万平方米，展区建筑面积3万平方米，建筑群整体呈庭院回廊风格，是国家一级博物馆、中国博物馆协会常务理事单位、中国西南博物馆联盟成员，也是中国规模最大的民族类博物馆和亚洲知名的博物馆。（图1）先后被授予全国"科普教育基地"、"民族团结进步教育基地"、云南省"爱国主义教育基地"、省级文明单位以及近40所大、中、小学校"教学、科研、实习基地"。全馆职工88人，由18种民族成分组成，其中21人具有文博高级专业技术职称。

作为一所以保护、弘扬民族文化为己任的博物馆，云南民族博物馆珍藏具有一定历史、科学、艺术价值的民族文物4万余套（件），其中民族服饰类文物为中国品类最齐全；基本陈列有：民族服饰

Yunnan Nationalities Museum (YNM), situated in the beautiful Kunming Dianchi National Tourist Resort, covers an area of 133,300 square meters. Open to the public with a gross floor area of 30,000 square meters, the whole complex is shaped like a cloistered courtyard. As a standing council unit of the Museums Association of China and a member of the Southwest China Museum Association, it is rated as a national first-class museum, the largest nationalities museum in China, and a famous museum in Asia. (Figure 1) Since its inception, it has been successively awarded the titles of "National Popular Science Education Base," "National Unity and Progress Education Base," "Yunnan Patriotism Education Base," and "Provincial Civilized Unit." It serves as a teaching, research and practice base for nearly 40 primary schools, secondary schools, and tertiary institutions. The museum staff team consists of 83 persons from 18 ethnic groups, and includes 21 who hold senior museological titles.

As a museum committed to conserving and promoting ethnic cultures, YNM houses more than 40,000 sets (pieces) of cultural relics of historical, scientific and artistic value, including the most complete collection of ethnic costumes and accessories in China. The core exhibits, open to visitors all year around, cover ethnic clothing, ancient books in the writing systems of ethnic minorities, traditional production and living technologies,

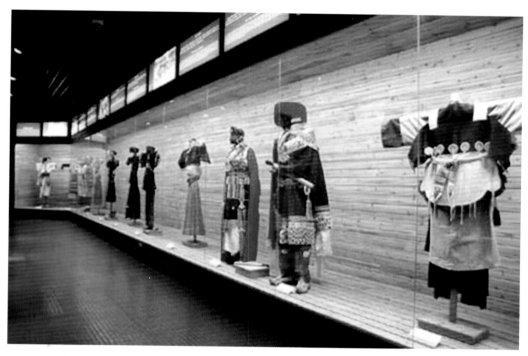

图 2. 云南民族博物馆陈列室　　Figure 2. Yunnan Nationalities Museum exhibition room

ethnic musical instruments, ethnic folk masks, folk roof eave ends, ethnic folk fine arts, and ethnic folk pottery. (Figure 2)

The museum also collaborates with various associations and agencies of minority ethnic groups in Kunming and provides space in the city for ethnic compatriots to gather and celebrate their traditional festivals. The museum's front plaza is famous among ethnic compatriots as the "plaza of festivals," in which they can celebrate their own traditions.

与制作工艺、民族文字古籍、传统生产生活技术、民族乐器、民族民间面具、民族民间瓦当、民族民间美术、民族民间陶艺等，常年向观众免费开放。（图 2）

我们还与云南各少数民族驻昆的同乡会、办事处合作，为他们庆祝民族传统节日的聚会和活动提供场地。我们的广场在旅昆民族同胞之中是出了名的"节日广场"，在这里他们可以欢庆自己的传统节日。

除此以外，我们还致力于促进少数民族文化的对外交流。先后赴法国、芬兰、韩国、越南、泰国、新加坡、美国、日本、俄罗斯、中国香港等地以及北京、上海、南京、杭州、西安、广州、武汉、南宁、合肥、太原、兰州、银川、呼和浩特、鄂尔多斯等地举办了 80 余次专题展览，在国内外引起强烈反响。

The museum is also dedicated to promoting ethnic cultures for external exchange and has been actively exploring cultural exchanges with museum peers both at home and abroad. To date, YNM has staged more than 80 thematic exhibitions in foreign countries as well as in other regions of China, all of which have aroused strong responses.

The museum also focuses on Intangible Cultural Heritage (ICH) research and international cooperation programs, has organized over ten international conferences, and completed more than 20 domestic and international projects. YNM has strong relationships with the Ford Foundation, the Rockefeller Foundation, the American Folklore Society, the Japan Soka Association, the Japan International Cooperation Agency, the

另一方面，我们大力促进ICH项目研究及国际合作，成功组织了10余次国际学术会议，承担和完成了20余项国际国内项目和课题；与美国福特基金会、洛克菲勒基金会、美国民俗学会、日本创价协会、日本国际协力机构、世界银行、亚洲开发银行等国际组织保持良好的合作关系；与厦门华侨博物院缔结友好馆；与韩国国立民俗博物馆、越南民族学博物馆、美中艺术交流中心、美国史密森研究院、美国密歇根州立大学博物馆等建立了长期合作关系和频繁的业务往来，开展多项展览交流、学者互访工作。

云南民族博物馆与一大批云南本土知名艺术家携手，创造性地在馆区开辟了海埂艺术家基地，常年开展各类艺术展览和讲座交流活动，大力传播和弘扬当代民族文化艺术。

通过这些努力，我们将把这座博物馆打造成传承与创新、保护与开发、收藏与交流文化遗产知识的平台。

World Bank, the Asian Development Bank and other international organizations. The museum is a sister museum of the Xiamen Overseas Chinese Museum and maintains long-term partnerships with the National Folk Museum of South Korea, the Vietnam Museum of Ethnology, the US-China Arts Exchange Center, the Smithsonian Institution and the Michigan State University Museum. These partnerships involve frequent exchanges of exhibitions and scholars.

Finally, the museum joined hands with a large number of local artists in Yunnan to start the Haigeng Artist Base, where various art exhibitions and lectures have been organized to promote contemporary ethnic cultures and arts.

Through these efforts, the Yunnan Nationalities Museum aims to serve as a platform of inheritance and innovation as well as protecting and developing, and collecting and communicating cultural heritage knowledge.

杜韵红 云南民族博物馆馆长助理，研究馆员

Du Yunhong, Director Assistant, Professor of Relics and Museology, Yunnan Nationalities Museum

马瑟斯世界文化博物馆

The Mathers Museum of World Cultures

马瑟斯世界文化博物馆（MMWC）成立于1963年，是一所包含人种学、民族学、文化历史学的美国博物馆。作为印第安纳州布卢明顿市印第安纳大学的一部分，本博物馆着重于领域研究，收集和保存体现世界文化广度的物件，举办有益于校园和社区观众的展览和推出公共方案，并提供大学生在许多领域，包括民俗学、人类学、历史学、民族音乐学、图书馆学、资讯科学、及艺术管理上可动手操作的培训。

虽然本馆在其50年的历史内，已经有相当不错的世界纺织品收藏，博物馆最近又获得了一些极为重要的纺织品捐赠，这些都是当前学生、博物馆工作人员和研究合作者的研究重点。玛丽·沃伦馆藏系列（图1）代表着西非时尚的大都会妇女所有的各

The Mathers Museum of World Cultures (MMWC) is an American museum of ethnography, ethnology, and cultural history founded in 1963. A part of Indiana University and located in Bloomington, Indiana, the museum pursues research in its fields, collects and cares for objects representing the breadth of the world's cultures, organizes exhibitions and public programs for the benefit of campus and community audiences, and provides hands-on training for university students in many fields, including folklore studies, anthropology, history, ethnomusicology, library and information science, and arts administration.

While the museum has built a fine collection of world textiles over its five-decade history, the museum has recently received new fabric-focused collections of special importance, and these are already the focus of current research by students, staff, and research

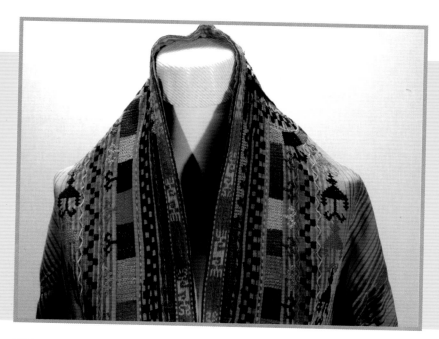

图1 从乌兹别克斯坦拉凯地区来的刺绣的妇女斗篷（paranja），追溯至19世纪末或20世纪初。这件衣服是的马瑟斯世界文化博物馆的迪伊·伯恩鲍姆收藏的一部分。（马修·塞伯摄）

Figure 1. An embroidered woman's cloak (paranja) from the Lakai of Uzbekistan dating to the late 19th or early 20th centuries. This garment is part of the Dee Birnbaum Collection of the Mathers Museum of World Cultures.（Photograph by Matthew Sieber）

式衣服，她们主要是社区领袖和女裁缝等，在美国、加纳和尼日利亚都拥有住房。这套馆藏包含450件衣物构成大约150套服装，此馆藏是研究非洲纺织品、时尚和贸易的独特资源。

迪伊·伯恩鲍姆馆藏系列是另一个MMWC特别关注的有丰富纺织品的馆藏。该系列包括由北非、中东和中亚三个相邻的地区来的2000多件衣服和首饰。该馆藏记录了伊斯兰世界许多族群的服饰传统。和玛丽·沃伦馆藏一样，迪伊·伯恩鲍姆馆藏的相关工作尚在起步阶段。在这样的情况下，博物馆渴望与学者和由来自社区的成员组成的团队进行合作，通过展览、出版、多媒体产品以及项目来更丰富地展现这些馆藏。作为一个大学博物馆，我们设法让大学生和研究生参与这些所有的活动。

MMWC的一个重要部分是印第安纳州传统艺术（TAI），TAI是一个研究和公共项目单位，专门用于记录印第安纳州传统文化并促进大众对这些传统文化的认知。TAI对本州的物质和非物质文化遗产都同样关注，记录了超过200个纺织艺人的作品，这些艺人包括拼布毯织造工迪·尼尔曼、蕾丝制作者露丝·纽豪瑟（图2）及拼布艺人玛克辛·斯托瓦尔。

collaborators. The Mary Warren Collection (Figure 1) represents the extensive wardrobe of a fashionable and cosmopolitan West African woman—community leader and seamstress—whose family maintained homes in the United States, Ghana, and Nigeria. Comprised of 450 garments making about 150 outfits, the collection is proving to be a unique resource for the study of African fabrics, fashion, and trade.

The Dee Birnbaum Collection is another textile-rich collection upon which the MMWC is focusing special attention. The collection is comprised of more than 2,000 pieces of clothing and jewelry from three contiguous regions—North Africa, the Middle East, and Central Asia. The collection documents the dress traditions of many societies from the Islamic world. As with the Mary Warren Collection, work with the Dee Birnbaum Collection is at an early stage. In both cases, the museum aspires to collaborate with teams of scholars and source community members to richly contextualize these collections through exhibitions, publications, media products, and programming. As a university museum, we work to involve undergraduate and graduate students in all of these activities.

A key part of the MMWC is a research and public programming unit called Traditional Arts Indiana (TAI) dedicated to documenting and increasing public

图2 印第安纳州的露丝·纽豪瑟使用被称为"梭织"的技术织造出五颜六色的蕾丝花朵。（乔恩·凯摄，2009年9月24日）
Figure 2. Ruth Neuhouser of Upland, Indiana creates floral-like arrangements from colorful lace flowers that she creates using the technique known as "tatting." （Photograph by Jon Kay. September 24, 2009）

图3 马瑟斯世界文化博物馆2015年"中国西南篮子展"中的一个展示柜（马修·塞伯摄）
Figure 3. A display case in the Mathers Museum of World Culture's 2015 exhibition of baskets from southwestern China.
（Photograph by Matthew Sieber）

虽然布料艺术是我们纺织研究工作的一个焦点，篮筐也是另一个MMWC织品的关注点。由于TAI的建档工作，我们最近举办两个篮筐展览："杨柳篮筐制作者威基·格雷伯"展研究了一位具备当代艺术家水准的篮筐制作者和延续家族传统杨柳编筐工匠；另外一个展览"木料作品：橡木条篮具"讲述了在印第安纳州布朗和杰克逊县地区一个渐趋式微的篮具制作传统的历史。另外，MMWC的第三个展览计划主要探讨本州内来自美国南方的土著的各种篮具的做法。该计划也促成了近期以"1973年切诺基工艺"为主题的展览。

MMWC参与了中美间民俗与非物质文化遗产项目，该项目给我们的博物馆带来了很多助益，包括获得举办西南中国拼布展的机会，以及与博学而又

awareness of traditional culture in the state of Indiana. Equally concerned with tangible and intangible cultural heritage from our home state, TAI has documented the work of over 200 textile artists, including rag rug weaver Dee Nierman, lace worker Ruth Neuhouser (Figure 2), and quilter Maxine Stovall.

While fabric arts are a key focus of our textile studies work, basketry comprises another current MMWC textile focus. Documentary work by TAI has recently resulted in two basketry exhibitions. Willow Work: Viki Graber, Basket maker examines the work of a contemporary artist and craftsperson who carries on a family tradition of willow basketry. The other, Working Wood: Oak-Rod Baskets in Indiana, tells the history of a moribund basketry tradition centered in Indiana's Brown and Jackson counties. Further from our home state, a third MMWC project is focused on basketry practices among the Native American nations of the Southern United States. This project has

慷慨的中国博物馆工作伙伴交流，了解云南、贵州、广西等地方及其文化的机会。这些互动促成 MMWC 与广西民族博物馆新的合作，我们共同研究和展示西南地区的篮具制作传统。在过去的两年，MMWC 已经收集了一些代表中国西南劳动人民生产生活中使用的篮具馆藏，并以此为基础在 2015 年举办了"百工之篮——中国西南篮子展"（图3）。

在接触这些纺织品的过程当中，我们想要了解纺织品本身以及制造和使用它们的人，更进一步理解由这些外在形式衍生出的各种复杂的乡土文化。我们对一些基本的问题有着更深远的理论思索。比如，我们希望更深入地理解传承的真正概念，以及在如今社会快速变迁的生活和工作环境下，传承会对哪些社会工作产生影响。与我们中国合作伙伴的对话以及参与在新墨西哥州、贵州、印第安纳州、云南的村庄和小镇的文化交流对我们在这些领域上的研究与努力产生了正面和深远的影响。

杰森·拜尔德·杰克逊 博士，马瑟斯世界文化博物馆馆长和印第安纳大学民俗学副教授

翻译 李凤荣

also produced a recent exhibition titled Cherokee Craft, 1973.

MMWC participation in the China–US Folklore and Intangible Cultural Heritage Project has brought a great many benefits to our museum, including the opportunity to host the Quilts of Southwest China exhibition and to be introduced to the places and cultures of Yunnan, Guizhou, and Guangxi Provinces by our knowledgeable and generous Chinese museum partners. These interactions have already prompted new collaborative projects of the MMWC and the Guangxi Nationalities Museum to research and present information about the basketry traditions of this region. Over the past two years the MMWC has assembled a representative collection of southwestern Chinese work baskets that were presented at our museum in the 2015 exhibition Putting Baskets to Work in Southwestern China(Figure 3).

In all of these textile engagements, we aim to understand the textiles themselves, the people who make and use them, and the varied and complex vernacular cultures out of which these forms arise. We also possess a broad theoretical interest in fundamental questions. We hope, for instance, to better understand what the concept of heritage entails and what social work it is being called upon to do in the rapidly changing social settings in which we live and work. Dialogue with our Chinese partners and joint cultural engagement with them in the villages and small towns of New Mexico, Guizhou, Indiana, and Yunnan has greatly and positively impacted our efforts in all of these domains.

Jason Baird Jackson, Ph.D., Director of the Mathers Museum of World Cultures, and Associate Professor of Folklore, Indiana University.

Translation: Fengjong Lee

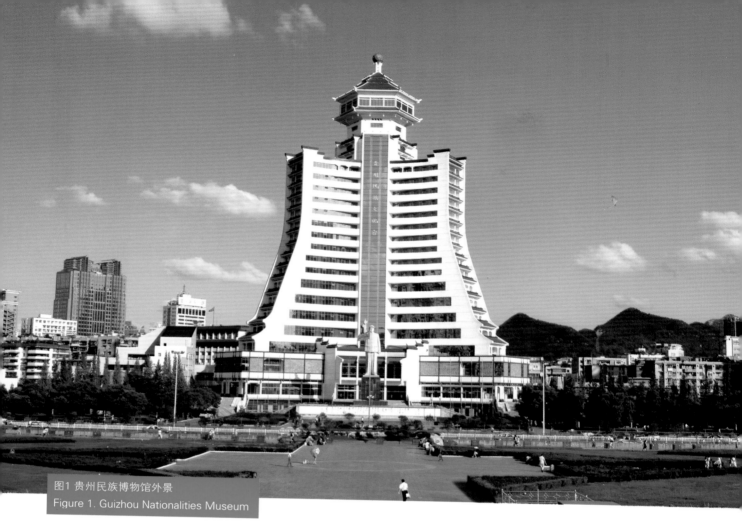

图1 贵州民族博物馆外景
Figure 1. Guizhou Nationalities Museum

贵州省民族博物馆
Guizhou Nationalities Museum

贵州省民族博物馆于 2009 年开馆并实行免费开放，2013 年被评为国家二级博物馆，目前拥有 2 个基本陈列展，即"贵州民族风情展"和"贵州少数民族文物精品展"。（图 1）2014 年，原创展"傩魂神韵——中国傩戏傩面具艺术展"在全国博物馆十大精品陈列评选中荣获十大精品陈列优胜奖。2009 年至今，曾多次赴日本、韩国、美国、土耳其、马来西亚、中国台湾等国家和地区办展，始终致力于宣传展示贵州优秀的民族民间文化，抢救保护贵州丰富多彩的非物质文化遗产。目前我馆以收藏展示贵州及全国部分省区少数民族服饰、生产生活用

Guizhou Nationalities Museum is a second-level nationalities museum that was established in 1984 and opened to the public in 2009.[i] The museum is committed to developing collections and exhibitions of the outstanding ethnic customs and cultures found in Guizhou and to protecting Guizhou's rich and colorful intangible cultural heritage. (Figure 1) The museum has 14,000 cultural items that represent every Chinese ethnic group. Drawing from this abundant collection, the museum has two basic long-term exhibitions: Guizhou Ethnic Customs and Guizhou Ethnic Group Cultural Relics and has held a number of original exhibitions, such as Decorate Beautiful Life—Silver Exhibition of Miao Ethnic Group and Farmer

图 2 贵州民族博物馆陈列室

Figure 2. Guizhou Nationalities Museum exhibition room

Paintings of Guizhou, which have received critical acclaim. The exhibition Leishan Miao Silver and Embroidery Museum of China promoted the development of local intangible cultural heritage. The exhibition, Miao Embroidery, contains 100 items from Miao in Guizhou, Yunnan, and Hunan provinces and explains the history and culture of Miao people. Miao embroidered textiles are famous; they are rich with meaning and require exceptional skills and knowledge to make them. Miao embroidery has been called "music made by needle work" and is listed in the first National Intangible Cultural Heritage Elements. In 2014, a new temporary exhibition organized by the museum, Magical Charm of Nuo Spirit—Chinese Nuo Drama and Mask Art, was selected for a Ten Recognition Exhibitions Award in China.

具为特色和亮点，拥有各类民族文物藏品 1 万 4 千余件套。依托丰富的藏品资源优势，独办或与其他博物馆合办了"饰美人生——苗族银饰展"、"贵州农民画"等 9 个原创展。

其中，与西南联盟成员馆及上海纺织博物馆合作成功开创了"绚彩中华"少数民族服饰系列展，陆续推出"绚彩中华——中国苗族服饰展"、"绚彩中华——中国彝族服饰展"、"绚彩中华——中国侗族服饰展"等，在文博界获得了极高的评价和认可。此外，由我馆独立完成的原创性展览"苗绣"，展示了贵州、云南、湖南等地 100 余幅苗绣精品，再现了苗族的历史与文化，体现了苗族的审美和情感。苗族刺绣以丰富的内涵和技法在我国绣苑独树一帜，被学者称为"用针线凝结的音乐"，列入首批国家级非物质文化遗产名录。（图 2）

贵州省民族博物馆在加强博物馆建设和非物质文化遗产保护上，帮助建设"中国雷山苗族银饰刺

The Guizhou Nationalities Museum has collaborated with other nationalities museums in southwest China as well as with the Shanghai Textile Museum to hold a series of "Colorful China" exhibitions, such as Colorful China—Clothing of Miao Ethnic Group in China, Colorful China—Clothing of Yi Ethnic Group in China, and Colorful China—Clothing of Dong Ethnic Group in China, all of which received very high critical praise. Every two years the museum organizes a Colorful Guizhou–Guizhou Ethnic Photography Exhibition to facilitate the documentation of the traditions, history, and culture of ethnic life. The museum published Historical Data Guizhou Ethnic Culture Serial Documentary, which contains valuable historical films of Miao, Buyi, Dong, Tujia, Yi, Shui, and Gelao peoples; the films document the daily life and religious practices of these groups and clearly show the harmonious relationship these groups have with nature. (Figure 2)

绣博物馆"，推动地方非遗项目发展。每两年举办一次"多彩 de 贵州"——贵州少数民族艺术摄影精品展，以图片的形式来收集记录贵州丰富多彩的民风民俗，展示生活背后的历史与文化。编辑出版了《贵州少数民族风情史料系列片》，涉及苗族、布依族、侗族、土家族、彝族、水族和仡佬族等少数民族在新中国进行民族识别时期的珍贵影像资料，以简朴纪实的形式展现了贵州各族与自然和谐共生的现状及信仰。

此次中国西南部拼布艺术展中美合作项目，是贵州省民族博物首次参与的中美六馆合作项目，我馆工作人员为此进行了大量的田野调查，对最具贵州特色的参展展品进行筛选、甄别、征集、拍摄、研究、撰写文字资料等，在这个过程中，与中美各馆相关业务人员互相沟通交流学习，获益良多。

Since 2009, the Guizhou Nationalities Museum has worked on exhibitions with museums in many other countries, including Japan, Korea, America, Turkey, Malaysia, and Taiwan. The Quilts of Southwest China project is the first collaboration of the Guizhou Nationalities Museum with U.S. museums and other Chinese museums. For this project, Guizhou Nationalities Museum staff participated in museum staff exchanges and planning meetings, conducted fieldwork, produced a video for the exhibition, loaned textiles, and contributed interpretative materials. Through The Quilts of Southwest China project the museum has built new museum professional relationships while simultaneously continuing our commitment to documenting and safeguarding intangible cultural heritage.

高聪 贵州民族博物馆馆长

马丽亚 贵州民族博物馆文物中心馆员

翻译 徐漪

Gao Cong, Director, Guzhou Nationalities Museum
Ma Liya, Curator, Collection Center, Guizhou Nationalities Museum
Translation: Xu Yi

Notes

i Second-level museums are museums at the second place of the national museum categorization based on the size of the museum and its collections and services.

国际民间艺术博物馆

The Museum of International Folk Art

国际民间艺术博物馆 (MOIFA) 拥有来自六大洲和至少 153 个国家超过 15 万件的藏品，是世界上馆藏最大的国际民俗艺术博物馆。本馆成立于 1953 年，是世界上第一个国际民俗艺术博物馆。博物馆的创始人，佛罗伦萨·迪贝尔·巴特利特在目睹了两次世界大战后体认到博物馆有潜力在促进文化理解上扮演积极的角色。巴特利特定下了这样的目标：工匠的艺术作品是世界各国人民之间的黏合剂。现今博物馆的使命是经由促进对传统艺术的了解来展现人类的创造力并塑造一个人性化的世界。

MOIFA 是新墨西哥州的公共博物馆，隶属于文化事务部。它坐落在新墨西哥州首府圣达菲，圣达菲是第一个获得联合国教科文组织指定为创意城市（民俗艺术与设计）的美国城市。作为一个国际民俗生活文化遗产保护的倡导者，博物馆需要一个跨领域的途径为来自世界各地博物馆的工作人员（包括人类学家、民俗学家、艺术史学家、史学家和教育家）及学者提供研究机会的方案。我们的教育部门工作人员给一万个学龄儿童介绍了民俗艺术及其制造者，包括每年在高失学风险的学校举办了一个课后双语介绍课程，课程内容与我们目前的展览、馆藏项目相关的实际操作相关。

博物馆拥有美国规模最大、最完整的民族纺织品及服饰馆藏，其中包括超过 25,000 件平面织品和 10,000 件完整的礼服馆藏，有来自 100 个国家的女装、男装、儿童服装、配饰和动物饰品。美国纺织品学

The Museum of International Folk Art (MOIFA) holds the world's largest international folk art collection of more than 150,000 objects from six continents and over 153 nations. Founded in 1953, the museum was the first international folk art museum in the world. As a witness to two world wars, the museum's founder, Florence Dibell Bartlett, recognized the potential for museums to take an active role in fostering cultural understanding. Bartlett left us with this goal: "The art of the craftsperson is a bond between the peoples of the world." Today the Museum's mission is to foster understanding of the traditional arts to illuminate human creativity and shape a humane world.

The MOIFA is a public museum of the State of New Mexico within the Department of Cultural Affairs. It is located in Santa Fe, the capitol city of New Mexico and the first U.S. city to receive UNESCO's designation as a Creative City (in folk art and design). As an advocate for the preservation of the cultural heritage of folk life internationally, the museum takes an interdisciplinary approach to programs by offering research opportunities to museum staff (comprised of anthropologists, folklorists, art historians, historians and educators) and scholars from around the world. Our education staff brings the world of folk art and their makers to 10,000 school children, including a bilingual after-school program held in at-risk schools each year through hands-on projects that are related to our current exhibitions and collections.

The museum holds the largest and most comprehensive ethnographic textile and dress collection in the U.S. This collection, which consists of over 25,000 flat textiles and 10,000 complete dress ensembles, includes

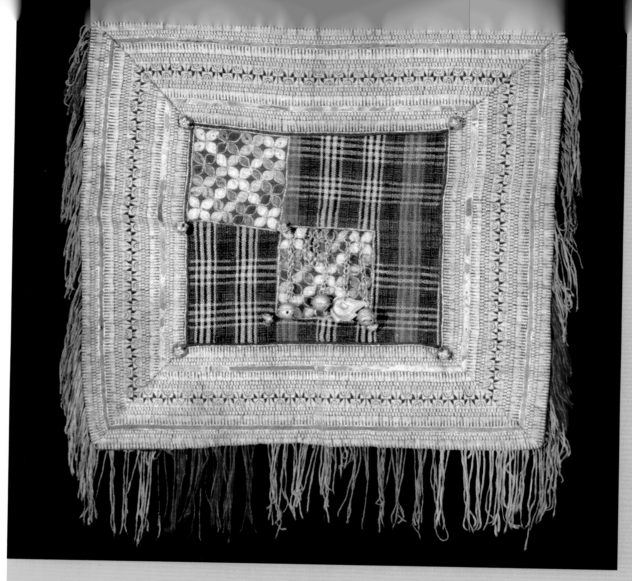

图1 妇女头巾，彝族，中国云南，20世纪，国际民俗艺术博物馆，IFAF收藏
Figure 2. Woman's head cloth, Yi culture, Yunnan, China, 20th c., Museum of International Folk Art, IFAF Collection.

者认为它是世界上前 10 名的纺织品收藏场所。馆藏的特长在于世界上高原住民的纺织品和服装，从南美的安第斯山脉到危地马拉和墨西哥的山区、北非的阿特拉斯山脉、喜马拉雅山脉、欧洲的喀尔巴阡区域和美国西南部的落基山脉。尽管该博物馆的亚洲纺织品收藏重点在南亚（印度、巴基斯坦和孟加拉国），但其也有不凡且极为丰富的亚洲高原馆藏，有来自中国南部、中国西藏、缅甸、不丹、老挝、越南、尼泊尔、阿富汗和乌兹别克斯坦的纺织品。（图1，图2）本博物馆目前正在规划设立一个新的国际纺织品和服饰中心容纳这些馆藏，建立一个纺织品

women's, men's, and children's dress and accessories, plus animal trappings from over 100 countries. Among American textile scholars, it is considered one of the top ten textile collections in the world. Strengths of the collection emphasize the textiles and dress of highland people worldwide, from the South American Andes to the mountainous regions of Guatemala and Mexico, the Atlas mountains of North Africa, the Himalayas, the Carpathian range in Europe, and the Rocky Mountains in the Southwestern U.S. Although the strength of the Asian textile collection is South Asia (India, Pakistan, and Bangladesh), the museum also has an unusual and very rich highland Asian collection, with textiles from

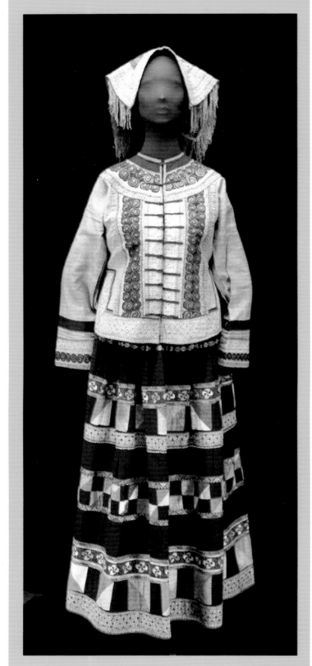

图2 妇女套装，彝族，中国云南，20世纪，国际民俗艺术博物馆，IFAF收藏

Figure 1. Woman's ensemble, Yi culture, Yunnan, China, 20th c., Museum of International Folk Art, IFAF Collection.

保护研究和处理实验室，扩大纺织品科研图书馆和档案馆以及艺术家工作室和教室。

　　在 2010 年成立的 MOIFA 马克·内勒和戴尔·耿意识形态展厅为国际和本地一些现代的传统艺术家提供了一个论坛，探讨他们在 21 世纪所面临的当代

Southern China, Chinese Tibet, Burma, Bhutan, Lao, Vietnam, Nepal, Afghanistan, and Uzbekistan. (Figures 1, 2) The museum is currently in the planning phase to develop a new Center of International Textiles and Dress, which will house this collection, a textile conservation research and treatment lab, an expanded textile research library and archives, and artists' studios and classrooms.

Launched in 2010, the MOIFA's Mark Naylor and Dale Gunn Gallery of Conscience provides a forum for today's traditional artists, both international and local, to examine contemporary social issues that they confront in the 21st Century. With the founding of this gallery, the MOIFA became a member of the International Coalition of Sites of Conscience, a network of sites and initiatives dedicated to the leveraging of power of place by fostering dialogue on contemporary social issues.

The MOIFA regularly participates in two cultural heritage programs, one at the federal level, the National Endowment for the Arts Heritage Fellows program, which recognizes and honors living master traditional artists in the U.S. and one at the state level, the New Mexico Governor's Arts Awards, honoring traditional artists of New Mexico. Two exhibitions at the museum have focused on the work of these master artists. The museum also works closely with the New Mexico Arts Division's State Folk Arts Coordinator.

Each July since 2004, MOIFA hosts the International Folk Art Market right outside the museum's front door, where some 170 master folk artists from over 59 countries congregate to sell their traditional arts to 20,000 shoppers within a 21 hour period. The artists take home 90 percent of their earnings. On the market's stage and inside the museum, gallery talks, workshops, music and dance performances go on throughout the preceding week, International Folk Arts Week, and during the market weekend.

社会问题。这个展厅的成立使 MOIFA 成为意识形态站点国际联盟的一员，网络般的站点和起始计划借由扩大对当代社会问题的对话来平衡区域势力。

本博物馆经常性地参与两项文化传承计划，其中一个为联邦级别的计划，是国家艺术传承研究员基金会计划，此计划用于表彰现存的美国传统艺术大师；另一个则是州级的计划，是新墨西哥州州长艺术奖，用以表彰新墨西哥州的传统艺术家。有两个博物馆的展览专门集中于这些艺术大师的作品。博物馆还与新墨西哥州艺术局的州民俗艺术协调员密切合作。

自 2004 年以来的每年七月，在博物馆的大门外举办国际民俗艺术市场，来自超过 59 个国家的大约 170 个民俗艺术大师聚集此地，展售自己的传统艺术作品，在 21 个小时内可以吸引 20000 个消费者，艺术家们可以获得 90％的收益。在市场开始前一周则是国际民俗艺术周与周末市场，在市集的舞台上及博物馆里面举办一系列的展览讲座、工作坊、音乐和舞蹈表演。

2014 年，世界各地十个国家的领头艺术家发起建立了全球民俗艺术网（GFAN），并从博物馆和民俗艺术市场挑选其工作人员。这个艺术网站的目标是"建立一个共同信念，即相信民俗艺术是一个正向社会变革的催化剂，也是宽容、欣赏、喜悦和尊严的载体；而民俗艺术的价值和民俗艺术家的习性是全球相互理解的工具。" [i]

玛莎.波尔博士 国际民俗艺术博物馆荣誉退休馆长

翻译 李凤荣

In 2014, the Global Folk Arts Network (GFAN) was launched by artist leaders from ten countries throughout the world, and selected staff from the museum and the Folk Art Market. This Network "is founded on a collectively held belief that folk art can be a catalyst for positive social change and is a vehicle for tolerance, appreciation, joy, and dignity; and that the values and traditions of folk art and folk artists are instruments for global understanding." [ii]

Marsha C. Bol, Ph.D., Director Emeritus, Museum of International Folk Art

Translation: Fengjong Lee

注释　Notes

i 全球民俗艺术网成立使命，2014 年 10 月 7 日，圣达菲，新墨西哥州

ii Global Folk Art Network founding mission, October 7, 2014, Santa Fe, NM

广西民族博物馆

Guangxi Museum of Nationalities

图 1 广西民族博物馆　Figure 1. Guangxi Museum of Nationalities

Guangxi Museum of Nationalities (GXMN) is a nonprofit ethnic cultural museum located in Nanning, the capital city of Guangxi Province, China. After six years of preparation and construction, the museum was opened to the public in May 2009. As a provincial ethnographic museum, GXMN collects and cares for objects representing the traditions and cultures of the 12 ethnic groups that have been living on the land for generations, and pursues research, protection, and development of traditional cultures among those who reside in Guangxi. The programs and collections at GXMN represent the richness and diversity of these ethnic cultures. At the same time, the museum's research, collection, and exhibition activities also extend to other parts of China and the world. There are six permanent exhibitions at the museum: Guangxi Ethnic Culture, Bronze Drum Culture, Zhuang Culture, Chinese Ethnic Culture, World Ethnic Culture, and Yesterday Once More—Century-Old Items Exhibition. The museum frequently invites artists to demonstrate and share their skills and stories at the museum with visitors. (Figure 1)

Because the museum is located in the Zhuang autonomous region, GXMN has built a especially

广西民族博物馆位于中国西南广西壮族自治区首府南宁市，是一座公益性的省级专题民族文化博物馆。经过六年的筹备和建设，广西民族博物馆于2009年5月正式对外开放。广西民族博物馆以收藏、研究、保护、展示和传承广西12个世居民族的传统文化为己任，同时也兼顾其他省份和世界各国民族文化的研究、资料收藏和展示。（图1）

民族文化多样性在我们的研究、展览、收藏以及传承活动中得到充分的体现。博物馆常设六个固定陈列展览，分别是：广西民族文化陈列、铜鼓文化展、壮族文化展、中华民族文化展、外国民族文

化藏品陈列和百年老物件展。展厅每月邀请非遗传承人进行现场展演和交流。另外，馆内还设有一个影视厅和一个传习中心。影视厅主要播放广西各地的传统文化和传统工艺纪录片；传习中心是专门为青少年开辟的传统工艺手工制作场所。

广西民族博物馆的馆藏极具地域特色。由于广西地区有大量的壮族人口，馆内壮族文化馆藏丰富，关于其他 11 个广西世居民族文化也有大量的馆藏。又由于广西与东南亚国家海陆相连，广西民族博物馆与东南亚国家的文化交流和交融也在展览和馆藏中得到体现。

纺织品是广西民族博物馆馆藏的重点之一。广西民族博物馆目前馆藏纺织品为 12482 件（套），占藏品总量的 39% 以上。藏品来自广西 12 个世居民族、中国其他地区以及东南亚和非洲等国家和地区。纺织品种类包括民族服饰、织锦刺绣类生活用品、宗教服装、织绣类工艺装饰品等。在民族服饰类馆藏中，壮族、瑶族、苗族和侗族的成套服饰种类较为齐全，特别是瑶族服饰涵盖了中国全境和东南亚各国瑶族服饰的众多款式。除了丰富的馆藏之外，馆内还设有纺织品保护修复实验室，结合传统工艺和现代生物化学技术对受损纺织品进行保护和修复。在研究上，广西民族博物馆的一批专业研究人员从考古学、民族学、人类学、民俗学、纺织工艺史等角度对不同类型的纺织品进行了深入的田野调查和专题研究。

large collection of Zhuang objects and its Southeast Asia collection shows the cultural communication and connection between Guangxi and Southeast Asia countries. In addition, GXNM has ethnic objects from around the world in order to understand other cultures and to compare and contrast similar materials. The GXMN textile collection, with 12,482 items, is especially strong and textiles comprise more than 39 percent of the museum's collections. While primarily focused on textiles from the Guangxi Province, the collection also includes materials from other parts of China, Southeast Asia, Africa and other regions around the world. Included in the collections are ethnic and religious costumes, brocade and embroidered daily items, ornaments and decorations. The museum's holdings of ethnic costumes of regional Zhuang, Yao, Miao, and Dong groups are notably extensive as well as a large collection of Yao costumes from China and Southeast Asia. The textile conservatory conservation lab at GXMN provides an important facility to conduct research and practice on the conservation of textiles with a special emphasis on combining traditional textile techniques with modern biological and chemical scientific methods. The museum research team conducts fieldwork and collects and studies different types of textiles from the perspectives of archaeology, ethnology, anthropology, folklore, and history of textile technology.

GXMN has played an important role in cultural heritage preservation and in museum professional services. One significant project launched by GXMN is the "1+10" project in which GXMN has assisted development of ten ecomuseums in the Guangxi Province. GXMN maintains an ongoing interactive relationship

图2 广西民族博物馆"畅享民歌"活动
Figure 2. Folksong Contest at Guangxi Museum of Nationalities

广西民族博物馆在民族文化遗产保护上的特色之一是其创建的"1+10"模式，即广西民族博物馆和分布于广西各地的 10 家生态博物馆形成整体带动的模式。"1+10"模式在促进社区传统文化记录、保护和传承的同时，也扩展了广西民族博物馆的文化遗产记录、保存和研究空间及平台。

广西民族博物馆还推出两项与文化遗产保护相关的大型活动。一是每两年一届的"广西国际民族志影展"。影展基于广西民族博物馆 10 个生态博物馆的平台，通过培训当地村民、大学生、志愿者，拍摄记录当地居民的传统文化、传统工艺、宗教、生活方式和习俗等，包括以纺织品为主题的纪录片。影展也面向全国乃至国外征集参展影片。这些影片不但存入广西民族博物馆的民族志影像数据库，而

with each of the museums, each of which is devoted to documentation, protection, and development of community traditional culture. Another important and innovative strategy GXMN uses for the documentation and protection of cultural heritage resources involves training members of local communities in ethnographic film techniques. Trained filmmakers now enthusiastically use cameras to document the daily life and traditions of their ethnic groups. Selected ethnographic films are screened in the biannual Guangxi International Ethnographic Film Festival. A digital repository has been built to store the ethnographic films and museum visitors get to know more about ethnic cultural heritage through the films produced by local people. The museum also organizes a folksong contest every two years for folksong singers to perform on stage and to promote folksongs among the public. (Figure 2)

且在广西民族博物馆的影像厅放映，让更广泛的观众群体通过这些纪录片了解民族文化遗产。二是每两年一次的"畅享民歌"活动。广西各地不同民族的原生态民歌，在广西民族博物馆的舞台上得到自信和充分的展示。此项活动，让流传千百年但正在消逝的民间民歌得到社会和公众的认知。（图2）

此次中国西南拼布展中美合作项目既是广西民族博物馆与参与此次项目的中美博物馆合作的延续，也是一次合作的全面拓展。在2013年初广西民族博物馆便与美方合作推出了"化零为整——21世纪美国拼布作品展"，展出了美国的25位拼布制作者制作的25幅来自美国不同文化和区域社群的拼布作品。在这次的"中国西南拼布展"的筹备过程中，广西民族博物馆研究一部和研究二部的工作人员参与了参展拼布的征集、纪录片拍摄、文字解读等大量工作，在业务上与美方工作人员进行了充分的沟通交流，在专业研究上也通过学术会议和学术文章的撰写得到学习和提升。在"中国西南拼布展"策展期间，广西民族博物馆基于民间拼布收藏爱好者提供的拼布举办了"百衲——壮族拼布被面艺术展"，并且邀请了壮族拼布艺人黄碧瑜到展厅进行展演并与观众进行现场交流。黄碧瑜是我们此次"中国西南拼布展"借展拼布的制作者之一，也是展览短片的主角之一。广西民族博物馆拼布展与美国巡展的"中国西南拼布展"遥相呼应，同时也说明了大洋两岸的人民对拼布这种文化遗产共同的重视和热爱。

In addition to showcasing ongoing displays of textiles, the GXMN was a host site in 2013 of the exhibition The Sum of Many Parts: 25 Quiltmakers in 21st-Century America. GXMN staff participated in the planning, collecting, video production, and interpretation of the Quilts of Southwest China exhibition, as well as contributed articles to and coordinated the companion publication project. GXMN also sent delegates to the September 2015 opening of the Quilts of Southwest China at Michigan State University Museum, and GXMN staff participated in museum-to-museum staff exchanges with U.S. museums involved in the project. The interest in Chinese quilts at GXMN has grown. In the fall of 2015 GXMN mounted a temporary Zhuang Patchwork Art Exhibition that included textiles loaned by a private collector in China. Zhuang quilt artist Huang Biyu demonstrated her art for visitors in the exhibition hall and made one quilt for the Quilts of Southwest China exhibition. GXMN staff created a video on Huang Biyu that is shown in the exhibition and becomes part of the documentary record of her work. The Zhuang Patchwork Art Exhibition at GXMN and the Quilts of Southwest China exhibition in the U.S. are not coincidences, but excellent demonstrations of the common interest in quilts as a form of traditional cultural heritage on both sides of the Pacific Ocean.

王頠 博士，广西民族博物馆馆长
张丽君 博士，广西民族博物馆研究二部馆员

Wang Wei, Ph.D., Director, Guangxi Museum of Nationalities

Lijun Zhang, Ph.D., Research Curator, Guangxi Museum of Nationalities

那不拉斯卡大学林肯分校国际拼布研究中心与博物馆

International Quilt Study Center & Museum, University of Nebraska-Lincoln

国际拼布研究中心与博物馆（IQSCM）拥有世界上最大的公共拼布馆藏。该机构于 1997 年在那不拉斯卡大学林肯分校成立，并于 2008 年开放了博物馆。这座环保型的博物馆设立经费来自个人，馆内拥有来自世界上大约 50 个国家的 4500 多件拼布藏品，这些拼布中最古老的有 400 年的历史。本馆还兼具艺术研究、收藏和展览等功能。博物馆通过优秀的展览来启迪大众对拼布文化和艺术重要性的认识。与其他艺术传统一样，拼布帮助社会建立联系，这些联系可以带来惊喜、启发和愉悦。对于那些可以通过拼布作品进行自省的人来说，他们收获的不仅是拼布知识，同时也提升了对自我的认识。

IQSCM 的两大主要任务是建立国际拼布馆藏和保护作为非物质文化遗产的拼布制作技艺。拼布制作是代代相传的艺术形式，因此它代表了我们日常生活中最基本的层面。为后代保存拼布制作知识并与新的群体分享这些知识是我们的重要职责。

因此，当我们在中国征集拼布和拼布被面时，我们力图寻找能够代表这种技艺的根的古老拼布。但与此同时我们也从当代艺人那里购买拼布，比如陕西小村庄里为旅游市场制作的拼布。同样的，在我们 2010 年举办的南亚拼布展中，我们也邀请了印度古吉拉特邦一个小地方的艺人来展示他们当下的拼布制作技艺。几乎每个周末我们都会在博物馆里让当地拼布艺人和我们的观众一起制作拼布并分享拼布技艺。

The International Quilt Study Center & Museum at Quilt House (IQSCM) is home to the world's largest publicly held quilt collection. Established in 1997 at the University of Nebraska-Lincoln, the center opened its museum in 2008. The privately-funded, environmentally sustainable museum houses more than 4,500 quilts, representing four centuries and almost 50 countries. It also features state-of-the-art research and storage space and spacious galleries. The museum strives to inspire an understanding of the cultural and artistic significance of quilts through thoughtful and robust exhibitions. Like other artistic traditions, quilts help societies make connections that surprise, provoke, gratify and delight. Those who open themselves to these works for the introspection that quilts promote, stand to gain knowledge not only about the world of quilts, but about themselves.

While building a comprehensive international collection is one of our primary goals, preserving quiltmaking as a form of Intangible Cultural Heritage is a twin priority at the IQSCM. Quiltmaking is an art form that has generally been passed down from person to person and it therefore represents fundamental aspects of daily life within each culture that practices it. Saving that knowledge for future generations and sharing it with new audiences is important to us.

Thus, when we collect quilts and quilt covers from China, we look for antique pieces that represent the craft's roots, but we also visit with and acquire from contemporary makers, for instance, women in small Shaanxi Province villages who sew items for the tourist market. Similarly, when we presented a large exhibition of South Asian quilts in 2010, we also invited artisans from

艺人和拼布老师经常来做演讲和开工作坊，馆里的员工也通过展览讲解、讲座和我们资源丰富的网站（www.quiltstudy.org）来与观众分享我们的研究成果。当学者对我们的馆藏拼布进行研究时，我们也很重视这些合作项目，比如中国西南拼布项目和与拼布联盟合作的口述史纪录（www.quiltalliance.org）。对于我们来说，拼布作品、拼布艺人和拼布制作技艺缺一不可，它们对于拼布这种国际非物质文化遗产的保护同等重要。

莱斯利·C.勒维 那不拉斯卡大学林肯分校国际拼布研究中心与博物馆执行馆长

翻译 张丽君

a small community in Gujarat, India to demonstrate the craft as they currently practice it. Nearly every weekend, we host our valued local and regional quiltmakers just outside our galleries who work together and share their projects and skills with museum guests.

Visiting artists and quilt teachers regularly present lectures and workshops at Quilt House and our own staff shares its discoveries with as broad an audience as possible—through on-site gallery talks, guest lectures, and our resource-rich website [www.quiltstudy.org]. Likewise, when scholars study and work with the quilts in our collection, their collective knowledge is shared through their publications, research, and public appearances. We also value collaborative projects, such as "Quilts of Southwestern China" with the Michigan State University Museum and oral history documentation efforts with the Quilt Alliance [www.quiltalliance.org]. For us, quilts, quiltmakers and quiltmaking are all of a piece; every aspect needs to be valued in order to preserve this important form of global Intangible Cultural Heritage.

Leslie C. Levy, Ardis & Robert James Executive Director, International Quilt Study Center & Museum University of Nebraska-Lincoln

Translation：Lijun Zhang

中国西南少数民族拼布纹样设计

Design Motifs of Ethnic Quilts in Southwest China

龙: 龙象征着权贵。在苗族关于他们族源的故事中,龙是由蝴蝶妈妈生的蛋中孵化出来的。

Dragon: Dragon Symbolizes power and nobility. In Miao stories of the beginning history of their ethnic group, dragons hatch from butterfly eggs.

凤凰: 在中国民间艺术中,凤凰象征着品德、地位和优雅。凤凰和牡丹图案代表着地位和财富。

Phoenix: In Chinese folk art, a phoenix symbolizes high virtue, status, and grace. When a phoenix is depicted with peony flowers, the design represents status and wealth.

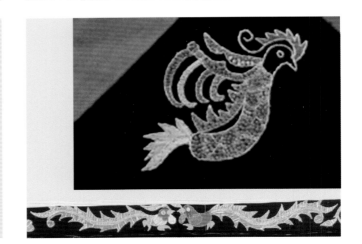

蝴蝶: 蝴蝶纹在西南少数民族绣品上经常出现,一般多与花卉组成主题纹样,表现蝶恋花的意境,象征着爱和对美好生活的向往。

Butterfly: Butterfly designs are commonly seen in ethnic embroidery in Southwest China. A design of a butterfly with flowers symbolizes love and the beauty of life.

蛙：中国西南民间艺术作品中会出现青蛙的图案。青蛙代表着繁殖力。壮族人又把青蛙称为蚂拐，是掌管风雨的神。

Frog: In Southwest China, frogs are a symbol of fertility and frog images are often found in art. Zhuang people regard frog as the god who is in charge of rain.

鱼：鱼与"余"谐音，代表富裕。中国道教中两条鱼相互环绕象征着两股相反但是互补的力量。

Fish: Fish in Chinese is a homophone with another character "yu", meaning "abundance." In the art of the Chinese Daoist religion, the motif of two fish circling each other represents two opposite but complementary and continuing forces.

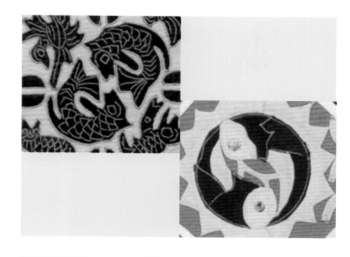

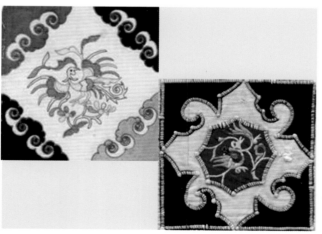

花鸟：花鸟纹在西南少数民族的拼布艺术中很常见，代表着人们对幸福美好的向往。

Birds and Flowers: Birds and flowers are common seen in quilting arts in Southwest China. It represents beauty and happiness.

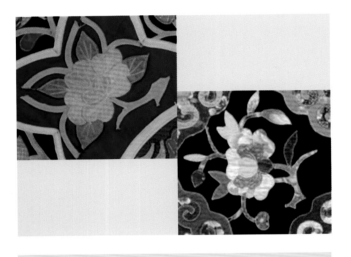

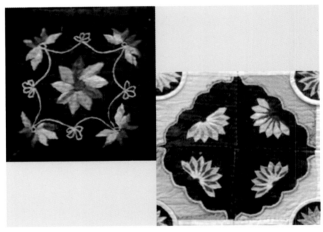

牡丹：牡丹代表着地位、财富和荣耀。作为"花中皇后"的牡丹是中国的国花。

Peony: Peony symbolizes rank, wealth, and honor. Thought to be the "Queen of Flowers," the peony is Chinese official flower.

莲花：莲花代表着纯洁，因为它出淤泥而不染。莲花也是中国佛教艺术中的重要元素。

Lotus: The lotus is believed to represent purity because it sprouts out of muddy ponds without any trace of dirt. The lotus is also an important element in Chinese Buddhist religious art.

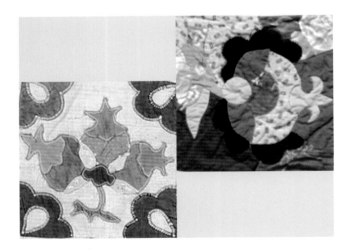

石榴：石榴因为籽多被认为是多产的象征，代表着多子多孙。

Pomegranate: Pomegranate connotes abundance due to the fruit's plentiful seeds. It symbolizes fertility.

狗牙：壮族人认为狗牙有驱邪魔保平安的作用。人们把狗牙或狗毛放到小孩的枕头下辟邪。

Dog's Teeth: Zhuang people believe that dog's teeth can ward off evil. Zhuang people sometimes put dog's teeth or hair under the pillow on their children's beds to keep bad spirits away from their children.

花楼：花楼图案代表着隆林当地壮族居住的干栏式木楼，里面的五色条纹代表壮族生活的环境和生命的延续，是壮族人对家庭家族的精神寄托。

Flower Building: This design, called flower building, represents the style of buildings constructed on stilts in Zhuang communities in Longlin County, Guangxi Province. The stripes in the center of this design also symbolize the local environment, the continuation of life, and family.

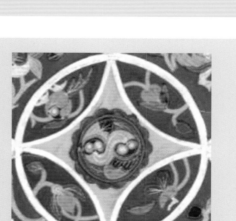

绣球：绣球是壮族的标志之一，代表着爱情和吉祥。

Silk Ball: Silk balls are a symbol of the Zhuang ethnicity. Silk ball represents love and good luck.

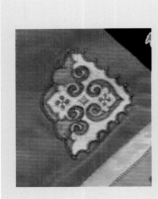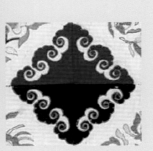

如意：如意是具有流线型手柄的器物。图片中的设计模仿如意的形状。如意象征着吉祥和梦想成真。

Ruyi: A ruyi is a ceremonial object with a curved handle. Ruyi represents having good luck or having your wishes granted.

寿：壮族经常使用寿字纹这种汉族传统纹饰，当地人在帽子、背带上也常绣有这个图案，它寓意着福寿安康之意。

Longevity: Zhuang people appropriated the Chinese character "寿" which means longevity from Han culture and often use the symbol as decorations on their hats and baby carriers.

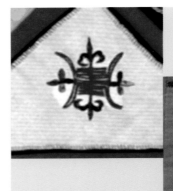

铜钱：古代的铜钱图案代表着财富。

Coin: The design represents of a coin symbolizes prosperity.

中国西南拼布作品

Gallery of Quilts and
Related Items from
Southwest China

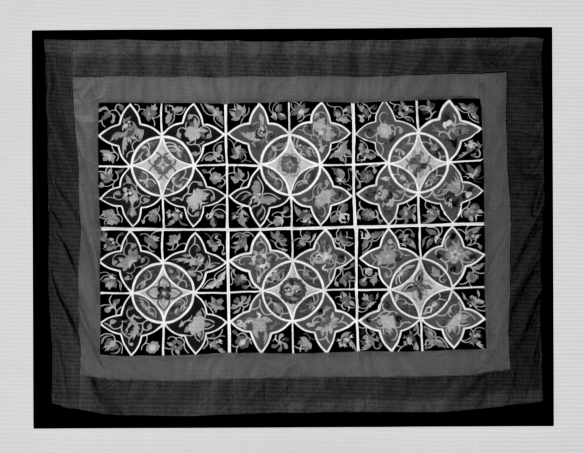

广西天峨壮族拼布被面

韦国娥，韦国芬
20 世纪 90 年代年代
221×170cm
中国广西河池市天峨县六排镇
棉，丝
手工贴布，手工拼布，手工加机器缝制
广西民族博物馆从制作艺人处购买

该被面为一对姐妹制作。被面的黑色底布
为纯手工制作棉布，也是由这对姐妹亲自纺织
和染色而成。被面中心由 6 个大小形状相同的
方形布块组成，每个布块上用布块拼接成各种
花蝶鸟虫的图案，每个布块中心的圆形代表了
壮族的吉祥物绣球，这些图案都取材于她们日
常生活中接触的植物和动物，象征着她们对美
好生活的向往与憧憬。

Bedcover

Wei Guoer and Wei Guofeng
c. 1990s
87" × 67"
Liupai Town, Hechi City, Tianer County,
Guangxi Province, China
Cotton, silk
Hand piecing, foundation piecing, hand
appliqué, machine sewing
Collection of the Guangxi Nationalities Museum,
acquired by purchase from artist

Two sisters made this bedcover top and also
hand wove and dyed the black cotton fabric used
in the quilt. The top is pieced with six square cloth
blocks of the same size. The central images on
each block are silk balls, a symbol of the Zhuang
ethnicity. Each block also has appliquéd images of
flowers, butterflies, birds, and insects familiar to the
Zhuang people in their daily life.

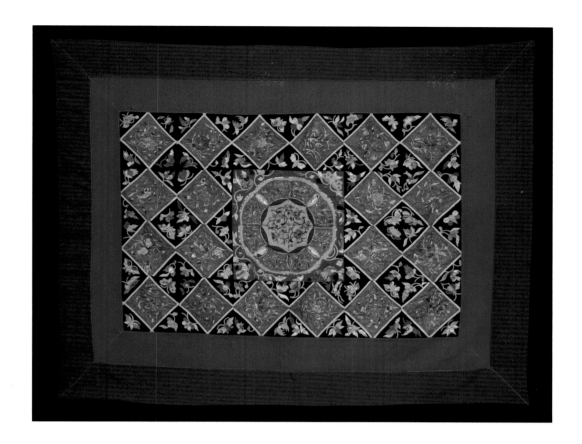

广西天峨壮族刺绣拼布被面

莫爱群

壮族

20 世纪 70 年代

215×150cm

中国广西河池市天峨县六排镇

棉，丝

剪纸，手工贴布，手工拼布，手工刺绣，手工
加机器缝制

广西民族博物馆从制作艺人处购买

该被面为莫爱群年轻时为自己新婚所作。被面
中心由 24 个大小形状相同的方形布块组成，每个布
块上用丝线绣制或碎布拼制出不同的花纹图案，多
为花蝶鸟虫，壮族人有着花神崇拜，绣满被面的各
种花朵象征着花神的怀抱和祝福。被面的黑色底布
为纯手工制作棉布，为艺人年轻时亲自纺织和染色
而成。

Bedcover

Mo Aiqun

Zhuang

c. 1970s

84–3/5" × 59"

Liupai Town, Hechi City, Tianer County, Guangxi Province, China

Cotton, silk

Hand piecing, foundation piecing, hand appliqué, embroidery, machine sewing

Collection of the Guangxi Nationalities Museum, acquired by purchase from artist

When Mo Aiqun was young, she made this textile for her own marriage. The top of the bedcover is appliquéd with 24 square cloth pieces. Each piece is further appliquéd or embroidered with designs, including flowers, butterflies, birds, and insects. Zhuang people worship the flower god and the flowers on the quilt top symbolize the blessing of the flower god. The black cotton fabric used as the foundation or background of the blocks was woven and dyed by the artist.

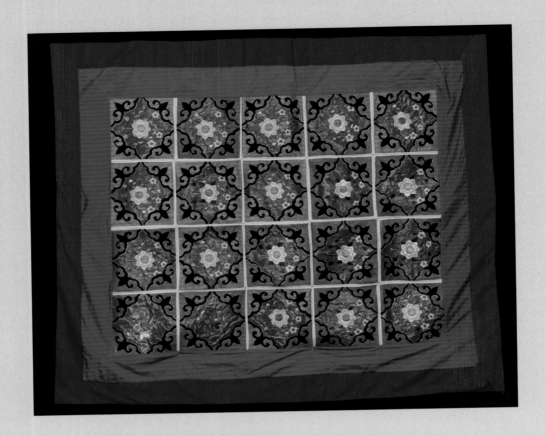

广西天峨壮族刺绣太阳花拼布被面

莫爱群
壮族
2010 年后
200×155cm
中国广西河池市天峨县六排镇
棉，丝
剪纸，手工贴布，手工拼布，手工刺绣，
手工加机器缝制
广西民族博物馆从制作艺人处购买

该展品被面中心由 20 个大小形状相同的方
形布块组成，其中 18 块布块图案皆为刺绣向日
葵花，另外两块分别为刺绣公鸡与蝶恋花图案，
象征着生命的美好与对生活的祝福。被面的黑
色底布为纯手工制作棉布，由莫爱群的母亲亲
自纺织和染色，整幅被面耗时一年时间完成。

Bedcover

Mo Aiqun
Zhuang
c. 2010s
78-7/10" × 61"
Liupai Town, Hechi City, Tianer County,
Guangxi Province, China
Cotton, silk
Paper cutting, hand piecing, foundation piecing,
hand appliqué, embroidery, machine sewing
Collection of the Guangxi Nationalities Museum,
acquired by purchase from artist

The top of the bedcover is appliquéd with 20
cloth squares that have additional appliquéd and
embroidered designs. Sunflowers are embroidered on
18 of the blocks and embroidered on the other two
blocks are a cock and butterfly on flower designs.
The designs symbolize the beauty and hope in life.
Mo Aiqun's mother hand wove and dyed the cotton
fabric used for the foundation or backing. It took Mo
Aiqun a year to make this bedcover.

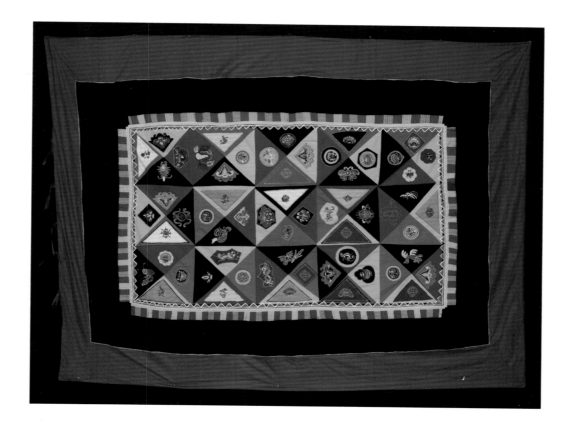

广西隆林壮族三角刺绣拼布被面

黄碧瑜
壮族
2010 年后
200×155cm
中国广西百色市隆林县新州镇
棉，丝
剪纸，手工贴布，手工拼布，手工刺绣，手工
加机器缝制
广西民族博物馆从制作艺人黄碧瑜处购买

该被面中心由 60 个大小形状相近的三角形布块
组成，每个三角布块上用丝线绣制或碎布拼制出不
同的花纹图案，这些图案包括蜈蚣、蝴蝶、狗牙和
花楼（代表着壮族地区的吊干栏式建筑）。

Bedcover

Huang Biyu
Zhuang
c. 2010s
78−7/10″ × 59″
Xinzhou, Longlin County, Baise City, Guangxi
Province, China
Cotton, silk
Paper cutting, hand piecing, foundation piecing,
hand appliqué, embroidery, machine sewing
Collection of the Guangxi Nationalities Museum,
acquired by purchase from artist

60 triangle-shaped pieces form the top of this
bedcover. Embroidered designs on the triangles include
representations of centipedes, butterflies, dog's teeth,
and flower building (referring to the style of buildings
constructed on stilts in Zhuang communities in this
region).

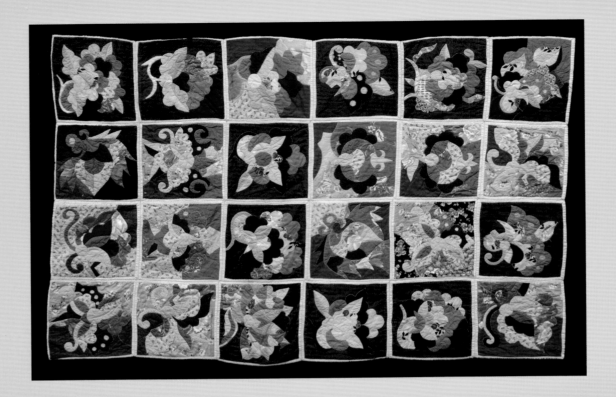

拼布被面

制作艺人未知

布依族或壮族（推测）

20 世纪中期

150×202.5cm

中国贵州南部或广西北部（推测）

棉、丝、蓝靛粗布、印染斜纹布

底布贴花、手工贴花、手工缝制

密西根州立大学博物馆馆藏，由密西根州立大学研究与研究生学习副校长办公室提供的资金购于新墨西哥州圣塔菲纺织珍品店。

　　这床拼布被面的基础图案由方形布片拼接而成。方形布片上用贴花绣的绣法呈现蝴蝶、秃头鸟以及牡丹和莲花等各种花朵。蝴蝶在花丛中翩翩起舞的图案在苗族艺术中很常见，并常用来表示求爱的行为。

Bedcover

Artist name unknown

Probably Buyi (Bouyei), possibly Zhuang

Mid 20th century

59" × 79-3/4"

Likely southern Guizhou Province or northern Guangxi Province, China

Cotton, silk, coarse indigo, printed twill

Foundation appliqué, hand appliqué, hand piecing

Collection of the Michigan State University Museum, acquired by purchase from Textile Treasures with support from the MSU Foundation through the Office of Vice-President for Research and Graduate Studies

This bedcover top features a basic pattern of blocks appliquéd with butterflies, two birds with heads with no feathers, and various flowers such as peonies and lotus. A design with butterflies flying among flowers is common in Miao art and is often used on items associated with courtship practices.

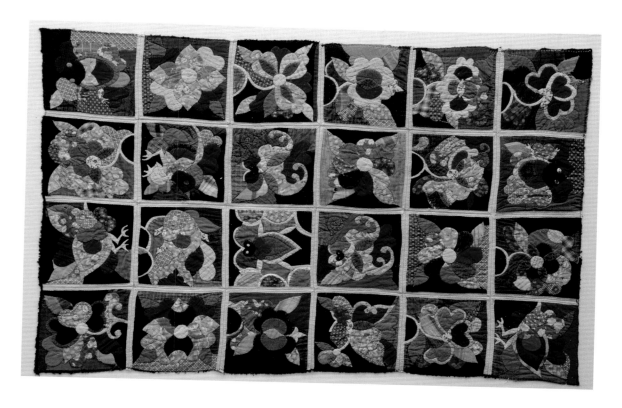

拼布被面

制作艺人未知

布依族或壮族（推测）

1930 年

86×132cm

中国贵州南部或广西北部（推测）

棉、灯芯绒、印染斜纹布、手工织布

底布贴花、手工贴花、手工缝制

密西根州立大学博物馆馆藏，由密西根州立大学研究与研究生学习副校长办公室提供的资金购于新墨西哥州圣塔菲纺织珍品店。

此拼布被面的贴布图案有鸟、花、昆虫、鱼和两只青蛙。青蛙的图案在中国艺术中很常见，是繁殖力的象征。在一些主要依赖农业经济的少数民族地区，青蛙有时候在仪式中用于求雨。

这床拼布被面的图案包括了两个中国最古老的民间艺术母题：公鸡和鱼。在中国人们认为公鸡有辟邪的作用，所以小孩使用的物品上经常有公鸡图案。鱼则代表着幸福与好运。

Bedcover

Artist name unknown

Likely Buyi (Bouyei) or Zhuang

c. 1930

34" × 52"

Likely southern Guizhou Province or northern Guangxi Province, China

Cotton, corduroy, printed twill, wovens

Foundation appliqué, hand appliqué, hand piecing

Collection of the Michigan State University Museum, acquired by purchase from Textile Treasures with support from the MSU Foundation through the Office of Vice-President for Research and Graduate Studies

Appliquéd on the blocks of this bedcover are birds, flowers, insects, fish, and two frogs. Frogs are a symbol of fertility and frog images are often found in Chinese art. In minority communities with a local economy heavily dependent on agriculture, the frog is sometimes used in rituals intended to bring rain to communities.

The textile also includes two of China's oldest folk art motifs, a young rooster and a fish. Young roosters are believed by many Chinese to ward off evil spirits so images of roosters are often featured in items associated with children. The fish symbolizes happiness and good fortune.

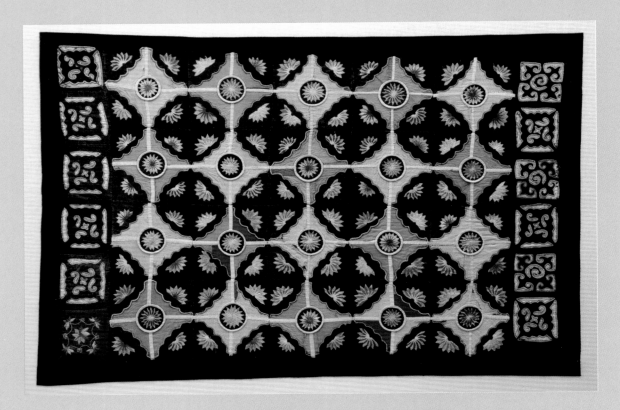

拼布被面

制作艺人未知
布依族
20 世纪后半期
101.6×152.4cm
中国贵州
棉、斜纹布
底布贴花、手工缝制、刺绣

密西根州立大学博物馆馆藏，由密西根州立大学研究与研究生学习副校长办公室提供的资金购于新墨西哥州圣塔菲纺织珍品店。

拼布被面上 20 个方块布片上的刺绣图案代表着菊花（或与菊花类似的花朵）。中国汉族和少数民族艺术中经常使用菊花图案。

Bedcover

Artist name unknown
Buyi (Bouyei)
Second half 20th century
40" × 60"
Guizhou Province, China
Cotton, twill
Foundation appliqué, hand piecing, embroidery
Collection of the Michigan State University Museum, acquired by purchase from Textile Treasures with support from the MSU Foundation through the Office of Vice-President for Research and Graduate Studies

Twenty of the blocks in this top feature an embroidered design representing a portion or all of a chrysanthemum (or similar flower). Chrysanthemums are often depicted in Chinese Han and some minority ethnic art.

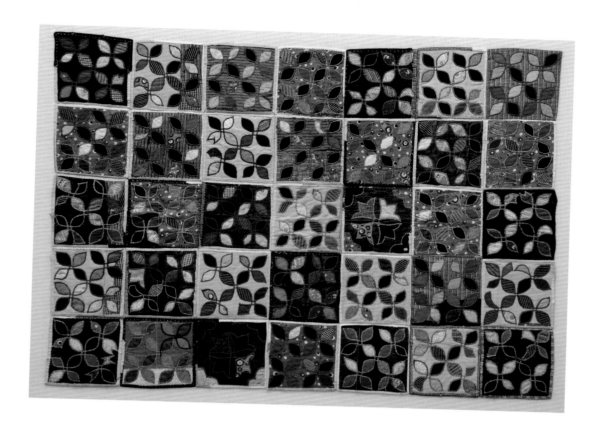

拼布被面

制作艺人未知

布依族、苗族或壮族

1930—1940 年

92.7×129.5cm

中国贵州南部或广西北部

棉、丝、缎、羊毛

底布贴花、手工贴花、手工缝制

密西根州立大学博物馆馆藏，由密西根州立大学研究与研究生学习副校长办公室提供的资金购于新墨西哥州圣塔菲纺织珍品店。

被面上的图案由四片贴布叶子构成。贵州少数民族的蓝靛染中也经常使用这种图案。

此拼布被面底布上的一张卡片称这床拼布为"婚礼被面"。被面正面的布料既有手工织的，也有机器织的。

Bedcover

Artist name unknown

Buyi (Bouyei), Miao, or Zhuang

c. 1930—1940

36–1/2" × 51"

Southern Guizhou Province or northern Guangxi Province, China

Cotton, silk, satin, wool

Foundation appliqué, hand appliqué, hand piecing

Collection of the Michigan State University Museum, acquired by purchase from Textile Treasures with support from the MSU Foundation through the Office of Vice-President for Research and Graduate Studies

Four leaves are appliquéd onto most of the blocks on this top. Guizhou minority artists use a similar pattern in their indigo blue tie-dyed textiles.

A card attached to the back of the textile called this a "wedding quilt top." The top includes both hand-woven and commercially produced fabrics.

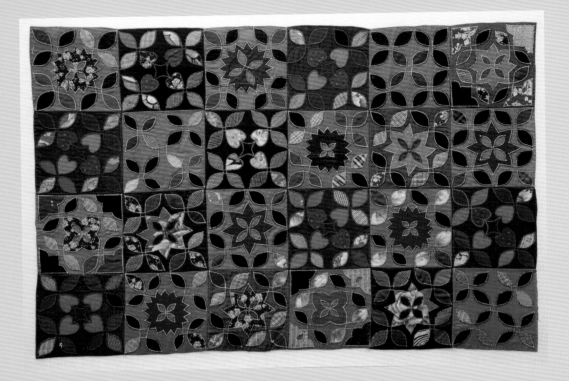

拼布被面

制作艺人未知

布依族、苗族或壮族

1950 年

91.4×137.2cm

中国贵州南部或广西北部

棉、粗斜纹布

底布贴花、手工贴花、手工缝制

密西根州立大学博物馆馆藏，由密西根州立大学研究与研究生学习副校长办公室提供的资金购于新墨西哥州圣塔菲纺织珍品店。

方形布片上的图案有树叶、心形图案和星星。贴花的小布片有些是没有图案的，有些是印染过图案的，有些看起来是从家里的其他物品上剪下来的小布条。被面上的一些图案是包含了四片叶子图案的太阳纹或星星纹。附在被面上的卡片称此被面为"苗族/布依族，婚礼被面"。

Bedcover

Artist name unknown

Buyi (Bouyei), Miao, or Zhuang

c. 1950

36" × 54"

Southern Guizhou Province or northern Guangxi Province, China

Cotton, denim

Foundation appliqué, hand appliqué, hand piecing

Collection of the Michigan State University Museum, acquired by purchase from Textile Treasures with support from the MSU Foundation through the Office of Vice-President for Research and Graduate Studies

Each block features leaves, hearts, and stars appliquéd of solid and print fabrics some of which appear to be scraps of cloth from other home textiles. Some blocks have sun or star shapes with the four-leaf pattern inside. Written on a card attached to the textile was "Miao/Bouyei, Wedding Quilt top".

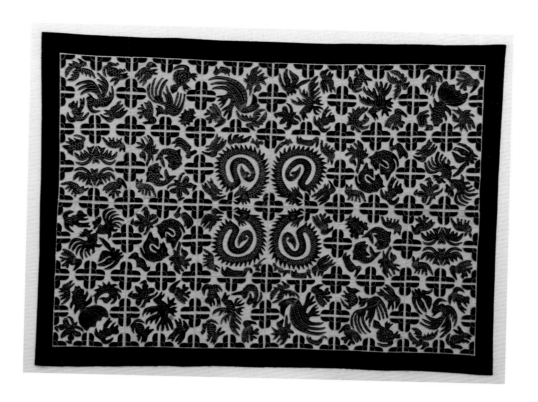

拼布被面

制作艺人未知

苗族

101×135.3cm

中国贵州黔东南苗族侗族自治州黄平县

棉

底布贴花、手工缝制

密西根州立大学博物馆馆藏，由密西根州立大学研究与研究生学习副校长办公室提供的资金购于新墨西哥州圣塔菲纺织珍品店。

此拼布被面上的图案有乌龟、猫、兔子、各种鱼和鸟、三片翅膀的昆虫、蝴蝶和三片花瓣或四片花瓣的小花朵。被面中间是四条背部有刺的卷曲的蛇。带刺的蛇形图案在中国陕西省的传统剪纸中很常见。乌龟代表着长寿。两条相互环绕的鱼代表着中国道教中的阴和阳，是两股互补并且源源不断的力量。

Bedcover

Artist name unknown

Miao

39–3/4" × 53–1/4"

Huangping County, Qiandongnan Miao and Dong Autonomous Prefecture, Guizhou Province, China

Cotton

Hand piecing, hand appliqué

Collection of the Michigan State University Museum, acquired by purchase from Textile Treasures with support from the MSU Foundation through the Office of Vice-President for Research and Graduate Studies

This textile includes depictions of a tortoise, cats, a hare (or rabbit), various fish and birds, three-winged insects, butterflies and tiny three and four-petal flowers. Four large spiked-back, coiled serpents form the visual center of this textile. The spiked-back serpent appears in other Chinese folk art, chiefly the traditional paper cutting of Shaanxi province. The tortoise is associated with longevity or a long life. The design of two fish circling each other motif reflects the yin and yang symbol used in the art of the Chinese Daoist religion; the symbol represents two opposite but complementary and continuing forces.

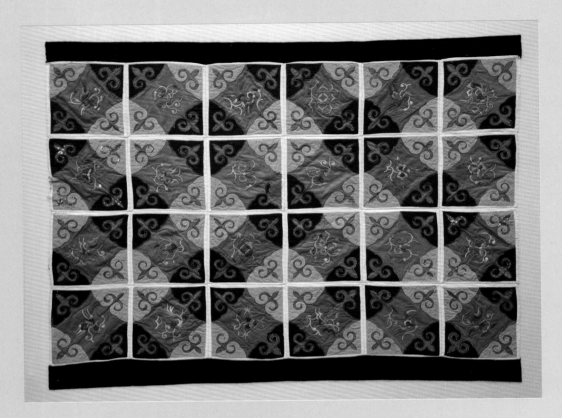

拼布被面

制作艺人未知

壮族（推测）

中国广西北部

20 世纪中期

99.1×115.6cm

棉

底布贴花、机器贴花、手工缝制、刺绣

密西根州立大学博物馆馆藏，由密西根州立大学研究与研究生学习副校长办公室提供的资金购于新墨西哥州圣塔菲纺织珍品店。

此被面的刺绣图案包括花、鸟（包括至少一只凤凰）、鱼和蝴蝶。

Bedcover

Artist name unknown

Possibly Zhuang

Northern Guangxi Province, China

Mid 20th century

39" × 45 1/2"

Cotton

Foundation appliqué, machine appliqué, hand piecing, embroidery

Collection of the Michigan State University Museum, acquired by purchase from Textile Treasures with support from the MSU Foundation through the Office of Vice-President for Research and Graduate Studies

The quilt includes several embroidered motifs including, flowers, birds (including at least one phoenix), a fish, and butterflies.

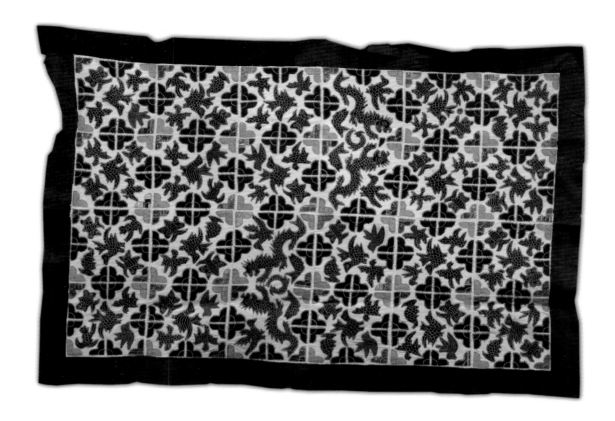

拼布被面

制作艺人未知

苗族

20 世纪后半期

92.7×136.5cm

中国贵州黔东南苗族侗族自治州黄平县

棉

底布贴花、手工缝制

密西根州立大学博物馆馆藏，由密西根州立大学研究与研究生学习副校长办公室提供的资金购于新墨西哥州圣塔菲纺织珍品店。

此拼布被面图案有抽象的龙、哺乳动物、鱼、蝴蝶、各种鸟以及被面中间的蜈蚣形龙纹。在苗族的起源神话中，龙是由蝴蝶妈妈的蛋孵出来的。苗族艺术中的龙通常背上有红色的尖刺。

Bedcover

Artist name unknown

Miao

Second half of 20th century

36 –1/2" × 53 –3/4"

Huangping County, Qiandongnan Miao and Dong Autonomous Prefecture, Guizhou Province, China

Cotton

Hand piecing, hand appliqué

Collection of the Michigan State University Museum, acquired by purchase from Textile Treasures with support from the MSU Foundation through the Office of Vice-President for Research and Graduate Studies

This textile has images of abstracted dragons, mammals, fish, butterflies, and various birds, and, in the center, centipede dragons. In origin stories of Miao, dragons hatch from butterfly eggs and in Miao art dragons are often represented with red-spiked backs.

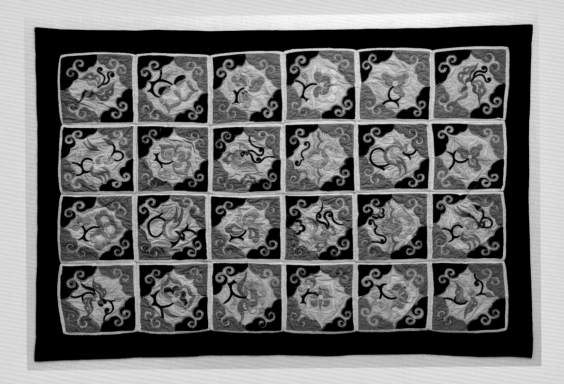

拼布被面

制作艺人未知

布依族

1950 年

100.3×137.2cm

中国贵州南部

棉、蓝靛粗布、缎、锦

底布贴花、手工贴花、手工缝制

密西根州立大学博物馆馆藏，由密西根州立大学研究与研究生学习副校长办公室提供的资金购于新墨西哥州圣塔菲纺织珍品店。

拼布被面上的淡蓝色方块布片上贴花绣了鸟（包括中间看起来是两只凤凰和龙的图案）、花、两只蝴蝶、两只螃蟹和两只带翅昆虫。四个方块布片环绕拼接成如意的形状。如意代表着梦想成真。

Bedcover

Artist name unknown

Buyi (Bouyei)

Southern Guizhou Province, China

c. 1950

39–1/2" × 54"

Cotton, coarse indigo, satin, brocade

Foundation appliqué, hand appliqué, hand piecing

Collection of the Michigan State University Museum, acquired by purchase from Textile Treasures with support from the MSU Foundation through the Office of Vice–President for Research and Graduate Studies

In the center of the light blue blocks are appliquéd birds (including possibly two phoenix accompanied by dragons in the center blocks), flowers, two butterflies, two crabs, and two winged insects. Four blocks meet at a corner to form a design called ruyi in Chinese. The design represents having one's wishes granted.

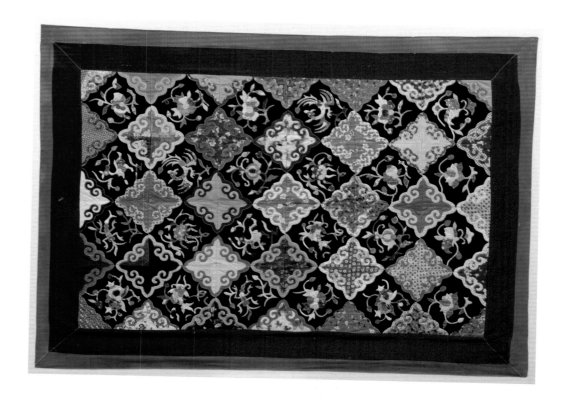

拼布被面

制作艺人未知

壮族、布依族或苗族

20 世纪五六十年代

119.4×161.3cm

中国广西南丹县（推测）

棉，丝

底布贴花、机器贴花、机器缝制

密西根州立大学博物馆馆藏，由密西根州立大学研究与研究生学习副校长办公室提供的资金购于新墨西哥州圣塔菲纺织珍品店。

拼布被面上的方块布片都是贝壳状的如意图案。布料有印染的也有没印染的，大多是几何或花朵图案设计。贴布绣的图案有鸟（包括公鸡）、花（包括莲花）、两只四脚昆虫、螃蟹、蝴蝶、鱼以及长得像鹿或马的动物。

Bedcover

Artist name unknown

Zhuang, Buyi (Bouyei), or Miao

Probably Nandan County, Guangxi Province, China

c. 1950–1960s

47" × 63–1/2"

Cotton, silk

Foundation appliqué, machine appliqué, machine piecing

Collection of the Michigan State University Museum, acquired by purchase from Textile Treasures with support from the MSU Foundation through the Office of Vice-President for Research and Graduate Studies

A scalloped shape called ruyi (meaning wishes granted) is featured in each block in this top. Fabrics include solids and prints, most of which are of geometric and floral designs. Appliquéd on the blocks are birds (including a rooster), flowers (including lotus) and two each of four-legged insects, crabs, butterflies, fish and animals that are either deer or horses.

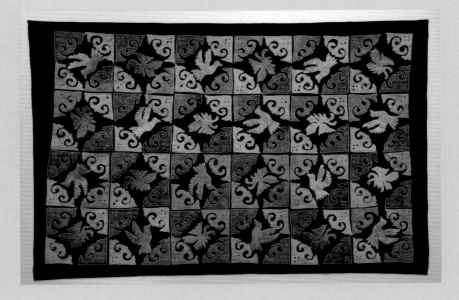

拼布被面

制作艺人未知

苗族（推测）

21 世纪（推测）

105.4×150.5cm

中国贵州省台江县施洞

棉

反面贴花、手工贴花、手工缝制、刺绣

密西根州立大学博物馆馆藏，由密西根州立大学研究与研究生学习副校长办公室提供的资金从吴国英手上购买。

拼布被面每个方形布片的中间一只鸟或一只蝴蝶。蝴蝶的翅膀绣成星星、钻石和圆圈的形状。鸟的尾巴用波浪线来与鸟的身体进行分隔。方块布片边角上的扇贝图案看起来像是如意，代表着梦想成真。贵州苗族的上衣和背带上也有类似的图案。

Bedcover

Artist name unknown

Possibly Miao

Shidong, Taijiang County, Guizhou Province. China

Probably 21st century

41–1/2" × 59–1/4"

Cotton

Reverse appliqué, hand appliqué, hand piecing, embroidery

Collection of the Michigan State University Museum, acquired by purchase from Guoying Wu, with support from the MSU Foundation through the Office of Vice–President for Research and Graduate Studies

A bird or a butterfly is appliquéd into the center of each block in this bedcover top. Designs embroidered on the wings of the insects include stars, diamonds, and circles. The tail feathers of the birds are distinguishable by their zigzag lines creating a break from the main part of the bird's body. The scalloped motifs in the corners appear to be the ruyi design that represents having one's wishes granted. Variations of this design are found embroidered on Miao upper garments and baby carriers from Guizhou.

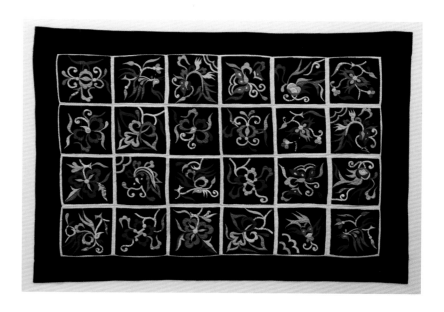

拼布被面

制作艺人未知

壮族、布依族或苗族（推测）

20世纪中期

114.9×158.8cm

中国贵州省罗甸县、独山县或望谟县（推测）

印染斜纹棉布、丝

底布贴花、手工贴花、反面贴花、手工缝制

密西根州立大学博物馆馆藏，由密西根州立大学研究与研究生学习副校长办公室提供的资金购于新墨西哥州圣塔菲纺织珍品店。

拼布图案有三条龙和各种鸟，包括四只凤凰。被面上的凤凰头冠上有两根羽毛，脖子下方也有一些羽毛，尾巴有三根或五根羽毛。

凤凰和龙一起用于民间艺术中时，凤凰通常代表女性，龙则代表男性。在中国历史上，皇上和皇后用龙和凤来表示。龙凤也可以象征道教中阴和阳的平衡与和谐。

苗族女性服饰，特别是上装，经常有凤凰图案。凤凰象征着高尚的品德、地位和优雅。在苗族文化中，凤凰牡丹代表着地位和财富。

Bedcover

Artist name unknown

Probably Zhuang, possibly Buyi (Bouyei) or Miao

Mid 20th century

45-1/4" × 62-1/2"

Possibly Luodian, Dushan, or Wangmo County, Guizhou Province, China

Cotton print twills, silk

Foundation appliqué, hand appliqué, reverse appliqué, hand piecing

Collection of the Michigan State University Museum, acquired by purchase from Textile Treasures with support from the MSU Foundation through the Office of Vice-President for Research and Graduate Studies

The top of this textile features three dragons and various birds, including four phoenix. In this textile, the phoenix can be identified by their head feathers (usually two on the crown of the head), several feathers resting below the neck, and a three- or five-feathered tail.

Generally a phoenix represents the female and when depicted in art it is often accompanied by a dragon as its male complement. In Chinese history, an emperor and empress were represented as the dragon and phoenix. The symbol also represents the balance and harmony in yin and yang symbol used in Dao religion.

The phoenix is often depicted in Miao women's textiles, especially in embroidered shirt garments or upper garments. The phoenix symbolizes high virtue, status, and grace. In Miao culture, when the phoenix is depicted with peony flowers, the design represents status and wealth.

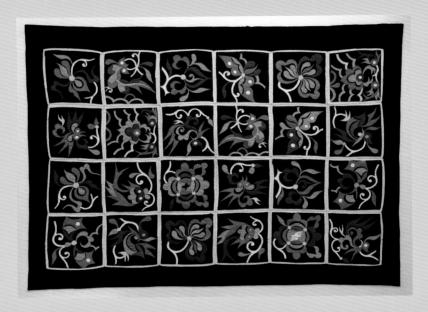

拼布被面

制作艺人未知

壮族、布依族或苗族

20 世纪中期

104.8×151.1cm

中国贵州省黔东南苗族侗族自治州独山县

（推测）

棉

底布贴花、手工贴花、手工缝制

密西根州立大学博物馆馆藏，由密西根州立大学研究与研究生学习副校长办公室提供的资金购于新墨西哥州圣塔菲纺织珍品店。

被面第二行从左边数的第三个方块上的图案是一朵莲花。莲花出淤泥而不染，代表着纯洁。莲花也是中国佛教艺术中很重要的元素。

有两个方块里的图案是螃蟹与两条跳跃的鱼。还有些图案是两只有着细长翎毛和翅膀的鸟，这些鸟看起来很抽象而且好像正准备打架。被面上的图案还包括钱币和蝴蝶。

Bedcover

Artist name unknown

Buyi (Bouyei)，Zhuang or Miao

Mid 20th century

44–1/4" × 59–1/2"

Possibly Dushan County, Qiannan Buyei and Miao Autonomous Prefecture, Guizhou Province, China

Cotton

Foundation appliqué, hand appliqué, hand piecing

Collection of the Michigan State University Museum, acquired by purchase from Textile Treasures with support from the MSU Foundation through the Office of Vice–President for Research and Graduate Studies

An abstract lotus flower design is appliquéd on the block in the second row, third from the left. The lotus is believed to represent purity because it sprouts out of muddy ponds without any trace of dirt. The lotus is also an important element in the iconography of Buddha's throne in Chinese Buddhist religious art.

Two squares each contain one crab with two jumping fish connected by a white strip of cloth. In some blocks, abstracted birds with elongated top feathers and wings appear about to take flight. Other designs on this top include appliquéd coins and butterflies.

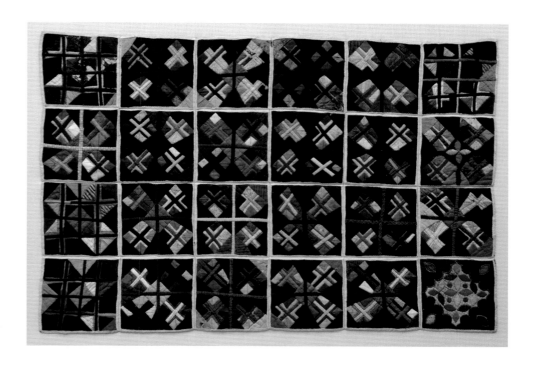

拼布被面

制作艺人未知

壮族（推测）

1930 年

73.7 × 111.8cm

中国广西南丹县

阔幅和粗斜纹斜纹棉布、丝、可能还有羊毛

底布贴花、手工贴花、反面贴花、手工缝制、多维度贴花、折叠贴花

密西根州立大学博物馆馆藏，由密西根州立大学研究与研究生学习副校长办公室提供的资金购于新墨西哥州圣塔菲纺织珍品店。

拼布被面上的大多是大方块都是由四个小方块组成的，小方块的图案是西方拼布艺人所说的十二角形。四片小方块中间成 X 或 + 的纹路。周围缝上三角形的布片组成大方块。方块上的图案与西方拼布艺人所说的经济模式图案类似。

Bedcover

Artist name unknown
Probably Zhuang
c. 1930
29" × 44"
Nandan County, Guangxi Province, China
Cotton broadcloth and denim, silk, and possibly wool
Foundation appliqué, hand appliqué, hand piecing, reverse appliqué, dimensional appliqué, folded appliqué

Collection of the Michigan State University Museum, acquired by purchase from Textile Treasures with support from the MSU Foundation through the Office of Vice-President for Research and Graduate Studies

Most of the blocks in this top are made of four smaller ones in a pattern called Twelve Triangle by Western quiltmakers. Blocks are built from a center X or +, then triangles are added three times around to build the square. The overall block pattern of this top is visually similar to one called Economy by Western quiltmakers.

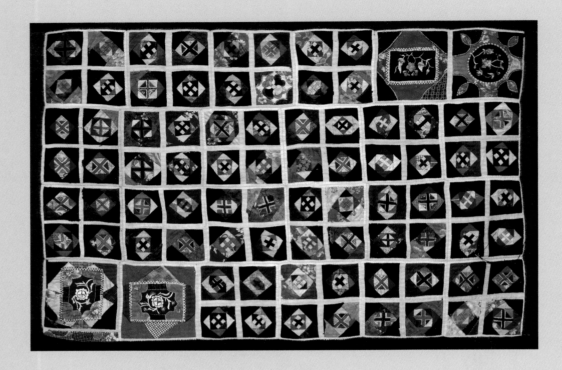

拼布被面

Bedcover

制作艺人未知

壮族（推测）

1930 年

114.3×195.6cm

中国广西南丹县

卡其棉布、宽幅布和斜纹布、丝

底布贴花、手工贴花、反面贴花、手工缝制、刺绣

密西根州立大学博物馆馆藏，由密西根州立大学研究与研究生学习副校长办公室提供的资金购于新墨西哥州圣塔菲纺织珍品店。

拼布被面上的 20 个大方块都是由 4 个小方块组成的，小方块的图案是西方拼布艺人所说的十二角形。4 片小方块中间成 X 或 + 的纹路。周围缝上三角形的布片组成大方块。有一个大方块上面的团是由树叶和 4 个角的三角形组成的。方块上的图案与西方拼布艺人所说的经济模式图案很接近，但西方拼布是布片拼接而不是底布贴花。

Artist name unknown

Probably Zhuang

c. 1930

45" × 77"

Nandan County, Guangxi Province, China

Cotton khaki, broadcloth and twill, silk

Foundation appliqué, hand piecing and hand appliqué, reverse appliqué, embroidery

Collection of the Michigan State University Museum, acquired by purchase from Textile Treasures with support from the MSU Foundation through the Office of Vice-President for Research and Graduate Studies

Twenty of the blocks are made of four smaller ones in a pattern called Twelve Triangle by Western quiltmakers. Blocks are built from a center X or +, then triangles are added three times around to build the square. One block has appliquéd leaves with triangles in the corners. The overall block pattern of this top is visually similar to one called Economy by Western quiltmakers although they would have pieced this together rather than use foundation appliqué.

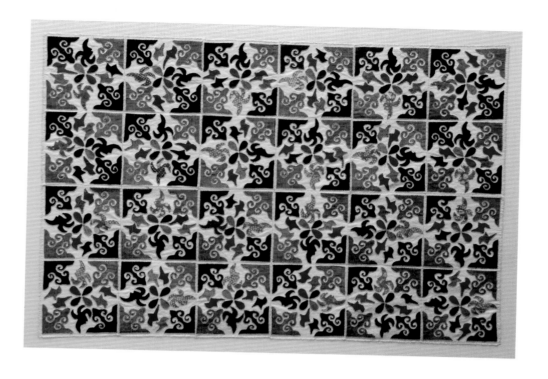

拼布被面

吴晓丽、潘刁久（音）
苗族
2015 年
84.5×126.4cm
中国贵州省黄平县
卡其棉布、宽幅布和斜纹布、丝
底布贴花、手工贴花、反面贴花、手工缝制、刺绣

密西根州立大学博物馆馆藏，由密西根州立大学研究与研究生学习副校长办公室提供的资金购于新墨西哥州圣塔菲纺织珍品店。

贵州施洞吴晓丽设计的图案，贵州黄平的潘刁久按设计图案进行制作。晓丽根据壮族和布依族的拼布图案来做设计并提供了老的手工织布。被面使用的贴线绣的方法在黄平妇女销售的现代被面中很常见。

Bedcover

Wu Xiaoli and Pan Diaojiu
Miao
c. 2015
33-1/4" × 49-3/4"
Huangping County, Guizhou Province, China
Cotton
Foundation piecing, hand appliqué, raw edge appliqué, couching,
Collection of the Michigan State University Museum, acquired by purchase from Textile Treasures with support from the MSU Foundation through the Office of Vice-President for Research and Graduate Studies

Wu Xiaoli of Shidong Township, Guizhou Province, designed the quilt that was then constructed by Pan Diao Jiu of Huangping County, Guizhou Province. Xiaoli based the appliquéd pieces on those she had seen in Zhaung and Buyi (Bouyei) quilts. She also provided the older hand-woven cotton fabrics incorporated in the top. The style of the couching is typical of the modern quilt tops made for resale by women from Huangping.

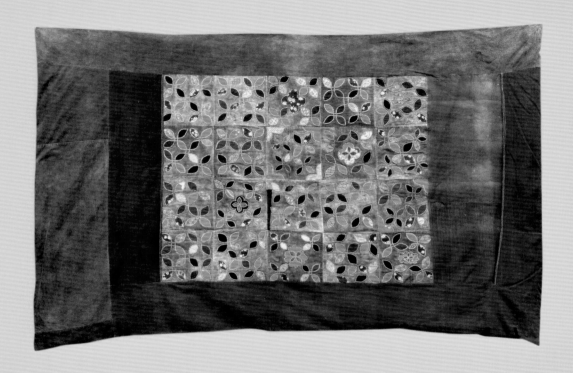

广西南丹县壮族贴花拼布被面

赵丽珍
壮族
20 世纪 70 年代
219×135cm
中国广西南丹县
棉
剪布，锁边，贴布，拼缝，机器缝制
云南民族博物馆从制作艺人处购买

该展品工艺形式主要为剪布，锁边，贴布，拼缝，被面中心由 1 个镶嵌拼缝有 20 个大小形状相同的正方形五色布块组成，其中布块图案采用五色布条拼缝为寓意吉祥富贵的四瓣花，团花等花草纹样，象征着生命的美好与对生活的祝福。整幅被面耗时一年时间完成。

Bedcover

Lizhen Zhao
Zhuang
c. 1970s
86–1/5" × 53"
Nandan County, Guangxi Province, China
Cotton
Fabric cutting, serging, patchwork, appliqué, machine sewing
Collection of the Yunnan Nationalities Museum, acquired by purchase from the maker.

The center of this quilt is a five-color piece composed of 20 identically shaped squares. Each square is appliquéd with patterns of four-petal and round flowers that symbolize an auspicious and rich life, praise the beauty of life, and express good wishes. It took one year for the artist to make the bedcover.

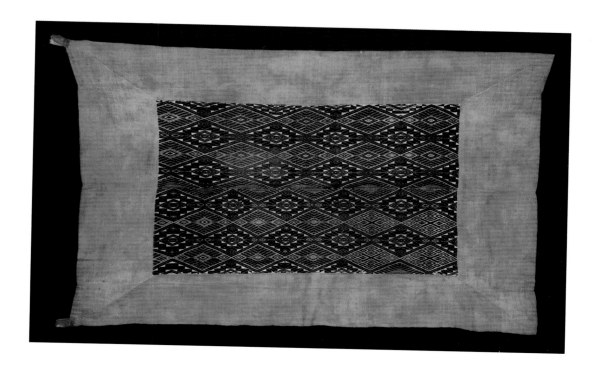

云南景洪市傣族织锦被面

玉香的母亲

傣族

20 世纪 70 年代

120×185cm

中国云南省景洪市

棉

纺织、提花、织造、拼缝

云南民族博物馆从制作者后人处购买

该展品为云南省景洪市傣族妇女玉香收藏的，其 80 岁的母亲制作的被面，工艺形式为纺织、提花、织造和拼缝。被面中心采用黑白相间的棉线制作成长条形织锦镶嵌其间，傣族自纺自织的浅黄色棉布四周环边拼缝而成长方形织物。被面织锦图案以菱形为主，菱形的框架由小方格构成，菱形的内部则填满多层菱形，色彩以白为底，间以深蓝色棉线织制，织锦构图严谨，纹饰古雅，形成沉静而华丽的装饰风格。整幅被面制作耗时 18 个月。

Bedcover

Artist name unknown

Dai

c. 1970s

47–1/4" × 72–4/5"

Jinghong City, Yunnan Province, China

Cotton

Weaving, jacquard weaving, contexture, patchwork

Collection of the Yunnan Nationalities Museum, acquired by purchase from Xiang Yu, the maker's daughter.

The Yunnan Nationalities Museum acquired this bedcover from 80–year–old Xiang Yu whose mother had made this textile treasure. The center of this rectangular textile is inlaid with two strips of brocade cloth woven of black and white cotton threads. The pattern of the brocade is mainly composed of diamond frames rimmed by small squares, while the central part is multiple layers of diamond patterns. The composition of the brocade is precise; the pattern is traditional and is of a style that symbolizes calmness and splendor. Dai weavers made the light colored cotton cloth around the brocade center. It took 18 months for the artist to make this quilt.

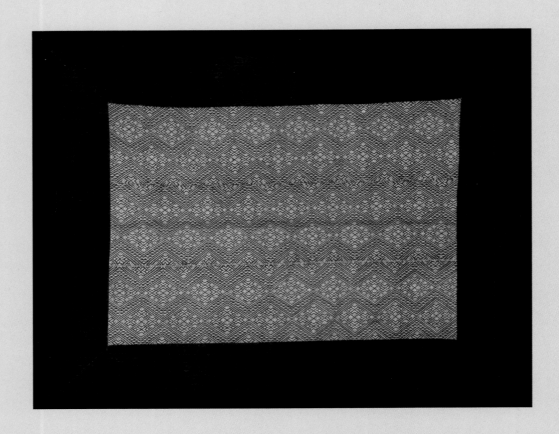

贵州安顺县布依族织锦被面

雷桂仙的母亲
布依族
20世纪90年代
115×150cm
中国贵州省安顺县
棉
纺织、提花、织造、拼缝
云南民族博物馆从制作艺人后人处购买

该展品工艺形式主要为剪布、织绣、拼缝为主。被面中心由织有菱形和其他几何图形的三条织锦物拼缝制作，整幅被面做工精细，构图新颖，极具民族特色。被面以蓝色底布为纯手工制作棉布，由雷桂仙的母亲亲自纺织和染色。整幅被面耗时近两年时间完成。

Bedcover

Artist name unknown
Buyi
c. 1990s
45-1/4" × 59"
Anshun County, Guizhou Province, China
Cotton
Jacquard weaving, contexture, patchwork
Collection of the Yunnan Nationalities Museum, acquired by purchase from Guixian Lei, the maker's daughter.

Guixian Lei inherited this textile from her mother. The center of this quilt is inlaid with three strips of brocade, patterned with diamonds and other geometric figures. The whole quilt top is of exquisite workmanship and novel composition. The blue fabric used in the foundation is handmade cotton cloth woven and dyed by Lei's mother. It took nearly two years for the artist to make this quilt.

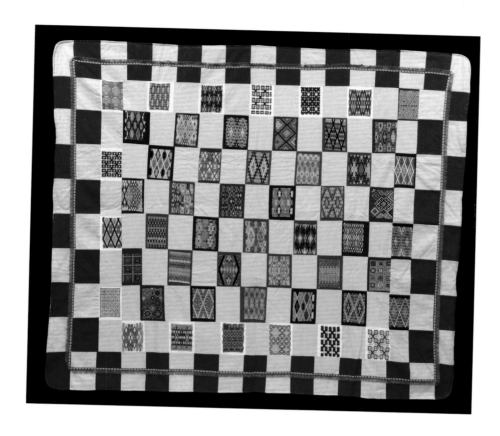

多民族元素融合创新织锦被面

沙莎
回族
2010 年后
196.5×172.5cm
中国云南省昆明市
棉
剪布、织绣、拼缝、机器缝制
云南民族博物馆从制作艺人处购买

该展品整幅被面图案融入了云南苗、景颇、傣等民族织锦图案造型，被面中心由 52 个大小形状相近，纹样不同的方形织锦图案拼缝组成。常见的纹样有苗族的山川湖泊、城墙，景颇族的螃蟹纹、蕨菜纹，傣族的方形、菱形等几何图案。整幅被面耗时半年完成。

Bedcover

Sha Sha
Hui
c. 2010s
77–2/5" × 68"
Kunming city, Yunnan Province, China
Cotton
Fabric cutting, Jacquard weaving, patchwork, appliqué, machine sewing
Collection of the Yunnan Nationalities Museum, acquired by purchase from the maker.

The quilt top is made of 52 pieces of brocade in different traditional and innovative patterns. Traditional patterns include the city–wall pattern of Miao people, the crab, the fern patterns of Jingpo people, the square, the diamond and other geometric figures of Dai people. It took six months for the artist to make this quilt.

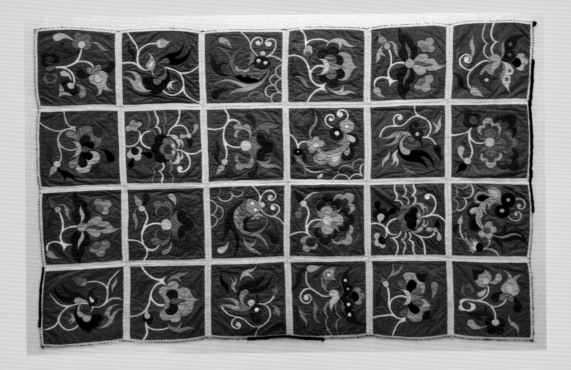

贵州黄平苗族布贴被面

制作艺人未知

苗族

20 世纪七八十年代

121×86cm

中国贵州省黄平县

棉

布贴工艺、手工贴布、手工缝制

贵州民族博物馆从贵州省黄平县购买

该展品由 24 块色泽明艳、工艺繁复的布贴所组成，有石榴、仙桃、花卉、螃蟹、凤鸟、龙、鱼龙、蝴蝶等图案。这些图案，体现了苗族对于自身生命起源和祖先的崇拜。蝴蝶妈妈是苗族传说里苗族人共同的祖先，称为"妹榜妹留"，因此，蝴蝶图案体现了"祈蝴蝶妈妈庇佑"之心态。

Bedcover

Artist name unknown

Miao

1970s—1980s

47-3/5" × 33-4/5"

Huangping County, Qiandongnan Miao and Dong Autonomous Prefecture, Guizhou Province, China

Cotton

Hand piecing, foundation piecing, hand appliqué

Collection of the Guizhou Nationalities Museum; acquired by purchase in Huangping, Qiandongnan Miao and Dong Autonomous Prefecture, Guizhou Province, China

The 24 blocks in this bedcover are appliquéd with images, including ones of pomegranate, peach, flower, crab, bird, dragon, fish, and butterfly. The images express Miao people's respect of life and worship of their ancestors. In Miao belief, the butterfly is the ancestor of Miao people. Miao call the butterfly mother. The appliquéd butterfly on this textile represents a wish for the blessing of the butterfly mother.

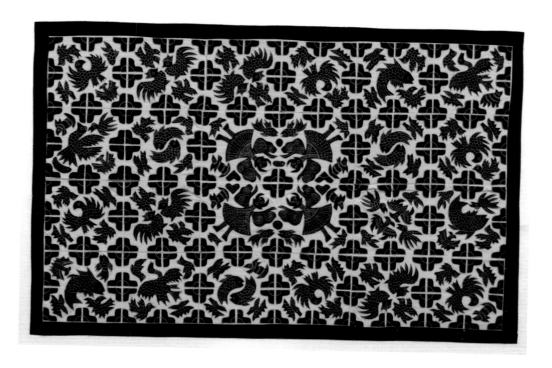

贵州黄平谷陇苗族布贴被面

制作艺人未知

苗族

20 世纪七八十年代

140 × 98cm

中国贵州省黄平县谷陇乡

棉

布贴工艺、手工贴布、手工缝制

贵州民族博物馆从贵州省黄平县谷陇乡购买

该展以黄色布为底，上饰褐色布贴，图案有苗姑娘跳铜鼓舞、凤鸟、大鸟背小鸟、一双金鱼、蚕虫、山猫、公鸡、八瓣花等，体现了苗家妇女独特的审美和追求。例如，跳铜鼓舞的苗姑娘头上所戴"牛角头饰"与南朝《述异记》中关于"蚩尤头有角"的记载以及出土汉砖上"黄帝战蚩尤"中关于蚩尤"头有角"的记述不谋而合，反映出如今贵州黄平苗族对其祖先蚩尤文化的历史传承。

Bedcover

Mo Aiqun

Miao

1970s—1980s

55" × 38-1/2"

Gulong, Huangping County, Qiandongnan Miao and Dong Autonomous Prefecture, Guizhou Province, China

Cotton

Hand piecing, foundation piecing, hand appliqué

Collection of the Guizhou Nationalities Museum; acquired by purchase from Huangping County, Qiandongnan Miao and Dong Autonomous Prefecture, Guizhou Province, China

The appliqued images on this bedcover include Miao girls dancing, a phoenix, a larger bird carrying a smaller bird, goldfish, silkworm, a lynx, a cock, and a flower with eight petals. The horn decoration worn on the heads of the girls references the horns worn on the head of Chiyou, considered by Miao as their ancestor and hero who fought Yellow Warrior, considered by Han as their ancestor.

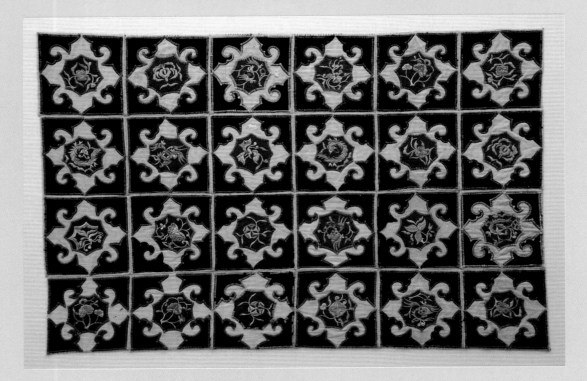

贵州荔波布依族破线绣布贴被面

制作艺人未知
布依族
20 世纪七八十年代
200×118cm
中国贵州省荔波县
棉
布贴工艺、手工贴布、手工缝制、刺绣
贵州民族博物馆从贵州省荔波县购买

该被面由 24 个形态各异又和谐统一的布块图案所组成，主要有蝴蝶、龙纹、花卉、凤鸟等，抽象生动，栩栩如生，色泽素雅，工艺精美，体现了中国传统刺绣技法中布贴和破线绣之高超技艺。破线绣又称剖线绣，一般将丝线分破成八至十二股细线，多用平针刺绣，绣品极为平整细腻，展现了"水稻民族"含蓄内敛的民族性格和审美品位。

Bedcover

Artist name unknown
Buyi (Bouyei)
1970s—1980s
78–4/5" × 46–1/2"
Lipo County, Guizhou Province, China
Cotton
Hand piecing, foundation piecing, hand appliqué, embroidery
Collection of the Guizhou Nationalities Museum; acquired by purchase from Lipo, Guizhou, China

Each of the 24 cloth squares on this top is embroidered with designs, including images of butterflies, dragons, flowers, and phoenixes. The artist used very thin threads in the embroidery.

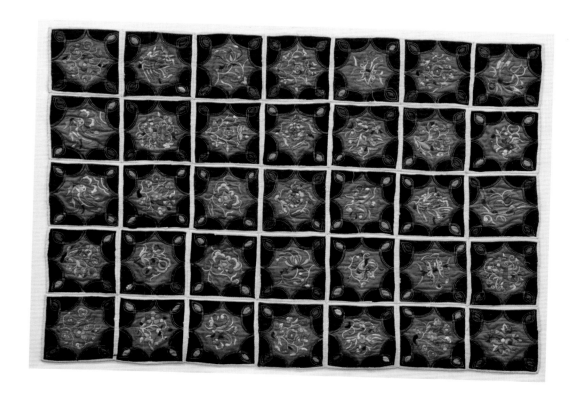

贵州荔波布依族破线绣布贴被面

制作艺人未知

布依族

20 世纪七八十年代

188×52cm

中国贵州省荔波县

棉

布贴工艺、手工贴布、手工缝制、刺绣

贵州民族博物馆从贵州省荔波县购买

该展品为贵州荔波一带布依族妇女所制作。被面由 35 个形态各异又和谐统一的布块图案所组成，主要有凤鸟、蝴蝶、鱼纹、花卉等象征着生殖、生命的吉祥图案，将其缝制于黑色布幅之上，观之形态丰富、色泽艳丽，十分精美。

Bedcover

Artist unknown

Buyi (Bouyei)

1970s—1980s

74" × 20–1/2"

Lipo County, Guizhou Province, China

Cotton

Hand pieced, foundation piecing, hand appliqué, embroidery

Collection of the Guizhou Nationalities Museum; acquired by purchase from Huangping, Qiandongnan Miao and Dong Autonomous Prefecture, Guizhou Province, China

The 35 designs appliquéd and embroidered on this top include those of a phoenix, butterfly, fish, flower and some designs that symbolize reproduction and life.

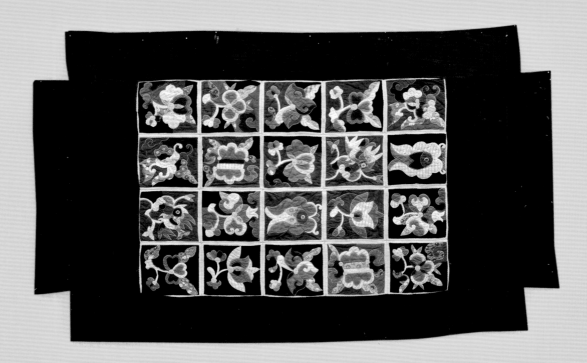

拼布被面

制作艺人未知

1940 年

中国贵州南部或广西北部（推测）

棉

机器缝制、机器贴花

密西根州立大学博物馆馆藏，由密西根州立大学研究与研究生学习副校长办公室提供的资金购于新墨西哥州圣塔菲纺织珍品店。

Bedcover

Artist name unknown

c. 1940

Likely southern Guizhou Province or northern Guangxi Province, China

Cotton

Machine piecing, machine appliqué

Collection of Michigan State University Museum, acquired with support from the MSU Foundation through the Office of Vice-President for Research and Graduate Studies

帽子

制作艺人未知

苗族（推测）

20 世纪后期

中国贵州省

棉

密西根州立大学博物馆馆藏，由 Richard Stamps
博士捐赠。

这顶儿童帽运用了中国西南地区少数民族艺人
在拼布被面上也会使用的贴布绣技术和图案。

Hat

Artist unknown

Possibly Miao

Late 20th century

Guizhou Province, China

Cotton

*Collection of the Michigan State University Museum,
acquired by donation from Dr. Richard Stamps*

This child's hat incorporates the appliqué technique
and symbols that are also used in quilts made by ethnic
minority artists in Southwest China.

包头布

制作艺人未知

彝族

20 世纪后期

中国云南省

棉，珠子

密西根州立大学博物馆馆藏(2010:123.5.2)。
由密西根州立大学研究与研究生学习副校长办
公室提供的资金购于中国云南民族博物馆手工
艺品店。

彝族妇女用这种布包头的时候，露出中间
的正方形布片。这块包头布和展览中展示的裙
子是配套的服饰。

Head covering

Artist unknown

Yi

Late 20th century

Yunnan Province, China

Cotton, beads

*Collection of the Michigan State University
Museum (2010:123.5.5), acquired by purchase from
Yunnan Nationalities Museum Handicraft Shop,
Yunnan Province, China, with support from the MSU
Foundation through the Office of Vice-President for
Research and Graduate Studies*

When wrapped around a Yi woman's head, the
central square patchwork portion of this textile would
have been exposed. This head covering and the skirt
also included in this exhibition were part of the same
set of clothing.

裙子

制作艺人未知

彝族

20 世纪后期

中国云南省

棉，丝

密西根州立大学博物馆馆藏 (2010:123.5.2)。由密西根州立大学研究与研究生学习副校长办公室提供的资金购于中国云南民族博物馆手工艺品店。

这件女裙展示了拼布工艺在传统服饰中的运用。这件裙子的腰部位置很宽而且没有缝合，需要用一条饰带或腰带绑起来穿。

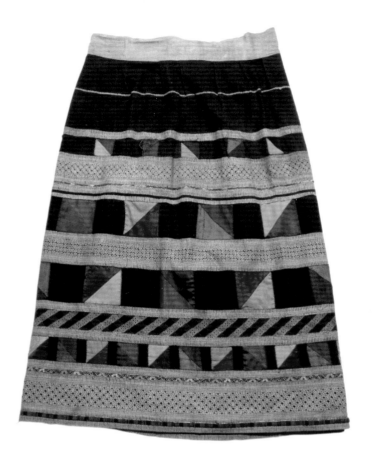

Skirt

Artist unknown

Yi

Late 20th century

Yunnan Province, China

Cotton, silks

Collection of the Michigan State University Museum (2010:123.5.2), acquired by purchase from Yunnan Nationalities Museum Handicraft Shop, Yunnan Province, China, with support from the MSU Foundation through the Office of Vice-President for Research and Graduate Studies

This women's skirt shows how patchwork is incorporated into traditional clothing. The skirt has a very large waist with no closure and would be worn with a sash or belt.

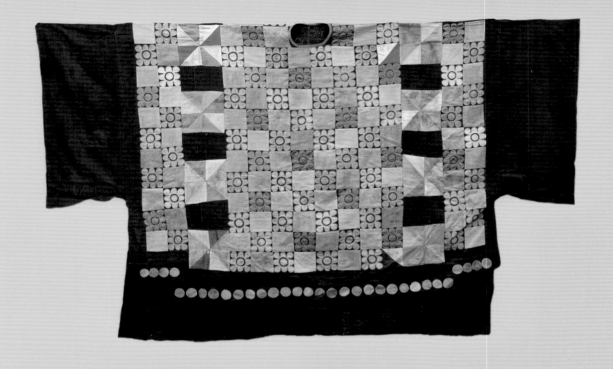

龙婆衣

制作艺人未知

彝族

中国云南省文山壮族和苗族自治州麻栗坡县

20世纪

丝、棉

手工拼接、手工缝制

密西根州立大学博物馆馆藏，由密西根州立大学研究与研究生学习副校长办公室提供的资金购于新墨西哥州圣塔菲纺织珍品。

在麻栗坡，当老人去世时，他的女性后辈会在葬礼上穿龙婆衣。当地彝族的神婆也穿龙婆衣。

Dragon Wife's Robe (Longpo Yi)

Artist name unknown

Yi

Malipo County, Wenshan Zhuang and Miao Autonomous Prefecture, Yunnan Province, China

20th century

Silk, cotton

Hand piecing, hand appliqué

Collection of the Michigan State University Museum, acquired by purchase from Textile Treasures with support from the MSU Foundation through the Office of Vice-President for Research and Graduate Studies

When an elderly person dies in the Malipon region, a female descendant wears a Longpo Yi as part of the funeral rituals. This robe is also worn by older women acknowledged by others in their Yi community as having healing powers.

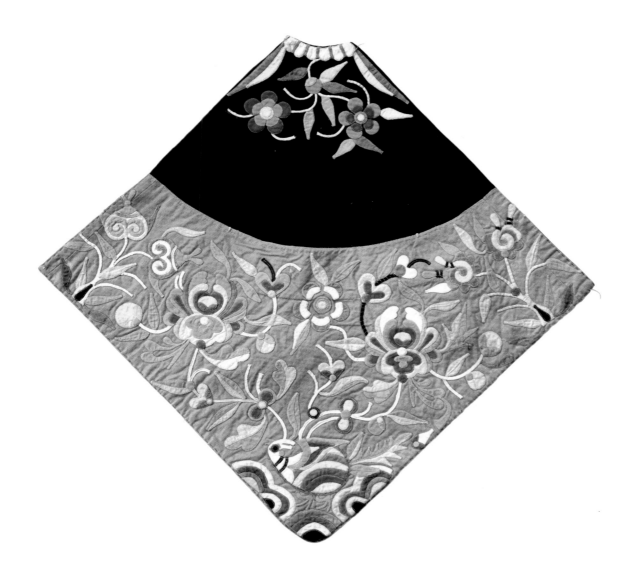

肚兜

制作艺人未知

汉族

中国陕西省

20 世纪早期

棉

手工贴花

密西根州立大学博物馆馆藏，由密西根州立大学研究与研究生学习副校长办公室提供的资金购于纺织珍品店。

Belly Apron

Artist name unknown

Han

Shanxi Province, China

Early 20th century

Cotton

Hand appliqué

Collection of the Michigan State University Museum, acquired by purchase from Textile Treasures with support from the MSU Foundation through the Office of Vice-President for Research and Graduate Studies.

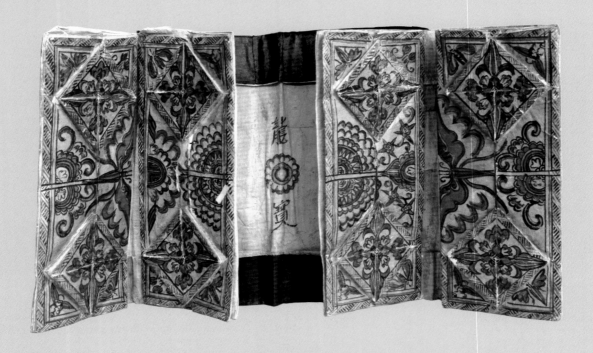

针线包

制作艺人未知

侗族

中国贵州省黔东南苗族侗族自治州从江县

1950 年

密西根州立大学博物馆馆藏，由密西根州立大学研究与研究生学习副校长办公室提供的资金购于新墨西哥州圣塔菲纺织珍品店。

由密西根州立大学玛莎.麦克道尔在田野作业中从艺人手中购得。

针线包是携带针线等手工缝制用品的便携小包。针线包由纸或布做成，上面经常会有书法或刺绣等装饰。针线包用于装放针、线、纽扣、剪纸以及照片等个人物品。

Zhen Xian Bao

Artist name unknown

Dong

Congjiang County, Qiandongnan Miao and Dong Autonomous Prefecture, Guizhou Province, China

c. 1950

Collection of the Michigan State University Museum, acquired by purchase from Textile Treasures with support from the MSU Foundation through the Office of Vice-President for Research and Graduate Studies

Translated literally as"needle thread pocket", a zhen xian bao is a portable container for sewing materials. Usually handmade of folded paper or cloth and often decorated with calligraphy or embroidery. these kits contain compartments for needles, thread, buttons, paper needlework patterns, and personal materials such as photos.

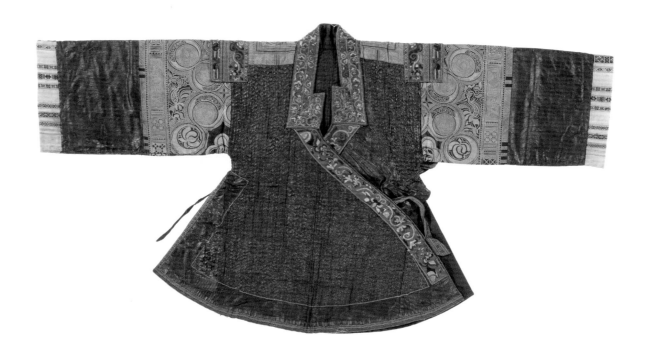

外套

制作艺人未知
苗族
中国贵州省三渡水自治县
约 1900—1925 年
127 × 71cm
蓝靛染和泥浆染棉布，亮布
手工缝制，手工拼布
纳布拉斯卡大学林肯分校国际拼布研究中心与
博物馆，编号 2011.037.0001

Jacket

Maker unknown
Miao
SanduShui Autonomous County, Guizhou, China
Circa 1900—1925
50″ × 28″
Indigo and mud–dyed cotton, glazed
Hand pieced, hand quilted
*International Quilt Study Center & Museum, UNL,
2011.037.0001*

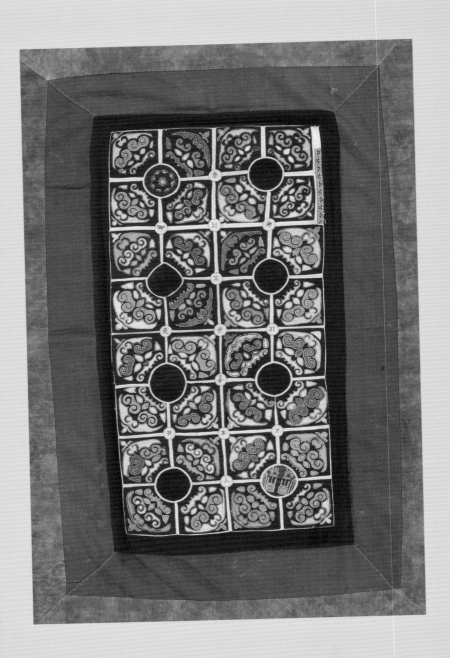

拼布被面

制作艺人未知

瑶族

中国广西（推测）

约 1900—1925 年

99×152.4cm

棉和羊毛

手工反面拼贴和机器拼贴，手工缝制，手

工刺绣

纳布拉斯卡大学林肯分校国际拼布研究中

心与博物馆，编号 2012.005.0001

Quilt Cover

Maker unknown

Yao

Probably made in Guangxi, China

Circa 1900—1925 年

39" × 60"

Cotton and wool

Hand reverse appliquéd and machine appliquéd,

hand pieced, hand embroidered

International Quilt Study Center & Museum,

UNL, 2012.005.0001

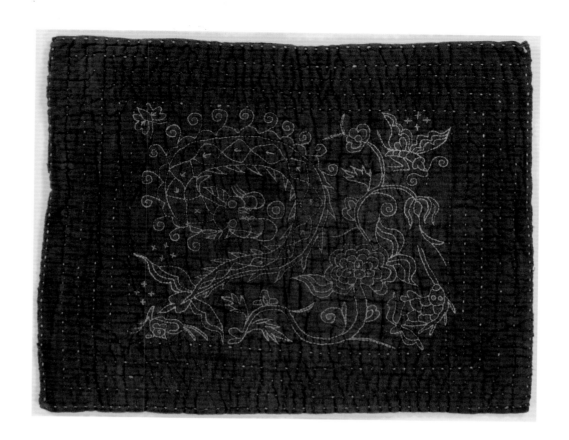

尿布垫

制作艺人未知

苗族

中国贵州施洞台江县（推测）

约 1950—1970 年

34.3×26.7cm

蓝靛染棉布

手工拼布

纳布拉斯卡大学林肯分校国际拼布研究中心与博物馆，编号 2011.046.0006

Diaper Pad

Maker unknown

Miao

Probably made in Shidong, Taijiang County, Guizhou, China

Circa1950—1970

13-1/2" × 10-1/2"

Indigo-dyed cotton

Hand quilted

International Quilt Study Center & Museum, UNL, 2011.046.0006

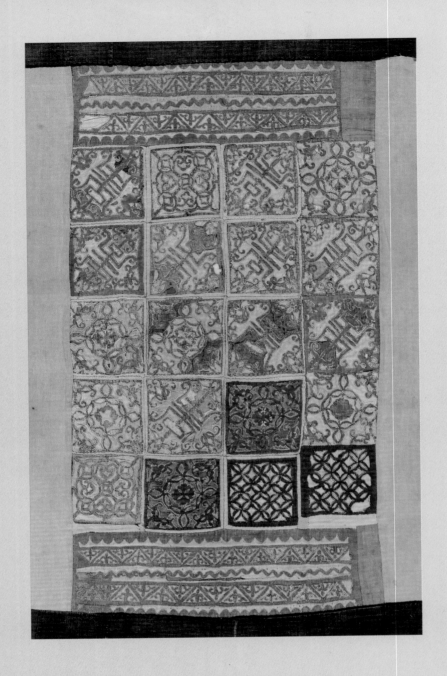

拼布被面

制作艺人未知

布依族

中国广西（推测）

约 1875—1900 年

90×147.3cm

棉

手工拼贴，反面拼贴，手工缝制

纳布拉斯卡大学林肯分校国际拼布研究中

心与博物馆，编号 2012.005.0003

Quilt Cover

Maker unknown

Buyi

Probably made in Guangxi, China

Circa1875—1900

35-1/2" × 58"

Cotton

Hand appliquéd and reverse appliquéd, hand pieced

International Quilt Study Center & Museum, UNL, 2012.005.0003

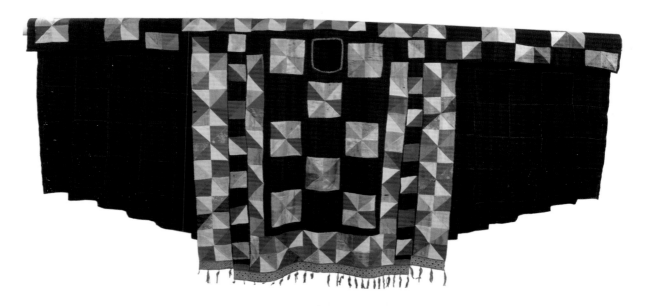

龙婆衣

制作艺人未知

彝族

中国云南麻栗坡县

约 1940 年

丝，棉

手工缝制，手工拼贴

纳布拉斯卡大学林肯分校国际拼布研究中心与

博物馆，编号 2012.021.0001

Longpo Yi（"Dragon Wife's Robe"）

Maker unknown

Yi

Malipo County, Yunnan, China

Circa1940

Silk and cotton

Hand pieced, hand appliquéd

International Quilt Study Center & Museum, UNL,

2012.021.0001

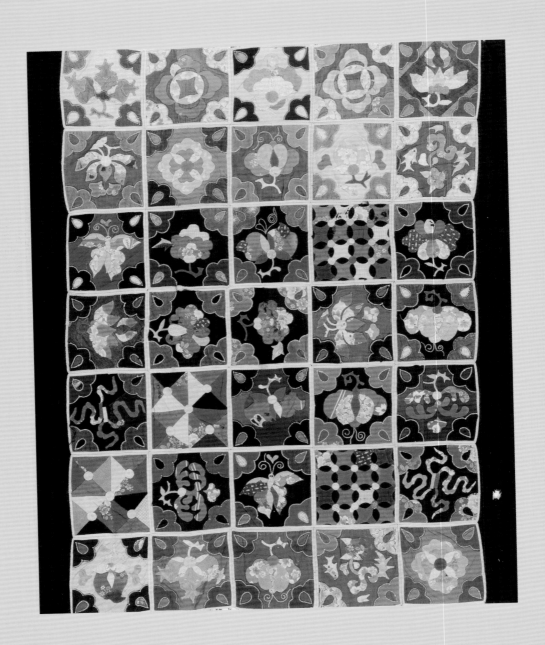

拼布被面

制作艺人未知

毛南族

中国广西环江毛南族自治县（推测）

约 1930—1950 年

116.8×119.4cm

棉

手工拼贴和反面拼贴，手工缝制

纳布拉斯卡大学林肯分校国际拼布研究中心与博物馆，编号 2012.040.0003

Quilt Cover

Maker unknown

Maonan

Probably made in Huanjiang Maonan Autonomous County, Guangxi, China

Circa1930—1950

46" × 47"

Cotton

Hand appliquéd and reverse appliquéd, hand pieced

International Quilt Study Center & Museum, UNL, 2012.040.0003

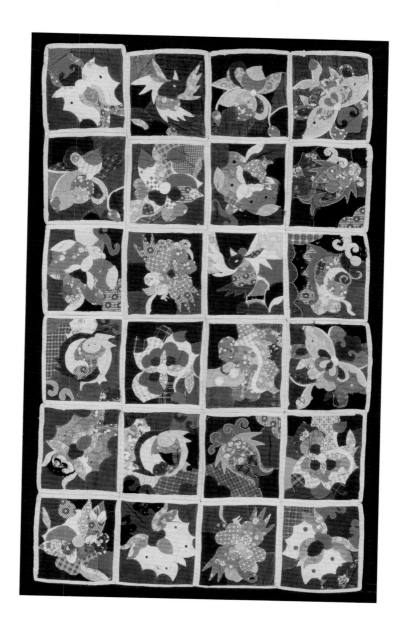

拼布被面

制作艺人未知

毛南族

中国广西环江毛南族自治县（推测）

约 1950—1970 年

114.3×167.6cm

棉

手工拼贴和反面拼贴，手工缝制

纳布拉斯卡大学林肯分校国际拼布研究中心与
博物馆，编号 2012.040.0004

Quilt Cover

Maker unknown

Maonan

Probably made in Huanjiang Maonan Autonomous
County, Guangxi, China

Circa1950—1970

45" × 66"

Cotton

Hand appliquéd and reverse appliquéd, hand pieced
International Quilt Study Center & Museum, UNL,
2012.040.0004

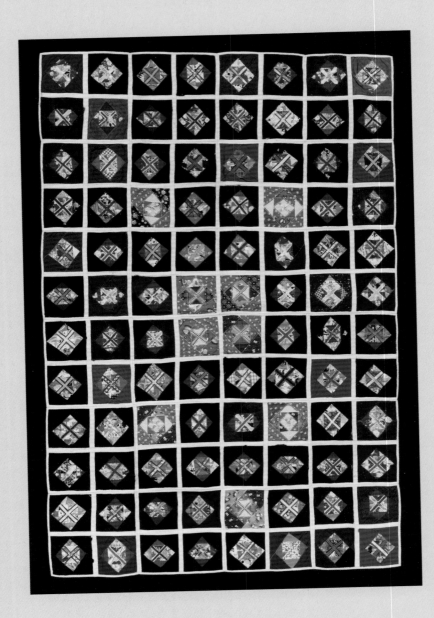

拼布被面

制作艺人未知

布依族

中国贵州省平塘县或独山县，或广西南丹

县（推测）

约 1950—1970 年

127×177.8cm

棉

手工拼贴和机器拼贴，手工缝制

纳布拉斯卡大学林肯分校国际拼布研究中

心与博物馆，编号 2013.026.0001

Quilt Cover

Maker unknown

Buyi

Probably made in Pingtang County or Dushan

County, Guizhou, or Nandan County, Guangxi,

China

Circa1950—1970

50" × 70"

Cotton

Hand and machine appliquéd, hand pieced

International Quilt Study Center & Museum,

UNL, 2013.026.0001

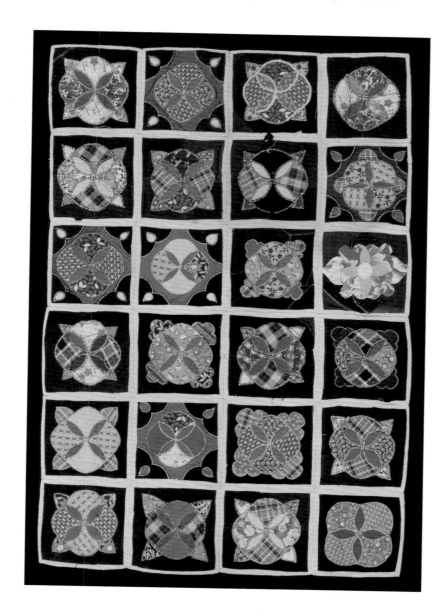

拼布被面

Quilt Cover

制作艺人未知

布依族或苗族

中国贵州省独山县（推测）

约 1960—1980 年

147.3×181.6cm

棉

手工拼贴和反面拼贴，机器拼贴，手工缝制

纳布拉斯卡大学林肯分校国际拼布研究中心与

博物馆，编号 2013.026.0002

Maker unknown

Buyi or Miao

Probably made in Dushan County, Guizhou, China

Circa1960—1980

58" × 71-1/2"

Cotton

Hand appliquéd and reverse appliquéd, machine appliquéd, hand pieced

International Quilt Study Center & Museum, UNL, 2013.026.0002

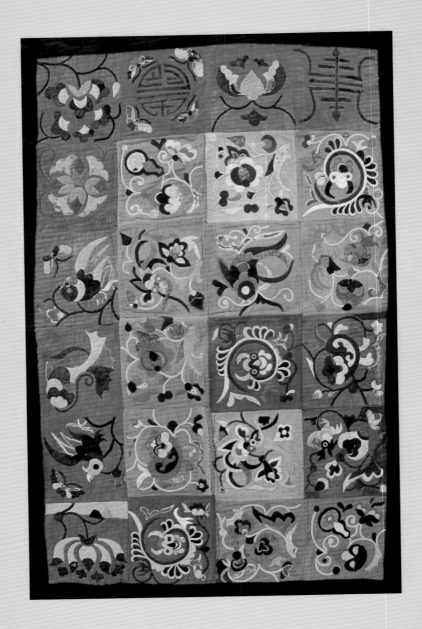

拼布被面

制作艺人未知

壮族

中国广西天峨县（推测）

约 1910—1930 年

104×141cm

羊毛，棉

手工拼贴和反面拼贴，手工缝制

纳布拉斯卡大学林肯分校国际拼布研究中

心与博物馆，编号 2014.027.0001

Quilt Cover

Maker unknown

Zhuang

Probably made in Tian´e County, Guangxi,

China

Circa1910—1930

41"× 55-1/2"

Wool and cotton

Hand appliquéd and reverse appliquéd, hand

pieced

International Quilt Study Center & Museum,

UNL, 2014.027.0001

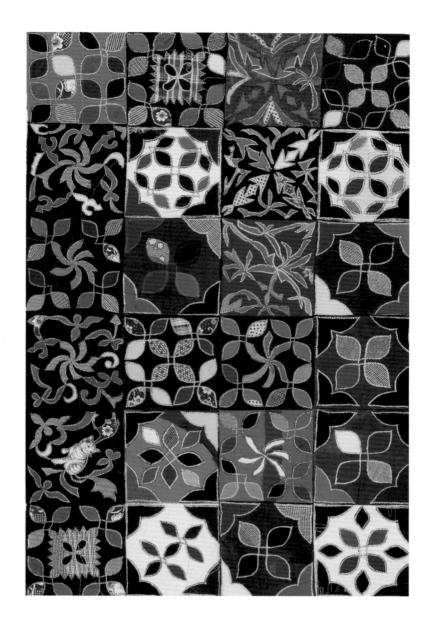

拼布被面

制作艺人未知

壮族

中国广西南丹县（推测）

约 1920—1940 年

棉

手工和机器拼贴，手工缝制

纳布拉斯卡大学林肯分校国际拼布研究中心与博物馆，编号 2014.027.0002

Quilt Cover

Maker unknown

Zhuang

Probably made in Nandan County, Guangxi, China

Circa1920—1940

Cotton

Hand and machine appliquéd, hand pieced

International Quilt Study Center & Museum, UNL, 2014.027.0002

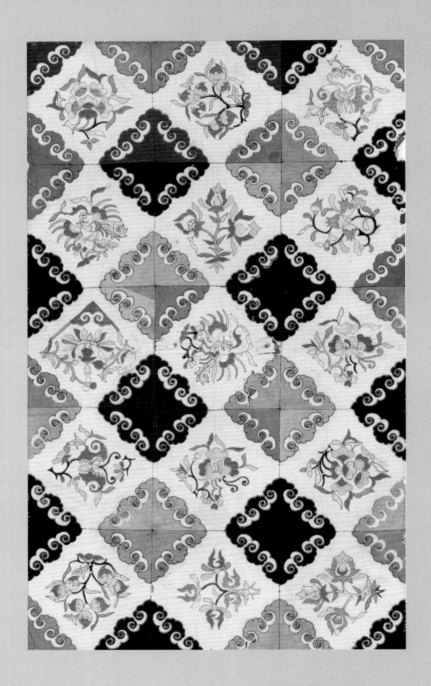

拼布被面

制作艺人未知

壮族，布依族或瑶族

中国广西南丹县（推测）

约 1900—1920 年

棉，丝

手工拼贴，手工缝制

纳布拉斯卡大学林肯分校国际拼布研究中

心与博物馆，编号 2014.027.0003

Quilt Cover

Maker unknown

Zhuang or Buyi or Yao

Probably made in Nandan County, Guangxi, China

Circa 1900—1920

Cotton and silk

Hand appliquéd, hand pieced

International Quilt Study Center & Museum, UNL, 2014.027.0003

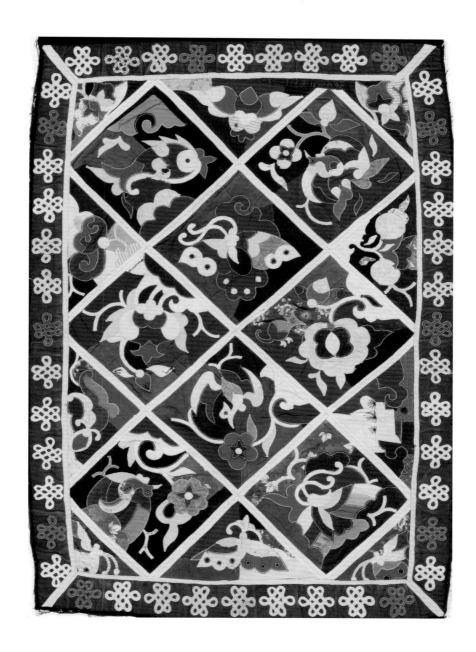

拼布被面

Quilt Cover

制作艺人未知

布依族

中国贵州省荔波县（推测）

约 1920—1940 年

88.9×132cm

棉，丝

手工拼贴，手工缝制

纳布拉斯卡大学林肯分校国际拼布研究中心与

博物馆，编号 2014.027.0005

Maker unknown

Buyi

Probably made in Libo County, Guizhou, China

Circa1920—1940

35" × 52"

Cotton and silk

Hand appliquéd, hand pieced

International Quilt Study Center & Museum, UNL,

2014.027.0005

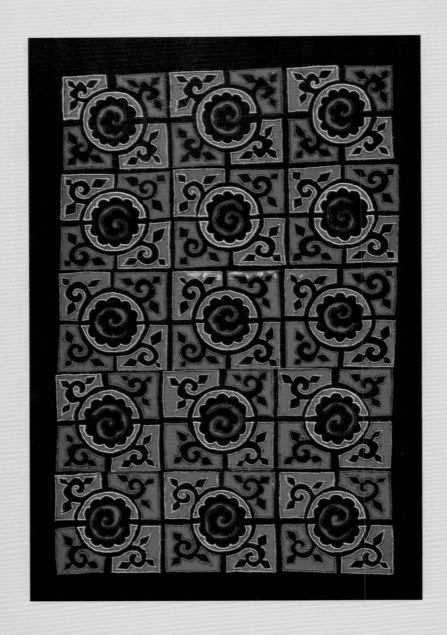

婴儿摇篮被

制作艺人未知
苗族
中国贵州省贵阳市花溪区（推测）
约 2000 年
50.8×68.6cm
棉
手工反面拼贴，手工缝制
纳布拉斯卡大学林肯分校国际拼布研究中心与博物馆，编号 2014.027.0008

Crib Quilt Cover

Maker unknown
Miao
Probably made in Huaxi, Guizhou, China
Circa2000
20" × 27"
Cotton
Hand reverse appliquéd, hand pieced
International Quilt Study Center & Museum,
UNL, 2014.027.0008

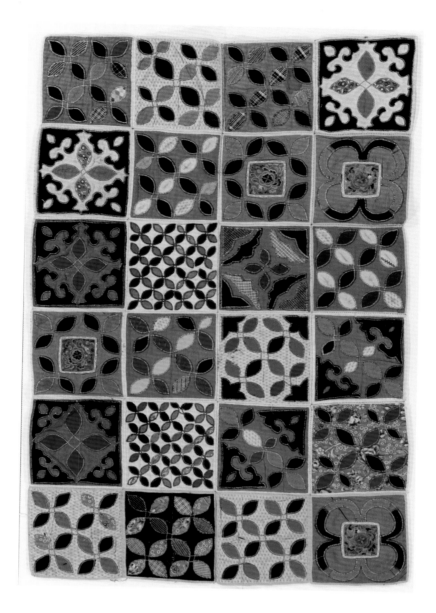

拼布被面

制作艺人未知

壮族

中国广西南丹县（推测）

约 1920—1940 年

97.8×144.8cm

棉

手工拼贴和反面拼贴，手工缝制

纳布拉斯卡大学林肯分校国际拼布研究中心与

博物馆，编号 2014.027.0011

Quilt Cover

Maker unknown

Zhuang

Probably made in Nandan County, Guangxi, China

Circa1920—1940

38–1/2" × 57"

Cotton

Hand appliquéd and reverse appliquéd, hand pieced

International Quilt Study Center & Museum, UNL,

2014.027.0011

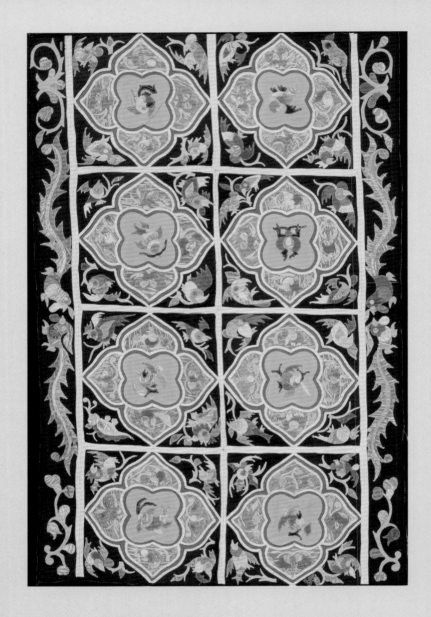

拼布被面

制作艺人未知

壮族

中国广西南丹县芒场镇（推测）

约 1930—1970 年

104×157.5cm

棉，丝

手工和机器拼贴，手工缝制

纳布拉斯卡大学林肯分校国际拼布研究中心与博物馆，编号 2014.046.0001

Quilt Cover

Maker unknown

Zhuang

Probably made in Mangchang, Nandan County, GuangxiChina

Circa1930—1970

41" × 62"

Cotton and silk

Hand and machine appliquéd, hand pieced

International Quilt Study Center & Museum, UNL, 2014.046.0001

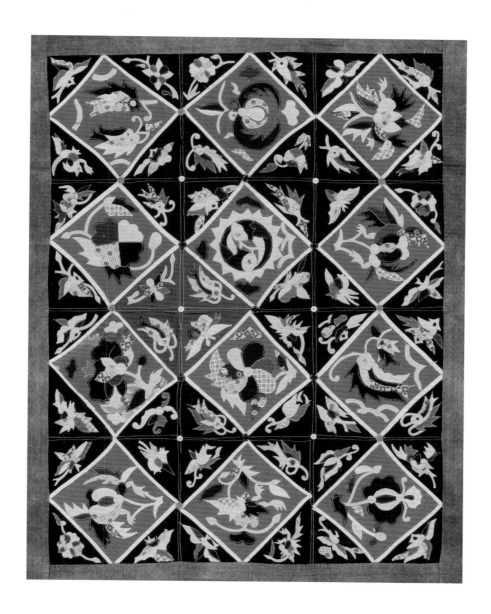

拼布被面

制作艺人未知

壮族

中国广西南丹县（推测）

约 1950—1970 年

114.3×139.7cm

棉，丝

细纹布 / 平纹细布

机器拼贴，手工缝制

纳布拉斯卡大学林肯分校国际拼布研究中心与

博物馆，编号 2014.046.0002

Quilt Cover

Maker unknown

Zhuang

Probably made in Nandan County, Guangxi, China

Circa1950—1970

45″ × 55″

Cotton and silk

Broadcloth/Muslin

Machine appliquéd, hand pieced

International Quilt Study Center & Museum, UNL,

2014.046.0002

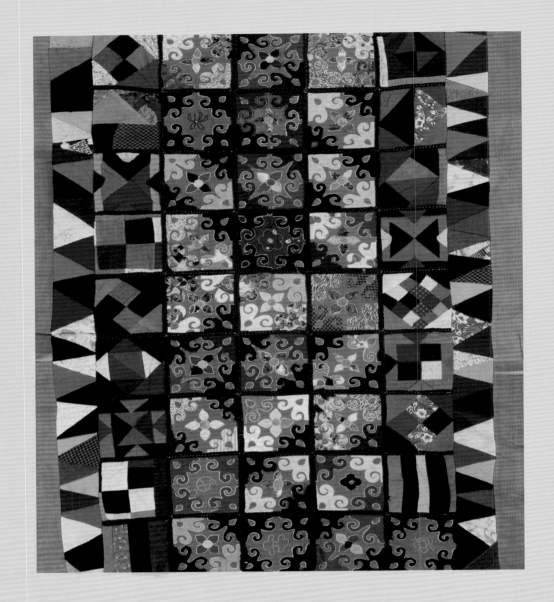

拼布被面

制作艺人未知
毛南族，壮族，布依族或苗族
中国贵州省荔波县茂兰镇（推测）
约 1960—1970 年
120.7×160cm
棉
手工拼贴和反面拼贴，手工缝制
纳布拉斯卡大学林肯分校国际拼布研究中
心与博物馆，编号 2014.046.0003

Quilt Cover

Maker unknown
Maonan or Zhuang or Buyi or Miao
Probably made in Maolan, Libo County,
Guizhou, China
Circa1960—1970
47–1/2" × 63"
Cotton
Hand appliquéd and reverse appliquéd, hand
pieced
International Quilt Study Center & Museum,
UNL, 2014.046.0003

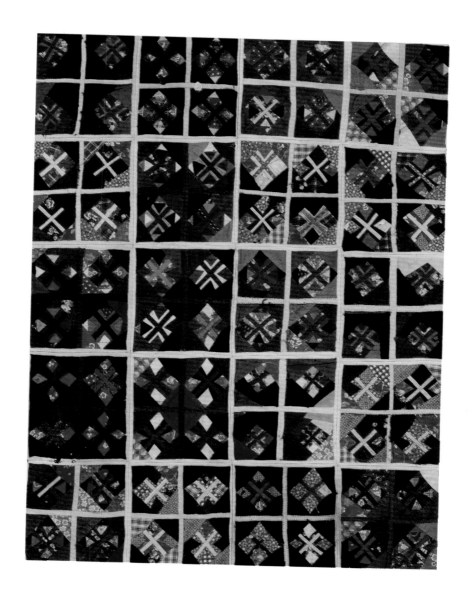

拼布被面

制作艺人未知
壮族，布依族或毛南族
中国贵州省荔波县茂兰镇（推测）
约 1930—1950 年
88.9×116.8cm
棉
手工拼贴，手工缝制
纳布拉斯卡大学林肯分校国际拼布研究中心与
博物馆，编号 2014.046.0007

Quilt Cover

Maker unknown
Zhuang or Buyi or Maonan
Probably made in Maolan, Libo County, Guizhou,
China
Circa
1930—1950
35" × 46"
Cotton
Hand appliquéd, hand pieced
International Quilt Study Center & Museum, UNL,
2014.046.0007

拼布被面

制作艺人未知

中国广西环江毛南族自治县（推测）

约 1960—1990 年

119.4×157.5cm

棉

手工拼贴，反面拼贴，手工缝制，手工和机器刺绣

纳布拉斯卡大学林肯分校国际拼布研究中心与博物馆，编号 2011.046.0001

Quilt Cover

Maker unknown

Maonan

Probably made in Huanjiang Maonan Autonomous County, Guangxi, China

Circa 1960—1990

47" × 62"

Cotton

Hand appliquéd and reverse appliquéd, hand pieced, hand and machine embroidered

International Quilt Study Center & Museum, UNL, 2011.046.0001

Text:"Develop a self-reliant attitude and work hard in the face of difficulties in order to continue upholding our new socialist countryside"(propaganda slogan).

参考文献 / Bibliography

1976. Chinese Folk Art. New York: China Institute in America.

2011. The Art of Patchwork. A Series on the Special Exhibitions at the Ethnic Costume Museum of Beijing Institute of Fashion Technology. Beijing: China Textile Publishing.

2009. Writing with Thread: Traditional Texties of Southwest Chinese Minorities. Honolulu: University of Hawai'i Art Gallery.

2014. "Patchwork, Heilongjiang Province" Tradition and the Art of Living

http://www.festival.si.edu/past-festivals/2014/china/from_the_land/index.aspx

Abibula. 2006. Colorful Cultures of Beautiful China. Translated by Li Hua. Beijing: Minzu University Press.

2001. Asian Costumes and Textiles from the Bosphorus to Fujiyama. New York: Skira.

Berliner, Nancy Zeng. 1986. Chinese Folk Art. Boston: Little, Brown and Company.

Ce, Yang Wenhing and Yang. 2002. The Traditional Miao Wax Printing. Guizhou: Guizhou Ethnic Press.

2014. Chinese American: Exclusion/Inclusion. New York: The New-York Historical Society.

Chung, Young Yang. 2005. Silken Threads: A History of Embroidery in China, Korea, Japan, and Vietnam. New York: Harry N. Abrams.

Corrigan, Gina. 2001. Miao Textiles from China. Seattle: University of Washington Press.

Gangyi, Dai. 1988. Shaanxi Folk Arts. Hong Kong: Xinminzhu Publishing.

Gillespie, Spike. 2010. "China: Opulent Textiles and Patchwork from the Silk Road". In Quilts Around the World: The Story of Quilts from Alabama to Zimbabwe. Minneapolis, MN: Voyageur Press. pp. 160-167.

Gittinger, Mattiebelle, and H. Leedom Lefferts Jr. 1992. Textiles and the Tai Experience in Southeast Asia. Washington D.C.: The Textile Museum.

Corrigan, Gina. 2002. Guizhou Province: Costume and Culture in Remote China, Odyssey.

Feng, Shanyun and Lan Peijin. 2002. The Patchwork Art of Shaanxi Province, Beijing: Foreign Language Press.

Hanson, Marin F. 2014. "One Hundred Good Wishes Quilts": Expressions of Cross-Cultural Communication." in Lynne Zacek Bassett, ed. Uncoverings 2014: Volume 35 of the Research Papers of the American Quilt Study Group. Lincoln, NE: American Quilt Study Group, pp. 60-89.

Garrett, V., 2007. Chinese Dress: From the Qing Dynasty to the Present, North Clarenden, Vermont: Tuttle Publishing.

Hanson, Marin. " 'One Hundred Good Wishes Quilts' : Expressions of Cross-Cultural Communication."

Uncoverings: Research Papers of the American Quilt Study Group (2014).

Hanson, Marin. "One Hundred Good Wishes Quilts." Quilters Newsletter (December–January 2016), pp. 35–37.

Harvey, Janet. 1996. Traditional Textiles of Central Asia. New York: Thames and Hudson.

Howard, David. 2008. Ten Southeast Asian Tribes from Five Countries: Thailand, Burma, Vietnam, Laos, Philipines. San Francisco: Last Gasp of San Francisco.

Huang, Teresa and Chen Mei–chih, ed. 2005. Six Continents of Quilts. Kaohsiung, Taiwan: Kaohsiung Museum of Fine Arts.

Jacobson, Clare. 2013. New Museums in China. New York: Princeton Architectural Press.

Jian, Hang and Guo Quihui. 2010. Chinese Arts & Crafts. Cambridge: Cambridge University Press.

Li, Qise 李启色. "Design Motifs and Folk Beliefs of Baby Carrier 娃崽背带的装饰纹样与民俗心态", Decoration 装饰 2004.5.

Lv, Shengzhong 吕胜中. 2002. Baby Carrier 娃崽背带. Nanning: Guangxi Art Press 南宁：广西美术出版社.

MacDowell, Marsha, and Mary Worrall. 2012. "The Sum of Many Parts: 25 Quiltmakers from 21st–Century America," in Teresa Hollingsworth and Katy Malone, eds. The Sum of Many Parts: 25 Quiltmakers from 21st–Century America. Minnesota, Minneapolis, Minnesota: Arts Midwest.

Naenna, Patricia Cheesman. 1990. Costume and Culture/ Vanishing Textiles of some of the Tai Groups in Laos P.D.R. Chiang Mai: Studio Naenna Co. Ltd.

Najdowski, Pamela and Tricia Stoddard. Unpublished Report. Submitted to International Quilt Study Center and Museum, 2015.

MacDowell, Marsha and Mary Worrall. 2012. "The Sum of Many Parts: 25 Quiltmakers in 21st–Century America." in Teresa Hollingsworth and Katy Malone, eds. The Sum of Many Parts: 25 Quiltmakers in 21st–Century America. Minnesota, Minneapolis: Arts Midwest, pp. 13–34.

Nosan, Gregory, ed. 2000. Clothed to Rule the Universe: Ming and Qing Dynasty Textiles at The Art Institute of Chicago. Chicago: The Art Institute of Chicago.

Roberts, Bea. 2010. Vanishing Traditions: Textiles and Treasures from Southwest China. Davis: University of California Davis.

Shanyun, Feng. 2002. The Patchwork Art of Shaanxi Province. Translated by Gu Wentong. Beijing: Foreign Language Press.

Smith, Ruth, and Gina Corrigan. 2012. A Little Known Chinese Folk Art: Zhen Xian Bao. West Sussex: Gemini Press.

Smith, Ruth. 2005. Miao Embroidery from SW China. Occidor, Ltd.

Smith, Ruth. 2007. Minority Textile Techniques, Costumes from SW China Occidor, Ltd.

Smith, Ruth. 2012. Folded Secrets Paper Folding Projects, Booklets 1–4

Torimaru, Sadae, and Tomoko Torimaro. 2004. Imprints on Cloth. Fukuoka–city: Takao Kawasaki, The Nishinippon Newspaper Co.

Xu, Wen and Liu Qi 徐雯, 刘琦, 2010.The Art of Patchwork 布纳巧工：拼布艺术展, Beijing: China Textile & Apparel Press 北京：中国纺织出版社出版的图书.

Vollmer, J.E., 2004. Silks for Thrones and Altars: Chinese Costumes and Textiles from the Liao through the Qing Dynasty, Paris: Myrna Myers Gallery.

Xue, Ye, and Zhang Xiaomei 薛野，张晓梅. "Folk Culture of Guangxi Dong Baby Carrier 广西侗族娃崽背带上的民俗文化", Journal of Wuxi Institute of Commerce 无锡商业职业技术学院学报2007.12.

Xun Zhou and Shanghai Shi Xi Qu Kue Kiao. 1987. 5000 Years of Chinese Costumes. San Francisco: China Books & Periodicals. [see especially . 167)

Zhang, Jingqioung. 2009. "Patchwork, Functions, and Origin of Clothing for Women in Jiangnan Watery Region of China", Asian Social Science, Vol. 5, no. 2 (February 2009) www.ccsenet.org/journal.html. Accessed July 25, 2015.

Zhang, Juwen. "Chinese American Culture in the Making: Perspectives and Reflections on Diasporic Folklore and Identity", Journal of American Folklore (Fall 2015) Vol 128, no. 510, pp.449–475.

Zhang, Lijun. 2010. Chinese Folk Art Crafts. Beijing: Nongcun Duwu Press.

致谢

许多机构和个人为本展览提供了大量的帮助，促成了这次中美两国对中国西南地区有形和无形物质文化传统的合作研究。除了文章作者以及书中已经表达过谢意的机构和个人之外，谨此向以下为中国西南拼布项目作出重要贡献的相关人士致谢：Ignacio Andrade, Audrey Bentley, Dr. Siddarth Chandra, 普卫华, 梁志敏, 起国庆, 李永华, 田军, Kyla Cools, Beth Donaldson, Randi Fields, Veronica French, Teresa Goforth, Paulette Granbury-Russell, Kelly Hansen, Sarah Hatcher, Sarah Hegge, Lora Helou, Dr. Carrie Hertz, Bill Ivey, 宋俊华, Jilda Keck, Helena Kolenda, Micah Ling, Jennifer Mitchell, Stephanie Palagyi, Mike Secord, Sue Schmidtman, 屈盛瑞, Matt Sieber, Venice Smith, Frances Spring, Susan Tu, 王立阳, Minday Wang, Sunny Wang, Ashely Wu, SongYi Wu, 金媛善, 张举文, Dr. Weijun Zhao, Cecily Cook, 蒋贞, 徐昕, 梁小燕, 吕妍, 罗长群, 陈君, 王玉成, 郭慧莲, 王晓佳, 李洪涛, 李晋, 郭少妮, 王立, 吴昊。其他无法一一列举姓名的人士，在此一并表示我们衷心的感谢！

Acknowledgements

This exhibition would not have been possible without the commitment of numerous institutions and individuals to engage in and support a collaborative, bi-national research inquiry into the intangible and tangible aspects of a material culture tradition in southwest China. Acknowledgement to many of these institutions and individuals has been included in individual articles of this manuscript. In addition to those, we would also like to thank the following who also played important roles in developing and implementing this multi-faceted Quilts of Southwest China project: Ignacio Andrade, Audrey Bentley, Dr. Siddarth Chandra, Pu Weihua, Liang Zhimin, Qi Guoqing, Li Yonghua, Tian Jun, Kyla Cools, Beth Donaldson, Randi Fields, Veronica French, Teresa Goforth, Paulette Granbury-Russell, Kelly Hansen, Sarah Hatcher, Sarah Hegge, Lora Helou, Dr. Carrie Hertz, Bill Ivey, Dr. Song Junhua, Jilda Keck, Helena Kolenda, Micah Ling, Jennifer Mitchell, Stephanie Palagyi, Mike Secord, Sue Schmidtman, Qu Shengrui, Matt Sieber, Venice Smith, Frances Spring, Susan Tu, Liyang Wang, Minday Wang, Sunny Wang, Ashely Wu, SongYi Wu, Ji Yuansha, Dr. Juwen Zhang, Dr. Weijun Zhao, Cecily Cook, Jiang Zhen, Xu Xin, Liang Xiaoyan, Lv Yan, Luo Changqun, Chenjun, Wang Yucheng, Guo Huilian, Wang Xiaojia, Li Hongtao, Li Jin, Guo Shaoni, Wang Li, and Wu Hao.